Art Platforms and Cultural Production on the Internet

DRILL HALL LIBRARY
MEDWAY

WITHDRAWN
FROM
UNIVERSITIES
AT
MEDWAY
LIBRARY

D0420720

HFINE
1300
5759

Routledge Research in Cultural and Media Studies

3050523

Art Platforms and Cultural Production on the Internet

Olga Goriunova

Routledge
Taylor & Francis Group

NEW YORK AND LONDON

UNIVERSITIES AT MEDWAY

2 8 APR 2014

DRILL HALL LIBRARY

First published 2012
by Routledge
711 Third Avenue, New York, NY 10017

Simultaneously published in the UK
by Routledge
2 Park Square, Milton Park, Abingdon, Oxon OX14 4RN

*Routledge is an imprint of the Taylor & Francis Group,
an informa business*

First issued in paperback 2013

© 2012 Olga Goriunova

The right of Olga Goriunova to be identified as author of this work has
been asserted by her in accordance with sections 77 and 78 of the Copy-
right, Designs and Patents Act 1988.

Typeset in Sabon by IBT Global.

All rights reserved. No part of this book may be reprinted or reproduced or
utilised in any form or by any electronic, mechanical, or other means, now
known or hereafter invented, including photocopying and recording, or in
any information storage or retrieval system, without permission in writing
from the publishers.

Trademark Notice: Product or corporate names may be trademarks or
registered trademarks, and are used only for identification and explanation
without intent to infringe.

Library of Congress Cataloging-in-Publication Data
Goriunova, Olga, 1977–
 Art platforms and cultural production on the internet / Olga Goriunova.
 p. cm. — (Routledge research in cultural and media studies ; 35)
 1. Art and the Internet. 2. Arts and society. 3. Internet—Social
aspects. 4. Technology and the arts. I. Title.
 NX180.I57G67 2011
 700.285—dc23
 2011014224

ISBN13: 978-0-415-89310-7 (hbk)
ISBN13: 978-0-415-71792-2 (pbk)
ISBN13: 978-0-203-80214-4 (ebk)

**For my parents, Tatiana Konstantinovna
and Anatoly Ivanovich**

Contents

Figures

Acknowledgments

Part of the research presented in this book was financially supported by the Ford Foundation International Fellowship Programme, and I would like to thank IFP staff in Moscow and New York. I have also had the pleasure to be supported by Media Lab, now part of Aalto University, School of Art and Design in Helsinki, Finland. I am grateful to the Faculty of Applied Social Sciences, London Metropolitan University for granting me research leave to finish the manuscript. It was a pleasure to work with Erica Wetter at Routledge.

I would like to thank Matthew Fuller for his kind readership, critical commentary, and belief in the book. The individuals and institutions involved in the organization of four Readme software art festivals and all the people who co-created and contributed to the Runme.org software art repository greatly influenced my thinking-in-practice. Thank you to Sergei Teterin, Tomas Traskman, Soeren Pold, Christian Andersen, Morten Breinbjerg, Jacob Nielsen, Saul Albert, Alex McLean, Inke Arns, Francis Hunger, Amy Alexander, Florian Cramer, the Yes Men, Pit Schultz, and all the others involved.

The following people have read various parts and versions of the book and provided useful comments and have also organized opportunities for the work to be discussed and developed: Andrea Botero Cabrera, Teemu Leinonen, Lily Diaz, Anna Kotomina, Natalia Smolyanskaya, Saida Danilova, Natalia Konradova, Katy Teubener, Henrike Schmidt, Andrew Goffey, Geoff Cox, Sally Jane Norman, Joasia Krysa, Aymeric Mansoux, Marloes de Valk, Simon O'Sullivan, Andrew Murphie, Jussi Parikka, and Michael Goddard. Udaff.com translations were made by Ksenia Golubovitch.

I am grateful to Alexei Shulgin for working with me on a series of projects and concepts that led to this book and for help during some of the core stages.

The work of which the book is a part is as old as my son Nikolai, whose force of arrival and becoming made me complete it.

Introduction
Departing from an Art Platform

Here . . . , in connection with the socio-political moment in which we are living, the goal of the new synthesis has been organization as a principle for any creative activity.

(Liubov Popova, 1921)

The ways in which culture occurs, how it is practiced, and the ways in which art enacts itself in relation to culture, humans, and society are now irreversibly coproduced by networked media technology. In order to understand this, we need to look at the ways in which aesthetic forms of life cut through processes of subjectification and organization, how they mobilize and reinvent network systems and cultures, and how those, in turn, condition and cocreate these forms of life. Everyday digital objects, gestures, and their assemblages, such as file uploads and downloads, form filling, data handling, searches and postings, protocols, scripts, software structures, and modification parameters are all plugged in to contemporary aesthetics and coconstruct the ways in which the individual, cultural, and social spheres are produced, organized, and disrupted. Art platforms both conform to and are part of this overall development, but they also stand out from it in very striking ways.

Art platforms bring together human-technical creativity, repetition, aesthetic amplification, folklore, and humour, all concepts to be examined in the course of the book, to generate a cultural organizational mechanism powerful enough to disrupt some of the domineering and stratifying tendencies of digital media, culture, and society. Art platforms are self-unfolding mechanisms through which cultural life may advance to produce fascinating aesthetic objects and processes; they occupy a special place within organizational aesthetics on the Internet.

Whereas art platforms possess a multilevel unfolding of their own and have direct involvement in the operation of digital aesthetics, they are generally unrecognized as a specific form of aesthetic life. On one hand, there is not a name for these phenomena, except the one this book proposes, but on the other hand, art platforms implicitly self-conceptualize as specific subjects of culture.[1]

Working with or thinking about the aesthetic practices and scenes of art platforms means following the paths they take through a complex set of mutually determining relationships that have larger subjective and societal

effects and finding out what is happening to digital technology as a tool, as a context, as a metaphor, as an agent, and as culture-at-large.

In writing this book, I go round art platforms, drawing now nearer and then retreating, nibbling on a side and then releasing the object, continuing my circular movement in order to set up the idea of the art platform as a figure and an instrument that can be useful, imaginative, gay, and nonintrusive. Art platforms act as the horizons and catalysts enacting certain events but are also formed by such things; they stimulate certain struggles but also refrain from steady development and, as often as not, are formed by disjunctures, awkward mappings between technical, aesthetic, and social forces. In this way, I propose that art platforms can be thought of as a deviation from the main thoroughfares of digital cultures, paths that allow us to come closer to key issues manifesting in larger cultural formations—such as self-organization and creativity, folklore production and free participation—but that also allow us to discover the exceptionality of the particular, to hunker down close to the very stuff of digital culture as a means of their close reading in order to scent the exuberant air of today.

To have the complexity of the figure set up, let us start from something clear and simple, a tautology: An art platform is a network platform that produces art, here understood broadly as a process of creative living with networks. A 'classical' art platform differentiates itself from other networks and sites by a number of the relations it establishes and by those that emerge from within it. As a self-organized institution, an art platform is flexible; it is informed and codeveloped by users and the aesthetic work that it propels. An art platform can also take the form of a crossroads at the intersection of several systems or actors of different scales and as such may be a momentary expression of creative power. Therefore, in practical terms, an art platform can be a stand-alone website that, together with other actors, forms an ecology of aesthetic production, but it might also take place as a subsection of a large platform, or even as a space between a corporate service, artists' work, hacking, collaborative engagement, and a moment of aesthetic fecundity. An art platform engages with a specific current of technosocial creative practices and aims at the amplification of its aesthetic force.

Here, the art platform is a terminological solution for describing a website or an assemblage of human-technical objects and relations reflexive of their own processual composition, which acts as a catalyst in the development of an exceptionally vivid cultural or artistic current. As a locus of such activity, it induces the propagation of aesthetic phenomena transcending the inventory of their formation, and as such it is a system whose behaviour cannot be deduced from the trajectories of its elementary characteristics. The aesthetic phenomena that emerge through art platforms are of a character 'natural' to technical networks. Be it software art, 8-bit music, short stories, 'primitive' Web pages, short videos, scripted behaviours of 3-D objects, or recorded reenactments, they are integral to the art

and cultures of the Internet age and delve deep into the exploration of the materiality of digital media. If art platforms seem a kind of misplacement of the organizational forces of a previous era, this is because they are an array of forces with which to explore and map the characteristics of the organizational aesthetics of a new type of cultural emergence.

As a process of emergence, an art platform is an assemblage of structures, notes, codes, ideas, emails, decisions, projects, databases, excitement, humour, mundane work, and conflict. Here an art platform is best understood through the metaphor of a railway platform, as an element that unfolds in its arriving and departing trains, in tracks that cover vast spaces, in the forests those rails run through and the lakes they pass by, in the humdrum and dreams of passengers and their bags and lunches, in the hills and sunsets forming the landscape, in the rain on the train's window, in the mechanics of an engine, logistics of rolling stock, semaphores, encounters, and in rail crashes. An art platform is never simply a technocultural object, but it is a resonance, a movement, an operation. The capillaries of aesthetic emergence in art platforms draw from the technical materiality of networks, databases, and software; from grass-roots, folklore creativity; from forces of repetition and sociality; from conflictual border zones and disjunctures between normality, capitalism, politics, quotidian labour and despair, escape, and creation.

THE DIFFERENTIATION OF NETWORKS

An art platform is a particular type of practice, but it is also a type of network, a genre of network organization. As such, the art platform is a conceptual device that allows for a differentiation and problematization of networks.

Since the introduction of the concept of the network in the cultural sphere, it has travelled a long way. In the social sciences, and especially in the context of actor-network theory, as Bruno Latour reminds us, the network was celebrated as a conceptual device that allowed for an acute analysis of the performance of transversal relations among actors of different types and orders that constitute the social as a certain kind of circulation rather than as a fixed entity.[2] In actor-network theory, the concept of the network was conceived as a means to address societal processes without withdrawing into a closed, cultured, and mechanical universe of the traditional 'institution' and 'organization.' The idea of the network was at the core of the struggle against certain normative, essentialist, and linearly causal versions of modernity, and carried along with it the rhizomatic thought of Deleuze and Guattari[3] as a related conceptual practice introducing deformation, disequilibrium, and asymmetry while working through nonstructural and nonrepresentational processes of conjunction and change. The network, from this angle, was about difference, transformation, and heterogeneity.

Or else, let us start anew. The concept of the network stems from network theory, whose language was developed by a branch of applied mathematics called graph theory that studies link relationships between objects. With Leonard Euler's[4] first proof of the theorem dealing with the Königsberg bridge problem in 1736, a concept of the graph was formed as a mathematical object consisting of discrete nodes (vertices) linked together by lines (edges), to be studied in terms of its connectivity, disembodied from any other characteristic. In the 1950s, sociology went on to borrow and adapt the conceptual apparatus of graph theory to apply it to the quantitative analysis of data, coupling the structural and the behavioural characteristics of networks.[5] Over the last decade, more or less, a radical update on these developments was undertaken and termed network theory, which was most prominently popularized by the book *Linked* by Albert-László Barabási. Network theory is on a mission to describe the general topological features of different kinds of networks including, but not limited to, biological, ecological, technical, social, and communication networks. This theory is a rapidly developing field, which no longer seems to be reproachable for its purely spatial approach (devoid of the dimension of time) and a level of general abstraction (the God's eye perspective).[6] Eugene Thacker's criticism of the concept of network stemming from network theory as essentially a Eulerian-Kantian enterprise, published in 2004, seems to be overcome by the most recent developments, which urge the examination of the properties of 'real-world' networks in empirical terms and for the recognition of the dynamic properties of networks evolving over time, including both the behaviour of the nodes and the changing character of the links between them.[7] The development of the typology of networks, to account for hierarchical structures, for instance, is a new direction pursued for its ability to address heterogeneous networks.[8]

Curiously enough, the social sciences form a terrain of the imagination where the exact sciences meet the humanities in order to effectively misunderstand each other. Such a 'misunderstanding' is essentially a set of beliefs of how one strand of thinking and acting, which is quantitative and mathematics based, can make use of another, which is qualitative and which is at its best a poetic act of hacking the process of formalization, and vice versa. Throughout the twentieth century, a number of disciplines were formed that essentially work on the translation between and use of both sides. Examples include operations research, social simulation, or to an extent, organization theory, to be discussed a bit further on in this introduction. It is worth noticing that network theory is ultimately a quest to understand the systems whose underlying structures are networks.[9] In this endeavour, a 'family photograph' develops, with its stepgrandmother in the second row, namely, system theory (with organization theory on its lap). Here, network theory aspires to be a cybernetics of the twenty-first century, a mode of thinking based on the successful application of a number of abstract conceptual instruments to the analysis of diverse fields in order to

understand them at a sufficient degree of generality, while often subjecting what is thus analysed to the rigours of greater efficiency and control. Such sciences can acquire the reputations of being mere pseudosciences while at the same time having an enormous impact and efficacy in practical applications, in military research, engineering, agent-modelling systems, robotics, and biotechnology, to name a few.

The two concepts of the network discussed previously, a network as an emergent ensemble that is elusive and heterogeneous in its inclusivity of actors, and producing an ongoing resonance between them (from actor-network theory) and that of a network as a topological distribution producing coefficients of connectivity (from network theory) do not exhaust the means of thinking networks, of imagining them in both heterogeneous and nonlinear ways and of being able to differentiate between them. There are ways of developing concepts that need not be marked as the sole property of a specific mode of thinking and making but which can be unfolded as openly shared and enriched by their combinations, such as Gilles Deleuze practiced and argued.[10] Such approaches have given us concepts of network production such as the bifurcation (Prigogine and Deleuze/Guattari), networks as assemblages (Manuel DeLanda), and ecologies and media ecologies (Guattari, Bateson, and Fuller), to name a few.

Media ecology[11] is a green metallurgical concept that is both modest and mad. Its modesty is in its close and quiet attentiveness and in being submerged in the material, which we listen to while it is given space and means to speak. Media ecology's madness is in its explosiveness as a way of working that not only wipes away traditional tools of understanding but also disassembles the world to the state of a primal soup, in order to further reflect on its phylogeny in action. Media ecology is formed of networks, which are never found at equilibrium but are forever disassembling to become 'something else.' It is formed of networks that mutate into objects, resonances, pictures, people, and organs. Alternatively, one could argue that networks have nothing to do with media ecologies, which involve complex processes of differentiation and amplification that well-defined networks with their accumulated flavour of pernickety tracing cannot stand up to.

Media ecologies are processes of emergencies of particular assemblages that are discovered and participated in by sensitively following the activity of material composition. They are conceptual devices to question the evolving couplings of humans, animals, networks, machines, wave space, and art in order to fight premature or final closedness. Media ecologies are not especially preferential towards humans, though, nor is much of the vitalist philosophy the concept partially stems from.

What then, in this context, are art platforms? Particular types of networks? Seeing them as such allows us to talk about how they are constructed, how they operate, and what their actors, agencies, and publics are. What is it that gets produced by their metabolism? Are art platforms a particular type of media ecology whose constituents are to be described

as if by a taxidermist? Or shall we instead talk of a media ecology of art platforms? We could discuss what human-technical processes emerge as art platforms, how they evolve, disassemble, change appearance, set things off. Media ecology is, first of all, a way of looking and seeing, of doing and making. An art platform is an entity, an activity, and a process of development. Ideally, it is a concept that is inclusive of a reflection upon its own media ecology.

A number of concepts might thus be used to address the phenomenon, but it is worth developing an approach that would allow for an art platform to manifest all its facets and particularities on its own terms to enable the concept to run free, to find something new to trip over.

Art platforms are plugged into processes of creativity and subjectification, into art worlds, folklore and repetition, into the late capitalist eminence of 'immaterial' labour, into the politics of participation, publics and self-organization. Art platforms shed light on key factors in the organization of cultural practices today, suggesting an analysis of the shifting positions, linkages, and policies in their technoaesthetic significance. Developing their own mechanics of becoming, art platforms provide us with concepts, which may help reflect upon more powerful or traditional trajectories, as well as demonstrate the existing and future practices of divergence. In designing their time and space figuration, art platforms become settings that ask questions. What becomes culturally significant, what constitutes such a process, especially in relation to wider figurations of culture? How do cultural processes acquire agency, and what is their value? How might they organize themselves, and what constitutes their ecology? How open can such a process be? What are their poetics of diversity and its new orders? What lies at the heart of art platforms? How does its force exhibit itself? What plays out in such an assemblage as an art platform? How do technical acts such as the writing and execution of code or the development of interface design couple with time, political decisions, email communication, working together, enthusiasm, funding, small gestures of signing in or adding a vote; how do they couple with inventiveness and humour?

Art platforms are types of networks, a specific colouration of new media ensembles, a fashion and an obsession, which do not form an Internet genre that is soon-to-become-obsolete due to technical upgrades. Art platforms disseminate themselves among a variety of activities undergoing formation and change across contemporary new media: in participatory platforms and social networks, democratic widgets, postarchives, online curating, 3-D worlds, and other loci of technocultural reality. Art platforms, their parts, features, and effects can be found across the Internet, as stand-alone websites, sections of larger portals, islands and constellations of objects. Art histories constructed personally for each database user, video exhibitions assembled as part of video-sharing sites, the usage of taxonomies and wikis as integral elements of new curating—all are proliferations of the germs if not memes of the aesthetic devices experimented on by art platforms.

As a current that is strongly articulated in the movement of artists on the Internet, art platforms come in the footsteps of archives and databases aimed at collecting and historicizing new media art, such as Media Art Net, the Walker Art Centre Collections of net art, Netzspannung.org, V_2 Archive, and so on.[12] All of these initiatives are more or less successful attempts to maintain and enhance the sustention of media and digital-media-based art. These projects aim to reflect on media art by constructing durable systems of files, descriptions, contexts, and links; by building histories ever at risk of being rendered conventional. Whereas classifying, reflecting upon, and preserving media and digital media art is a task of immense importance and difficulty, such initiatives tend to work primarily with rather categorical concepts, for instance, of what is worth including in a collection (in terms of its past influence) or how an art trend can be traced and presented once it is removed from an immediate living state. More importantly, such projects primarily focus on art, or what is presented as art.

In contrast to that, art platforms engage with living practices in their blurred and 'dirty' forms between a more broadly defined swathe of culture and art. Here, they are found in the 'grey' zones of cultural production. They undergo formation in ways that allow them to be witnessed and taken part in. Such cultural production has not yet acquired the kinds of aesthetic value characteristic of art; however, it is here that brilliant aesthetic practices may be born (as well as mediocre repetitions of fixed formulas). Despite the term, art platforms work with such practices that often do not self-conceptualize as art per se but that might become culturally significant. Such 'art' in 'art platforms' is precisely the point of their strength: something becoming art, failing to become art, aspiring to become art, where art is an avant-garde formation of new realities, language; ways of living, seeing, and imagining. As such, art platforms aim at mapping wide assemblages of ideas, territories, and practices in the processes of emergence that always maintain a possibility of breakthrough as well as of failing to come to fruition.

Here, the openness and polyphonic character of the new regimes of organization come to the forefront to distinguish art platforms from other forms of nurturing and structuring culture. Dealing with creative production, experimenting politically with governance methods of different sorts, self-organization and formulations of autonomy, art platforms unite projects, activities, and discourses of differing levels, aims, working methods, materials, contexts, and outcomes. In doing so, art platforms compel one to think about the organizational forms of culture—and, as such, organizational aesthetics.

A PLATFORM FOR ART

The concept of a 'platform' as an organizational concept is shaped most expressively by the history of political struggles, revolutions, and

avant-gardes. Initially used most often in a political sense, a platform meant a program, an outline of theories or beliefs, the future prospects and organizational guidelines upon which a number of people could agree. A popular example of such usage of the term can be found in a pamphlet titled 'Organizational Platform of the Libertarian Communists' published in 1926 by a group of Russian anarchists in exile, Dielo Trouda (Workers' Cause), that set out to establish a number of common ideas and working principles.[13] Although it set out a debate among anarchist groups on stronger organization and disorganization, it is exemplary in its usage of the term.[14] Probably the earliest bright example, however, is the pamphlet 'The Law of Freedom in a Platform' by Gerrard Winstanley, a member of the Diggers who cultivated common lands, aiming to distribute crops without charge in the seventeenth-century England. The text is a thoughtful and vivid plan for a new structure of society addressed directly to Oliver Cromwell.[15]

Since then, 'platform' has generally meant a set of shared resources that might be material, organizational, or intentional that inscribe certain practices and approaches in order to develop collaboration, production, and the capacity to generate change. A platform would be likely to emphasize collective and preferably anonymous work, encourage inclusivity and the dissolution of the amateur versus professional or high-brow versus low-brow registers of work. Art activism and artist collectives are two other forces that have further shaped the concept of a platform, and these have a long and complex set of histories.

In the 1920s, Soviet constructivism set out to establish laboratories as production and organization platforms to process art as engineering, to turn factories into culture engines and massively and collaboratively manufacture culture.[16] The collective and anonymous organization of creative activity was regarded as a true basis for social engagement and the profound political transformation of society and individuals on the basis of art. The laboratory as a factory, as material resource and as a creative repository, a platform to stand on to move the earth with an Archimedean lever, was tested by the constructivists as well as objectivists, engineerists and productivists.[17] Organizational methods of art activism, such as situationists, Gutai and the lettrists, CoBRA and the International movement for the imaginist Bauhaus, Fluxus, Art Workers Coalition, and the Art & Language groups of the 1960s continued on to the rather poorly documented North American, British, European, and Russian community art and art collective activist practices of the 1970s and 1980s.

The features of a platform as an alternative system of organization and circulation and as a resource to constantly reposition art to reflexively disrupt institutional, representational, and social powers can also be recognized in many of the organizational constellations of art collectives and activist art groups of the years following 1968. Group Material, S.P.A.R.K., PAD/D, and Gran Fury[18] as well as the Exploding Cinema,

the Scratch Orchestra, the International Mail Art Network, Brixton Artist's Collective, and Working Press[19] of the 1970s, 1980s, and onwards are among many that explicitly carried out art as a collectively distributed social practice that forms society.

Political movements and artistic laboratories, art collectives and activist groups, and other such influences on art platforms often drew on the potential of the technological, whether in terms of providing education, training, or instruments, routes of communication, distribution, and presentation for carrying out political acts or as an aesthetic dimension to work in and with. Platforms, whether they are feminist groups or youth centers, e-learning systems and participatory design toolkits, databases of artistic ideas[20], trucks,[21] and camps[22] are all organizations of technologies, bodies, and concepts, exploring and pursuing certain kinds of knowledge, aesthetics, and politics.

A renewal and flattening of the term arose during the Web 2.0 hype and in such use originates from Tim O'Reilly's article in which he describes 'the (new) web as platform,' not as a figure of speech but a description of concrete developments.[23] Throughout the 2000s, the idea of the platform is rearticulated as a website, possibly a tool repository but also largely as a concentrator of data flows. To articulate the position of art platforms in relation to the participatory web, let us first roughly generalize on existing art platforms.

ART PLATFORMS PRECISELY

Technically speaking, an art platform usually has, and often centres around, a database, structured in a variety of ways, that users can upload to (sometimes with sets of restrictions applied, such as filtering), download from, or browse through (again sometimes with filtering) and sets of functions centred around this activity, such as voting, ranking, featuring, commenting, and others. Stand-alone art platforms, such as the software art repository Runme.org, or the 8-bit music community Micromusic.net, both of which will be examined in later sections of this book, all have such structures. More freeform and ad hoc, or relational and flanêuring, art platforms have ways of dealing with massive amount of cultural work, whether constituted by complete projects, artistic pieces of data, or creative 'mud,' to enable an appearance and amplification of a certain aesthetic power. Lists, threads, blogs, diaries, and collages may all become the 'databases' of art platforms. But this simple technical description must immediately be supplemented.

Art platforms appear as experiments in the aesthetics of organization. They focus on a certain kind of cultural practice, as an open-ended and grass-roots process rather than on a set of objects. The cultural or artistic practice, the moment of a certain aesthetic formation undergoing rapid change that the platform embraces certainly may exist prior to and beyond

the art platform, often at the borders of art, in grey zones of culture as described above. Art platforms participate in and often enable the processes of formation and amplification of currents in culture and techno-social movements, some of which may produce aesthetic brilliance across domains beyond art.

Creativity, folklore production, frustration, aesthetic intoxication, and other dynamics self-organize and evolve through systems such as art platforms. Here marginal, unprofessional, self-governed currents may create new cultural figures and work out vectors of change, whether aesthetic, social, or subjective. The strength of art platforms lies in the way they deal with immanent creative cultural forces that are at once insubsumable in their entirety and diversity to any single principle or institution and that are a foundational power in arts, economies, and politics, domains where, more often than not, they may be beheaded.

A development that addresses and capitalizes on the changing role of creative cultural emergence in social, political, and economic life and one that is closely related to art platforms is the participatory web, or phenomena that have recently been subsumed under the 'Web 2.0' title.

PARTICIPATORY WEB

'Web 2.0' is an umbrella term, which has even been claimed as a trademark,[24] that has been used to address the diversity of technical means enabling Internet users to participate, exchange, link, map, upload, post, edit, and comment—all in all, to engage in social creation online. The phrase 'Web 2.0' was popularized by O'Reilly Media[25] in 2004 to market the rising phenomena of participatory content production, collaboration, sharing, and communication through the interfaces of wikis, blogs, collaborative mapping, tagging, or social networking platforms. It has since become a buzzword, triggering both excitement and criticism.

There are two, or rather three, key conceptual issues in grasping such activity: its technical realization, explained in the following; and its communal creative 'substance' as interwoven with its implications for policy and forms of economy. O'Reilly and his confederates stress the technical side, maintaining that the previous (Web 1.0) versions of online creation and collaboration were only open to people (understood as companies) who had software packages with which to, first, create content with some other word, image, or video processing software, then create an html version of it with an html editor, and then upload the data with a file transfer application. According to this account, such data was most often published on personal websites or portals ran by companies or institutions. By contrast, and still in technical terms, Web 2.0 platforms allow any user to create, upload, and edit data within the browser window without the need for special desktop software: All applications are served through a Web browser

that allows interaction with any content. For Web 2.0 adepts, a platform spans 'all connected devices,' 'delivering software as a continually-updated service,'[26] and is 'a platform for interacting with content.'[27] Even 'the web and all its connected devices as one global platform' implies the meaning of a platform as of a server (or servers) 'delivering desktop-like applications over the web.'[28] Such a definition is useful and helps to make a distinction for designers and programmers between Web 1.0 that was supposedly about static, html-based websites that are sometimes characterized as the read-only Web and Web 2.0's dynamic platforms, characterized as the read-write Web. (In this respect, Web 2.0 become an extension of content management systems.)[29] Here the credibility of the Web 2.0 term ends because such a description does not adequately address the politics of the technical architectures and applications involved. O'Reilly and his followers try to raise the profile of the term by nodding towards the fostering of community, collaboration, the 'architecture of participation,' 'rich-user experiences,' and 'collective intelligence,'[30] but they continuously fail to prove that such cultural phenomena were not present in the time of what they term as Web 1.0. This criticism is not new; Slate.com has called Web 2.0 merely a technical upgrade, whereas the participatory or social aspects of Web 2.0 are 'what the Web was supposed to be all along,' as Tim Berners-Lee, whose first browser incidentally included a write function, puts it.[31] Despites the term's poverty, its success subsumes all the attempts to talk about social software; a participatory web; collaborative work; and other, different, and preexisting models.

How do art platforms as a partially marginal avant-garde genre relate to the participatory platforms that have gained enormous popularity in the recent years? It would be just as misleading to radically withdraw art platforms from the field of operation of the participatory Web as to not distinguish between their methodologies at all. This task is intricate; on the one hand, both art platforms and the participatory Web feed on the same machinery of creative energy, building algorithms and acting spontaneously in order to get warmed up next to its thrumming engines, making it more structured or functional, pleasurable, or accelerated and intense. Both art platforms and the participatory Web deal with the human capacities, technology, and societal structures that generate what is known as culture. This book tends not to distinguish in a hard and fast way between culture and art; it is focused on the grey anomalous zones in which one becomes another and vice versa, and my interest is driven precisely by these processes of conversion. It is through the allowance for these moments that the participatory Web and art platforms may differ from each other, as particular technical settings, devices, and ecologies whose metabolism produces diverging energies.

Art platforms exhibit a capacity to form a system of human-technical assemblages and arrangements that produce a common aesthetic, political, and creative horizon of the practices involved. The arrangements can

include various structural devices, whether a taxonomy (list of categories) or associational classification (keywords), collections of scripts, files, reports, and recordings, constellations of contributions or a list of the latest ones, digital objects and postings, most popular projects, features, and texts. The structure of art platforms may vary significantly, but generally each one comes into being in order to enable the amplification of a particular aesthetic drive in a manner individually tailored to it.

Participatory platforms are not always interested in creating the conditions that might allow for such an aesthetic amplification to occur, to transform itself and become something else. The logic of their operation generally performs itself in relation to different societal functions and systems. It is worth repeating that it is, however, perfectly possible to create art platforms inside and as parts of participatory networks of different sorts; an art platform may indeed implant itself into the body of the participatory Web. Given this, any assemblage of code, creativity, sociality, anger, excitement, repetition, and amplification may, under certain conditions, become an art platform.

One of the features art platforms exhibit is a certain kind of attentiveness to and allowance for the mechanisms of differentiation. Such differentiation, while often being generous and maintaining affinities to the abundance of practice in its cultural performance, also acts as an inductive force to propel the aesthetic becoming that an art platform enhances. Here, one could speak about filtering or moderation that may be in place and that can be decisive in terms of what gets in (and is far from being 'automated curation')[32] or about human-technical policies and interfaces that enable certain kinds of aesthetic features and choices or about various kinds of distinction.

Thus, some art platforms may occasionally seem 'undemocratic.' After all, Internet technologies offer a great variety of tools enabling common, user-based decision making, and it seems that recently an urge to develop democratic widgets is intensifying. But if we look attentively at such developments, we might notice that many participatory platforms based on peer decision-making exhibit numerous features and methods of control, normalization, and/or distinction and choice. These start from 'abuse teams' in the case of blogs, the banning of certain users or accounts, or creating collections of the most useful postings on the matter core to a certain group and continue on to include more specific arrangements. For instance, the enormous power the 'talk page' has over the production of an article on Wikipedia makes it an efficient filtering mechanism because Wikipedia netiquette expects editions or new contributions to be discussed on the 'talk page' of the article prior to changes being published; suggestions by known authors (although only by username) are treated with more trust; and rarely do undiscussed contributions from unknown users survive for more than a few hours. Slashdot.org, the legendary news resource 'for nerds,' offers a highly elaborate set of multilevel filtering mechanisms relying on software

decisions and user contributions. However, the initial choice of whether a particular posting is to be published on Slashdot.org is taken by a team of editors who are employees of Open Source Technology Group.[33] Such examples are not offered to make a claim that all Internet developments are identical. However, differentiation can be more usefully seen as a nuanced gradient, and deciding on a variety of trajectories of organizing means choosing different topologies of danger to manoeuvre between rather than deciding in a blank manner on a higher or lower degree of openness, collaboration, and 'democracy.'

Generally, the complexity of new mechanisms of openness and control, as well as of creativity as linked to those in relation to capitalism, freedom, and culture requires a careful investigation, some of which will be undertaken in the following chapter through the discussion of certain aspects of autonomist Marxism, the FLOSS (Free Libre and Open Source Software)[34] movement, and a few other concepts and practices.

The question of organization comes to the fore here. Manifold changes in forms of production and character of labour, with changing social structures, control apparatuses, social practices, and aesthetic forms of life act through destabilizing and energetically open organizational processes. Organizational aesthetics, a concept and a process through which an art platform operates in ways reflexive of its own aesthetic genesis, sheds light on the ways in which digital culture and aesthetics are constituted and advance.

ORGANIZATION

Sven-Olov Wallenstein links the major change in function, organization, and perception of an (art) institution to the time period between the 1960s and the 1970s, and he regards it as a consequence of the conception of a new kind of the political. For him, such changes are specifically exemplified by the paradigmatic work of Michel Foucault.[35] Through Foucauldian theory, a 'general' understanding was built of institutions as modelling and controlling apparatuses that ensure the production and management of subjectivities necessary for the current mode of production, social order, and various other vectors of dominance. For Wallenstein, it is since this advent of a critical understanding of the institution that the critical stance was upheld by (art) institutions themselves, shaping a process in which the radical questioning of strategies and structures, self-criticism, and experiments in the degree of openness became a source of legitimation and a model of operation.[36] Since then, strategies of anti-institutional institutional behaviour started being employed as something between good manners and a survival strategy. Curating, the organization of art, and organizations in art have gone on a quest for radical self-transformation that includes the transformation of perception, of action, of authorship and

public participation, of staging the becoming and life of art in the rhetorical modalities of flexibility and experiment never before encountered on such a scale and level of proliferation. And art institutions were only one kind of organization setting off towards constant self-questioning and change.

The transformation of organization that was paralleled by, and had to follow, deep changes in the character of labour and of the political, is addressed in a current of analysis called organization theory.[37]

The concept of organization is one of those that are core to the social sciences. The origin of the notion of organization is commonly attributed to the work of Max Weber (as it is the one that has proliferated most beyond the boundaries of social theory) and is exemplarily addressed in his book *The Theory of Social and Economic Organization*. Weber distinguished three types of organizations: charismatic (such as small-scale revolutionary movements or religious groups), traditional (patrimonial and feudal forms) and rational-legal—all based on a different administrative apparatus.[38] It is the rational-legal organization, or 'bureaucracy,' that became the core focus of organization studies as the field formed to a large degree around surveying, understanding, and facilitating the management of organizations in the industrial or business sector.[39] This, despite some attempts to distance itself from business and to differentiate via the study of youth communities and other kinds of organization.

Although the nineteenth century saw the dawn of organizational, or indeed, institutional theory, as attributed to institutional economists, sociologists, and political scientists,[40] the argument for organizations remained one of a general character roughly from 1880 to the mid-twentieth century. Later, organization studies were enhanced by accounts of communication structures and processes that sustain organizations. These were essentially regarded as systems for differentiating and coordinating human activities. The process of organizing and other factors at play such as exchange, decision, and action theory also gained their devotees. Nevertheless, for a significant amount of time, whether structural or processual, organizational analysis coalesced around the 'orientation' of organization (orientation, a goal, was seen as a defining characteristic of organization that distinguished it from other social systems)[41] and drew its arguments along the lines of hierarchical forms of power and its legitimation.[42]

Despite this, some trends in organization studies fought for a more open-ended and process-related theory, and the 1970s brought along an active rethinking of the ontology of organization theory in the light of postmodernism. It is quite surprising to see that, with the resources of Foucault, postmodernism, postcolonialism, and gender theory, only in the 1970s did the racist and chauvinist biases of organizational functioning and its concomitant privileging of those in power become more evident. The violence and despair of Foucauldian disciplinary society brought quizzical looks to the faces of those previously concerned with running it effectively. Radical organization theory and its follow-up, critical management studies, had to

be established on grounds having nothing to do with the classic organizational analysis, to become a break-away paradigm of thought.[43]

If we look at societies, not as solid social structures to be found in relations of exteriority to the individuals or the nonhuman or technical agents composing them, as in Durkheim's tradition of analysis, but through Tarde's refusal to differentiate between micro and macro scales, equipped with a concept of a society as a form of association,[44] then thirty years of radical organization theory and its descendants stand out more vividly.[45] One of the writers in this current, Gibson Burrell, sought to refound organization theory, or radically break away from it, on the grounds of the apprehension of the roles it plays in maintaining the dominant homogeneity of socioeconomic and cultural order and in the propagation of certain versions of the rationality of modernity.[46]

It is not surprising that with the crisis or decline of organization as an adequate formulation, organization theory increasingly had to look for ways of updating the concept of organization in a way that would problematize the rational, hierarchical, representational, industrial, and functionalist orthodoxy it had previously developed and relied on. Large organizations underwent a radical decline, and network organizations, typified by flexible contracts, outsourcing, and precarious labour, came to replace bodies whose allowances for social heterogeneity were long questioned, even while such organizations were still being referred to by some as 'a source of pride.'[47] Organization theory found itself under a pressing demand to formulate new epistemological systems and to develop a certain ontological relativism (one drawn from actor-network theory, for instance) in order to be able to address and support organizations in changing market conditions. Boundlessness and flexibility, time-based and process-driven social formations, network nature, and the instant generation of actors found in organizational relationships are explored in a number of books and articles that together make a rather enormous bibliography.

Among these, here comes disorganization theory[48] and aesthetic organization,[49] along with creative and cultural entrepreneurship, e-commerce, business modelling and knowledge management—terms that signify a fragmentation of organizational analysis. This became a moment for the unfortunate naming of the discipline to play out. A feedback loop that locks the theory into such a rigid dependency on one of its objects of reflection can only amplify the limitations. What can organization theory do in the absence of organization, or if organization escapes, or if such theory is opposed to 'organization' and has a political project against it?

From another perspective, organization theory is one of the offspring of system theory (especially in the work by Tavistock Institute,[50] focusing on interactions along the boundaries of organization with the environment rather than among discrete units that are considered part of a system) and owes much of its initial inspiration and its conceptual devices to cybernetics.[51] Both start off from viewing systems in a manner that is

inclusive of the technical, social, and biological as a result of interactions both within themselves and with their environment, focusing on what constitutes, structures, and maintains these interactions and how those can be optimized to a maximum efficiency or can be subjected to prediction and control.[52] System theory's constituent parts, as accounted for by Bertalanffy,[53] such as game theory, theory of automata, and interestingly, graph theory and network theory, among others, in parts superseded or joined by operational research, action research, and simulation all exhibit a certain usefulness, if not owing their birth, to the military-industrial complex, however indignantly it is denied at times.[54] The Tavistock Institute of Human Relations mentioned previously, one of the outposts of organizational analysis in Britain, hosted the Institute of Operational Research, which in part arose from the need of the Royal Air Force to improve on the usage of a new technology—radar—during the Second World War. As J. Barton Cunningham reports, engineers working on radar had been put in contact with its end-users, following which it became possible for scientists (appointed as staff officers) to further collaborate with those in charge of higher command.[55] The operational research group studied these operations and evaluated their successfulness and the consequences of the usage of radar, making changes to the system as a whole including, essentially, its communications factors. From the mid-forties, operational research kicked off in many places around the world. In the United States, an independent branch developed, that of 'operations research,' that together with action analysis (and game theory) form a certain set of applied methodologies that today continue to be used in simulation, personality profiling, and software agent-based modelling of military conflicts[56] as well as in management studies, modelling and in changing 'for the better' the dynamic behaviours of complex and open systems, such as depressed human beings, organizations full of office plankton, nations on fire, or self-guided missiles haunted by automated defence systems.

Cybernetics certainly did not result only from the military experience of Norbert Wiener and the later aversion to it or from the telephone communication optimization of Claude Shannon; it was also developed by people such as Gregory Bateson, to be joined subsequently by Humberto Maturana and Francisco Varela in its 'second wave' who, like Heinz von Foerster, introduced a means of thinking that situates the position of the observer reflexively in relation to the system and offered the concepts of autopoiesis[57] and self-organization, both of which have significantly gained currency in cultural practices in the last decade. Whereas autopoiesis, especially in its application by Félix Guattari, can be used to reflect on the advance of creativity (discussed in broader terms in the next chapter), it is rather organizational aesthetics that can join self-organized creative powers with other human-technical objects and systems at different scales to transduce them into significant aesthetic events.

AESTHETICS AND ORGANIZATIONAL AESTHETICS

Organizational aesthetics is a process of emergence and a mode of enquiry that gives us a way to understand a digital object, process, or body. It is not only a way of looking, but also a dynamic of assembling and coming up with such a body. Considered as a process in which phenomena construct and operate themselves, it delves into the changing manner of actualization of various strata, which in turn move towards assimilation with aesthetic registers. As such, aesthetic registers such as those of sensuality or signification become planes that are also explicitly inhabited by social, economic, and political forces, a process that is as exciting as it is grim as it opens new horizons of the possible while enhancing stratification and capture to unforeseen levels.

Organizational aesthetics conceptualizes aesthetics as a register of becoming, a flow of production, a spectre of experience, and a mode of engagement ranging in its articulation from the political to the aural, from the social to ecological, from the performative to the formal. Such an aesthetics does not directly relate to the sensual apparatus or to art as we know it. Rather, it is about differentials in action and contemplation, which as such do not primarily send us off to the sensual, nor lock us into the form/content debate, but stage passage via routes of diversion, peering through, collapse, despair, humour, pain, trial, contrivance, and experiment. Such expansion or evolution starts before the morphogenesis of forces constituting a human being in a given society acquires a language by which it becomes quite fixed, enduring throughout such a process of structuration while retaining some of its fluctuating intensity. Such an understanding of aesthetics shares some of its resonances with what Gilles Deleuze and Félix Guattari describe as a desiring-machine (rather than an apparatus in Jacques Ranciere's terms of the 'making sensible').[58] Curiously enough, Deleuze rather traditionally conceptualizes aesthetics in relation to the sensible and to affect. Alain Badiou draws attention to this when accounting for the philosophy of art, within which he roughly identifies three vectors, slightly blurred but largely unchanged during the twentieth century: didacticism, classicism, and romanticism.[59]

For Badiou, thinking about art (understood as a precise approach to aesthetics) means enquiring into art and truth in terms of immanence and singularity. His own conceptualization places art in relation to truth in a manner that is both singular and immanent: Art is capable of truth that nothing else is capable of, and such truth is immanent to art. 'Art itself is a truth procedure.'[60] Because art is finite and truth is an infinite multiplicity, to distinguish such a position from the Deleuzian idea of art cultivating the infinite chaotic within the finite (which is, for Badiou, romantic), and to account for truth as an event, but not an event that can happen as a single work of art (which in Badiou's schema would be a Christian

modality), Badiou suggests that art is a procedure of truth, and such an artistic procedure is woven from a multiplicity of individual works.[61]

But relationship to truth set aside, art and aesthetics are directly plugged in to the electric waves of life. The Nietzschean idea of aesthetics includes a reflection on nature, which has an artistic force, 'artistic state,' itself. In such a state there are 'artistic powers which erupt from nature herself, without the mediation of any human artist, and in which nature's artistic drives attain their first, immediate satisfaction . . . as intoxicated reality.'[62] Such an abundant generation of intoxication is the ontogenetic quality that I am looking for, something quite distinct from a putative truth procedure. From such a perspective, aesthetics is a machine generating material variants of reality to enable knowledges, practices, and perceptions to constitute and affirm themselves. In this it partakes in the overflowing of creative emergence and surges with the energy and growing pains of coming into being. Art draws from this source. Art is a historically acknowledged and institutionalized form of creativity becoming tangible, socially acceptable, limited to cultured and human society. There are certainly other forms and currents in this process. That is why this book deals with autocreativity, the lifeblood of networks, as well as with freedom, repetition, and aesthetic brilliance; digital folklore, art currents, publics; and with objects and processes that stem from and define the topology, architectures, densities of amplification and equilibriums of creative emergence today.

The organizational aesthetics of art platforms is a practice and speculation on the forces that build them up and change them, that structure and channel their emergence but also enable them to make themselves available for varied practices, uses, and logics. Art platforms exhibit a capacity to become eventful, to reach a threshold that amplifies the material inhabiting them into forces of brilliance, enabling the transition into a different reality.

In such an account, organizational aesthetics does not primarily deal with the process or a body of organization in the arts, nor does it account for new postmodern types of organization in global business and culture. Organizational aesthetics is not preoccupied with the institutions destabilized by network logic, restructured and rearranged as leaking organizations. These are attended to and are to be further explored in the search for the keys to the new functionalities and collapses of today.

Notwithstanding this, art platforms mimic certain aspects of the structuring genealogy of organizations, partly due to their partaking in the sphere of organizations and networks dominated by forces and interests of particular kinds. They have to fight against, or learn to subtly deploy, the reflexions and projections of such forces that acquire the capacity to work from within upon their formation. Besides, energies and agents enter and leave art platforms to become parts of other ensembles, and in doing so, they may leave behind or project a trace to contaminate and recompose the forces acting and logics being actualized. That is why the organizational aesthetics of art platforms generates its effects on the fields of power, maybe

even playing a role in their constitution, effects generated to the tunes of diverse vectors of valorization and in ways that are composed by different objects, forces, and relationships: some form of inventory of which I hope to present.

The organizational aesthetics of art platforms can be conflictual and misbalanced. It plugs into the flows of energy and matter, humans and software; it participates in the formation of the more habitual, in the morphogenesis of the societal, but also retains certain catalytic functions to disrupt a putative balance and produce a variation.

Organizational aesthetics starts off from looking into the bare, the chaotic, and the turbulent plateau of emergences, of creative forces to then trace how these get pictured and mapped, restricted, capitalized on, exploited, but also how they may revolutionize the structured, the possible, and the different.

The account of the organizational aesthetics of art platforms presented here concentrates on an experienced yet relatively unseen, unknown but everyday reality. With the rapid development of software and the cultural practices that are triggered by the new generations of Internet applications and uses, many cultural behaviours are practiced while being either stupidly celebrated or disdainfully condemned. I am certainly interested in how these new emergent practices get structured and couple with the forces of imitation and repetition, but there is an audacity of curiosity in openly thinking of what their power is and to describe this power through means that do not exhaust it, or reduce it to a simple decidable equation. An organizational aesthetics of art platforms allows us to notice and get a grip on something that is widely discussed but is essentially lost in such debates, either under the rubric of a general creative ability that psychology feeds us with, under the neoliberal creative industries policies of cognitive capitalism or a totalizing Marxist critique of the latter. Today's polemics simplify once again, as previous polarized debates did in relation to the advent of the mass media, negativizing and denying certain powerful registers their own existence. I focus on what is brought along with the profound turmoil of the new types of networks, with new media constellations entering the cycle of becoming as rightful actors, setting certain forms of life into play, and on the experience and generation of cultural forms that vividly shape and inhabit these moments.

Organizational aesthetics works with the raw and virtual material of the creativity that traverses art platforms, which it structures and organizes while trying to keep it vital. My account of organizational aesthetics here, a quest for art platforms, focuses on how these energies work and what works alongside them: what type of objects and practices they create a space for, what kind of planes and pedestals they form, and what events they stage. Equally important is to understand the interplays of power such energies feed, and the kinds of structurations and conduct they imply. New kinds of actors are born from such interactions, which couple with existing

registers such as language, patterns of visuality, or software, or transform the fields of production, be it industries or subjectifications of different sorts in unmatched ways. The following chapters read art platforms very closely to account for their specificity, to feel the precision of their materiality.

AN ASSOCIATION, A PRACTICE, A TOOL, AND A METAPHOR

An art platform is a living organism, a continuous combination of factors, thriving on differentiation, responsive to its own fluctuation, and amplifying creative forces to enact a transformation. If we were to generalize on all the art platforms we can find, assemble them to be compared and analysed down to a common set of characteristics, to then decompose a generalized art platform into a set of simpler parts in order to understand how they function, will it provide us with an understanding of how the whole works?

A complex system behaves in ways that cannot be understood through the sum of the behaviour of its parts. Understanding the constituent processes of art platforms, in fact, does not authorize any generalization beyond itself.[63] If we follow what Isabelle Stengers offers as an aesthetics of learning and knowing, we will find that art platforms allow for aesthetic phenomena to manifest in a variety of ways, for different types of forces to come to the forefront. Such forces might even be frustration and aggression, or imitation, channelling itself to become a subcultural type of the stereotypical; alternately, we might witness a genuine digital aesthetics, a new language, an organizational revolt, or other occurrences.

How, in art platforms, are aesthetic phenomena channelled to repeat or deviate? How are they enabled? Shall we study objects, materialized cultures, and practices to deduct their implicit and explicit orders or shall we create objects, environments, organizations, and art platforms that would allow us to act and think anew, to depart from the path of the 'normal'? This would imply focusing on the movements, atmospheres, things, life events, acute moments of art platforms and eliciting an understanding of their emergent complexity as it develops itself. In an object such as an art platform, a factor can be insignificant or it may change everything. Letting art platforms tell their stories allows the hearing of something new, a story of the empirical or real that resists the too easy conceptualization of digital culture that is readily at hand. In doing so, we will learn something about the networks today; by following their rich integration with cultural dynamics, we will also discover something about technology and learn to appreciate the 'simply technical' as something more.

1 Organizing Free-range Creativity

> The role played by individual behaviour can be decisive. More gener-
> ally, the 'overall' behaviour cannot in general be taken as dominating
> in any way the elementary processes constituting it.
>
> (Isabelle Stengers and Ilya Prigogine,
> *Order Out of Chaos: Man's New Dialogue with Nature*)

The technical is aesthetic is political is cultural; each of these domains folds
into the other and is fed back on itself; every layer informs, embeds, and
models the others, distributing their particular power patterns through-
out societal systems and their blurry zones of transfer. Art platforms
work with cultural production that is immanent to societal unfolding.
But as an experimental process of organization in software and culture,
the ways of working it engages with may also manifest, although dif-
ferently, in the logics guiding the participatory and social Web, creative
industries, peer-to-peer networks, and the development and thoughts of
the FLOSS movement addressing these spheres. All this makes for further
highly interesting complications.

What is the core of art platforms? Creativity and some form of social-
ity. What is at the heart of participatory platforms? Sociality and some
form of creativity. If the encouragement of forms of creative expression
within a social context and with a dynamic vector of liveliness irreduc-
ible to formulae is a central characteristic of art platforms, annoyance is
often triggered by the way capitalism channels creativity and in doing so
privately captures 'community-created value' in varieties of the participa-
tory Web.[1] The networked cultural production and aesthetic force mapped
by art platforms are often understood as motor powers driving, among
other things, cognitive capitalism's valorization systems. As such they are
then too easily locked into opposition to 'truly open' endeavours,[2] such as
free-software-based open cultures, which are, in turn, criticized themselves
as free production ready to be capitalized on. In order to discuss art plat-
forms as loci of creative emergence that are enabled to organize according
to self-chosen logics in coupling with various factors at play, we first need
to examine the possibility of such freedom and the condition of creativity
as it actualizes with and through technology in today's world. Inevitably,
to proceed further, we have to look at 'free' technologies and the concepts
of creativity currently available.

POST-MARXISM AND LIBERALISM: FREE SOFTWARE AND OPEN CULTURE

A shift to precarious and 'immaterial' forms of labour, to open and flexible labour organization, spontaneity, collaboration and cooperation, and to the figure of the 'creative class' and to that of the creative industries as a set of mechanisms soliciting labour that acts in self-expression and self-development, is a continuation of, or rather, an enlargement of the tendency for open structures to become dominant and integrated into new forms of production. If network logic is the core model according to which our society is organized,[3] and creativity is seen as a crucial resource and power advancing its economy, such a system needs to be aimed at working with unprecedented degrees of openness and flexibility, and working towards the 'empowerment' of massive groups of people. It means the large-scale involvement of creative capacities into innovative practices.

Autonomist Marxist theory as well as a number of political theorists not directly associated with the Italian *operaismo* movements, such as André Gorz, Luc Boltanski, Eve Chiapello, David Harvey, Tiziana Terranova, Andrew Ross, and Brian Holmes, see the current phase of the 'creative' advancement of capitalist forms as an outcome of previous struggles made by workers, women, students, and others that forced capitalism to adapt to their protests and to transform itself to embrace new kinds of demands and realities. Here, crises in Taylorism, Fordism, and Keynesianism as the leading principles of the organization of working processes, wage structures, and economic policy are interpreted as connected to the struggles of the late 1960s and 1970s that challenged the stability of the 'Planner State.'[4] For Antonio Negri, describing this process, the Planner State was replaced by the Crisis State with a significant drop in welfare support and corporations restructuring to become flexible and mobile in order to put themselves beyond the reach of the proletariat.[5] David Harvey describes the same period as the transition to the regime of 'flexible accumulation' and beginning of the neoliberal project in politics.[6] Brian Holmes reintroduces Boltanski's and Chiapello's concepts of social critique—as rebellion against exploitation, and of artistic critique—as resistance to alienation, as two major lines of pressure that capitalism answered by mutating into a post-Fordist mode of production that celebrates flexibility, open communication, and creativity.[7] The problems in reconciling such changing structures with 'humane' work has been intensively documented by Andrew Ross in his work on companies developing creative websites that seem particularly to embody such contradictions.[8]

The history and current development of the FLOSS movement serves as one of the fullest examples of the changes described above. Free software destabilized existing definitions of property and threatened certain forms of wealth because it touched upon the transformation of agents involved in the constitution of relationships, subjectivities, and experiences linked to the

sphere of production and maintenance. It has also been noted that free and open-source software changed the culture of software because it provided a means of publicly thinking and speaking about software, a move that coincided with and was built on the development of Internet-based discussions.[9] As a force propagating the radical restructuring of ways things are made, with substantial developments in communication and organization of work as a social movement, free software informed and accelerated the proliferation of the principles of 'openness' into multiple settings, including those of the cultural, social, and artistic.

Adding a layer of (cultural) abstraction to the discussions of free software risks the danger of losing the coherence of a discourse grounded in American or European laws regulating ownership and defending property and their commonsense saturation with regimes of bills, prices, costs, contracts, lawsuits, and imprisonment. But not doing so runs the risk of making formalistic translations of its constructive principles to other domains of culture.

Software is not solely bound to objects: It is shaped by and proliferates into social and cultural relations. Breaking away from the fetishism of proprietary software may lead to the commodification of social processes layered into software production and operation, something resonant with the way the move from fixed institutional forms gives rise to a variety of institutional relationships in organizational aesthetics. Thus, the radical questioning of relations of ownership and of institutional architectures as a matter of control is inevitably linked to the proliferation of commodity logic into social and cultural relations. Although both autonomist Marxist and liberal thinkers promulgate such understandings, by means further discussed in the following, the logic of these arguments and the premises they rely on do not exhaust the array of access points to this problematic and the excess of drives and capacities always at work in questions of culture, even as they are interwoven with those of economy.

Freedom and creativity are essential operators in both neoliberal democracy and management jargon, but it is the concepts these strings of characters aspire to that are core to understanding modes in which cultures and art, free and open-source software are made, not least as they are formatted into the 'creative industries.' Freedom and creativity are the two horses that carry liberal thinking on free software and creative industries, but they are also, under a different interpretation, the unsteady mounts of post-Marxist thinking.

Freedom is closely related to creativity. A human being is an embodiment of the capacity for creation, and freedom is a quality of creativity (conceived as always free). With the lessening importance of 'ideal' worlds, creativity becomes an actualization of the real, a motor and an inborn character of life. Creativity is a chance to render a human being autonomous.

Whereas Marxist interpretations of freedom as an opposition to constraint are not new, they develop a close attention to the understanding

of a certain impetus to freedom as rooted in coercion and dominance (for example, in Theodor Adorno and Max Horkheimer's principle of mastery) and generate the ability to focus on the function of such mechanisms in culture (from Antonio Gramsci to Raymond Williams). Liberal theory, by contrast, adopts a concept of freedom as a self-fulfilling capacity for choice and action, assuming that a human being is de facto rationally thinking, free, and creative.[10] Autonomous individuals and free societies, according to Yochai Benkler, are those who benefit through property and common property (commons) that reinforce freedom and knowledge (creativity).[11] Thus, one side of open-source software and open-culture advocacy is incarnated most acutely in the cohort of liberal and neoliberal law and economics professors from prestigious American universities who push for enhancing democracy and knowledge through various realizations of open-source mechanisms.

Certain forms of labour-process organization aspired to by the 'creative class,' and characteristic of the creative industries, frame freedom and creativity in terms of an opposition to the factory, assembly line, or other previous forms of the structuring and enforcement of labour.[12] More will be said about creativity in the second part of this chapter, but in this respect, the FLOSS production model can be seen as a change in line with the overall transfer to new forms of labour in the First World and throughout global elites and, as such, neighbours upon the creative industries discussion. Although the intellectual property (IP) regimes of those parts of the creative industries with the busiest lobbyists do not appear very keen on freeing their products from copyright enforcements, autonomy and creativity of a liberal kind are terms widely used in creative industries' discourse and, as such, tend to replace the previous 'revolutionary' rhetoric of FLOSS.

As is well known and documented, whereas Richard Stallman and the early activists of free software equipped the free software movement with an ambition to profoundly revolutionize society through free access to knowledge and the means of making it, the free-market libertarian Eric Raymond and others, with the Open Source Initiative, moved towards creating a rhetoric appealing to business from the point of view of efficiency. More recently, a number of significant studies have explored the economics of FLOSS production with sociological surveys and a lot of empirical data.[13] Attempts were made to answer the question of whether FLOSS software presents a better model of software development in terms of quality and time and effort spent; and, especially in the work of Ghosh, to interrogate the motives of FLOSS developers, including altruism, pleasure, the drive for recognition, self-education, desire to signal professional competency in the job market, to map the structure of the community, and so on.

This wave of analysis is partly related to the economic success of FLOSS. Reports demonstrate a great increase in the share of open-source software usage in IT services and in economic revenues.[14] The FLOSS development model proved to be an efficient business model for software development,

and new research addresses such an evolution by attempting to build work-
ing economic models that radically depart from the rhetoric of gift culture
and volunteer labour of early explanations.[15]

Having divorced itself from revolutionary rhetoric, the Creative Com-
mons[16] incarnation of FLOSS led by Lawrence Lessig, which deals not with
software but 'content' is no longer concerned with transforming capitalist
society, for instance, but with enhancing liberal democracy and the auton-
omy of liberal individualism by creating legal tools that offer guarantees for
certain kinds of action in the form of licenses. Such freedom and autonomy,
as described previously, are assumed to be naturally given in liberal society
and automatically preserved if certain instruments are applied, irrespec-
tive of the systems of conditioning, subjectification, persuasion, coercion,
profit, discrimination, distortion, or control that may be operative in such
a society and in those dependent on it.

Such a stage in the development of the FLOSS movement has been widely
discussed in the free software world where it prompted angry, critical, but
also deeply ironic responses, such as the following: 'Lawrence Lessig is
always very keen to disassociate himself and the Creative Commons from
the (diabolical) insinuation that he is (God forbid!) anti-market, anti-cap-
italist, or communist.'[17] Pristine liberal democracy advocates flatten any
radical dissatisfaction with the capitalist forms of societal organization,
the tip of whose iceberg is property and ownership in the age of informa-
tion networks. The idea of an innately free ability to make informed ratio-
nal choices as ready-made subjects, conceptualized as a constant in liberal
thinking, is as 'useful' as an understanding of the human being as a robot.
Distancing themselves from Free Software Foundation pioneer Richard
Stallman's obsessions, that were in some ways parallel to the reappearance
of references to 'communism' within the digital domain, such accounts aim
at explaining clear routes to universal happiness through open-source soft-
ware, creative-commons-licensed content and, not least, flexible organiza-
tion and creativity in the workplace happily coinciding with at least the
promise of ready profits.

It did not take very long to apply such ideas and techniques to culture,
both for purposes of escaping fixed institutionalized controls, privatiza-
tion, and commodification, on the leftist side, and on the liberal side, for
cutting costs.

Various Open Content licenses have appeared concerning music, art, text,
or any other kind of publication, extending to sound sampling and many
more forms of use, that attempt to describe and match the rhetoric of 'free
culture' and open society.[18] Both the GNU project and the Open Source Ini-
tiative are built on an understanding of software programming that places
emphasis on unrestricted access to program code for the purposes of educa-
tion, use, and modification for improvement or further application. Various
license models, from the GPL[19] (General Public License by the Free Soft-
ware Foundation) to the 'legal toolbox' of Creative Commons are built on

such an understanding of source code, which seems to be directly applied to fields outside of computer programming. Free culture in this context is understood as the freedom to distribute and modify creative works. It is also about communal creation organized horizontally, with participants adding on and improving each other's contributions by a self-evolved mechanism. Wikipedia is often offered as the best working incarnation of open culture. Here agreement seems to end and confusion begins.

If for software, its functionality, minimization of bugs, safety, and other qualities may stand as evaluation criteria and allow for an objective estimation of more and less successful projects, such evaluation is hardly possible within the art field. The value attributed to a particular artwork is notoriously transitory and symbolic and cannot be directly derived from the costs or methods of its production, its momentary success, or any estimation of its 'quality.'[20] One cannot generally compile an artwork to see if it runs. A desire to build on a certain artwork does not in any manner originate from its usefulness or functionality but is one result of a complex mechanism governing the construction of value and meaning in the cultural sphere. Besides, if open-source code ensures the better development of both software and programmers' skills, the 'open-source code' of artistic work does not always offer a matching usefulness. When open content deviates from practicality and enters the realm of the symbolic, it becomes very glitchy.

License Art Libre is one example of a free-art license that exemplifies, in its evolution, the complexity of the problems described. LAL is a product of the group of French activists, Copyleft Attitude. Nicolas Malevé explains: 'Copyleft Attitude tried to seek out a reconciliation with an artistic practice which was not centered on the author, which encouraged participation over consumption, and which broke the mechanism of singularity that formed the basis of the processes of exclusion in the art world, by providing ways of encouraging dissemination, multiplication, etc. From there on, the LAL faithfully transposes the GPL: authors are invited to create free materials on which other authors are in turn invited to work, to recreate an artistic origin from which a genealogy can be opened up.'[21] LAL and the trajectory of Copyleft Attitude is an excellent demonstration of the contradictions inherent to this discussion: While attempting to make a political statement,[22] it serves as a legal tool and adheres to the principle of open access and communal creation at the same time that it exposes the difficulties of framing cultural and artistic processes and products as improvable source code.

Indeed, a precondition for the creation of open culture is an engagement with institutions and subjectivities, with control and production mechanisms, with the alteration of the meaning of art and the role of artist, with learning, that is able to force these spheres into the open and unknown. A serious discussion of free and open culture, as with Simon Yuill's text 'All Problems of Notation Will Be Solved by the Masses,'[23] searches for experiments with notation, improvisation, live performance, 'noise,' contingent, collaborative and 'distributive practices'—all politically informed

and informing elements crucial to contemporary production, in order to unfold the dimensions of the alternative at the borderlines of art, culture, politics, work, organization, and code.

If, as we have seen, the provision of a legal tool turns into a liberal flat universalism and does not yield an open art world, then, to return to the dialectics of the beginning of the chapter, what are the theoretical means employed to understand free and open cultural production, to recognize it or imagine it in post-Marxist terms? Or does Yuill's proposal and other serious thinking about forms of autonomy developed within digital cultures take us beyond such structures of thought?

The conceptualization of freedom through negation, as an absence of subsumption that, thus, can never be experienced while the mechanisms for extracting value remain a constant is an appealing tradition. Capitalist exploitation here drains every area of the naturally given juices of life[24]—a condition to be resolved in a future transformation.

With the success of the book *Empire* by Michael Hardt and Antonio Negri, and also with work of Maurizio Lazzarato and Tiziana Terranova, some currents of thought contributing to the autonomist Marxism, briefly introduced above, became widely adopted and used in discussions of digital culture and its operations in the last decade.

Past members of the Workers' Autonomy (Autonomia Operaia) movement, such as Antonio Negri, Paolo Virno, and others, have at different stages of the development of their work introduced the concept of the socialized worker, social labour power, immaterial labour, or the social factory that describe facets of the same changed reality of labour character and class composition. Initially, Mario Tronti, in an essay 'La fabbrica e la società,' which interpreted the potential of the working class as an agent of change in the capitalist system, suggested that the field of antagonism is transferred to a more socialized level, so that, to cite Tronti in a translation by Wright, 'the social relation becomes a moment of the relation of production.'[25] Moreover, the factory extends to the whole of society, making it a site of production, with capital extracting value from the entirety of social relations.

Wright suggests that whereas today the concept of the social factory is assumed to describe the process of the broadening of productive labour beyond the point of immediate production into the entirety of the society and human life, none of these meanings 'were to be forthcoming' in Tronti's work of the 1960s.[26] Nevertheless, the idea was established and further enriched by multiple developments. The figure of the socialized worker and the mapping of social labour power represents a new working class no longer limited to being a 'paid proletariat,' controlled by capital through the entire span of life.[27] Terranova, for instance, draws attention to the fact that within the conceptual framework of 'immaterial labour' developed by Maurizio Lazzarato (as 'labour that produces the informational and cultural content of the commodity'),[28] specific or classic class formation does

not have a meaning. Immaterial labour is not confined to the elite of skilled workers but is applicable to any productive subject within postindustrial society.[29] Immaterial and affective labour rooted in human communication and relationships serves as a source of surplus value in the new process of production. For Virno, 'thought becomes the primary source of the production of wealth.'[30] Contemporary production thus includes linguistic competence, knowledge, imagination, and social interaction as its core sources of value.

It is evident that this analysis of labour power and production is enormously suggestive for the discussion of free and open-source software, network cultures and new forms of subjectification, production and organization, including art platforms, manifest in them. Tiziana Terranova offered an analysis of FLOSS, along these lines, at a moment in which the movement was undergoing major conceptual (and economic) transformations. She maintains that FLOSS production and, more broadly, cultural production on the Internet, does not only always originate and occur within the capitalist system but is also functionally and economically central to its development. For her, if Internet-based cultural, network, or FLOSS production depends on a vast amount of continuous work, most of which is 'unremunerated,' it can only mean that such free labour is immanent and fundamental to cognitive capitalism, rendering the gift economy an important economic tool.[31] Thus, there is no struggle with and no appropriation of an 'authentic moment,' but a mutual constitution advancing towards more developed forms of capitalist production. 'Late capitalism does not appropriate anything: it nurtures, exploits and exhausts its labour force and its cultural and affective production. . . . Especially since 1994, the Internet is always and simultaneously a gift economy and an advanced capitalist economy.'[32] Certainly, according to such an understanding, present forms of technosymbolic production cannot, even temporarily, hold keys to freedom.

In *Network Culture: Politics for the Information Age*, Terranova omits the detailed analysis of the open-source movement as an avant-garde form of capitalist production that she provided in her earlier article, but any desire for autonomy still clocks in as a new method of capitalist production.[33] The term 'free' is used in the sense of 'free beer' or free labour as unpaid, financially uncompensated labour and interconnects it with pleasure and desire (for affective labour).[34] Thus, while we are left with an image that labour is free, not something imposed, such an account lacks an encounter with a dynamics of processual freedom in the sense of 'liberation' or moments beyond capitalism.

Describing digital cultural production as a process core to the capitalist system of relationships, one that is nurtured and exhausted within it, the book tends to build a picture of the passage of capitalism as a smooth, seamless, and monolithic process. Although the point that it would be a mistake to take such coexistence for an unproblematic equivalence is made, it is not

developed further.[35] Every field discussed is interpreted as a zone of experimentation for late capitalism. The digital economy is an experiment with production models and new kinds of value,[36] network culture is a political experiment,[37] and new forms of production and cooperation are experiments with new technologies of control.[38] If there are no contradictions and ruptures, no potentials and struggles, no excess, no gaps, no liberation, emancipation in this figuration of the free, then what kind of action and practice is possible today, and where could the potential lie? The total system has no exit and no outside, except for an annihilating catastrophe.

Somewhat reminiscent of Adorno's negative dialectics, such a method builds up sets of mutually exclusive and interlocked oppositions. It is a project (to paraphrase Jameson)[39] aimed at desubjectifying the analysis of labour and power while committing to prolonging the traditional framework of Marxist understanding of capitalism as a totalitarian system, one reliant on the coherence of operations of its categorical units, and which thus can only move towards collapse (for aesthetics, Adorno chose to describe such a condition as the 'unsayable').

Whereas Marx envisaged proletarian exploitation intensifying to a moment of its absolute impoverishment but, as a process, sustaining within itself the gains and means of transformation, subsumption theory regards the domain of biopower as an ever-subsumed totality. Setting subsumption as a prerequisite of any action, emotion, or thought, rendered alike as productive forces, intensifies exploitation to its highest peak, entailing the potential for collectivization as a foundation for revolutionary change. Here, freedom is an exclusive category, transcendent of bodily, aesthetic, and mundane reality. Radical action, early hobbyist practices, aesthetic experiment, slow-motion microchange, a moment of freaking out, a potential, would have little immanent presence or power because they are tuned in to a historical tonality that necessarily involves the evolution of capitalism. Where the social plane is seen as a totality, participatory platforms and network cultures become machines of exploitation and subsumption, involving the deformation of transcendental freedom.

In order to evade the closed circuits of both subsumption and liberal theories, we need to step outside of these modalities of analysis. New actors may then come on stage and provide art platforms with the language to speak about themselves. If freedom is to be rethought in culture and art, one should start, drawing on a Deleuzo-Guattarian heritage, to sense and develop the energies and mutations in cultures themselves that, in their multiplicity reinvent, extend and disrupt the dominant modes of operation. A concept to address the scale and modes of domination and power in contemporary society can, famously, be found in a short text published in 1992, wherein Deleuze departs from the Foucauldian model of a disciplinary society to sketch emerging paradigms of power operating within what he calls control society. Whereas Foucault studied the roles of institutions in modelling subjectification, Deleuze, echoing work from Guattari, allows

for a new concept to appear, that of a 'free-floating' control, operating at miniscule levels. Testing this developing kind of control against Foucault's disciplinary power, Deleuze describes it through a metaphor of modulation whose nature is numerical (he states that it does not necessarily mean binary) complementing disciplinary 'molds' whose nature is analogical. To trace this metaphor would mean to draw from telecommunications engineering, where modulation refers, roughly speaking, to a process of the transfer of nonstandard (unstructured) signals through standard means (by means of signal with a clear structure). Modulation is a principle that can be applied to any signal. That is what allows Deleuzian control-as-modulation to be described as a never-finished, individually customized, atomized, but nevertheless 'universal system of deformation.'[40]

Now, what can be done with such an understanding of power and control as a horizontal immanence feeding on resistance, but not subsuming it, that is continuous, limitless, and mutating, a 'self-deforming cast' acting as the common denominator, and that proliferates as individual 'codes'? Which sites and strategies of leakage, avoidance, and backing out can be made palpable, can be opened up and discovered as already put into practice by coders, artists, and agents of aesthetic practices?

Inherent in the mutual constitution of power and resistance, control as a prerequisite for freedom is a recurrent motif for which Gayatri Chakravorty Spivak gives the example of birth control as a basis of sexual freedom. Wendy Chun, referring to this example, writes about control in networks as a basis of their freedom, but also about freedom as something exceeding control.[41] For Tiziana Terranova, modern forms of control are more akin to setting up a system and letting it develop freely to either milk its results if they are desirable or abandon it to self-annihilation if undesirable, catastrophic mutations have taken place.[42] Control makes freedom possible, but also freedom, openness, and self-evolution are the conditions of control. Thus understood, control and freedom are interlocked in specific relationships, not to say dependencies, and diffused into each other. However, the specific distribution of these forces and their processual change are unpredictable and in turn can be found in conditions beyond mutual exclusion and exhaustion. If we talk of FLOSS and proprietary software, or discuss the systems that software art or participatory platforms run on, we should not forget to include a discussion of Internet protocols and hardware: and to capture these systems in terms of openness and closures would mean talking about combinations and dispersion as well as oppositions and concentration.

These modalities of freedom are often best sensed through art, software art, and practices that would not describe themselves through such figures but that are made through related forms of creative emergence. Fuller has talked about the proliferation of 'art methodologies' of which 'interrogability' in software is one.[43] Interrogability is an openness to or capacity for sensing or probing at many scales, a quality that occurs as a happening, a process rather than a defined property, one that provides a key to various

events, living objects, and ecologies. Such a concept slides us smoothly towards the key problem of this chapter—creativity and its processes of organization in relation to freedom. It is through opening new modalities for these concepts that we prepare grounds for discussing art platforms in their specifically open and aesthetically brilliant emergence.

CREATIVITY

In recent years the concept of creativity (and as previously mentioned, freedom as inseparable from it) has been charged with such an amount of attention, detailed description, financial investment, distrust, and hatred that it has become barely possible to discuss it. The triumphant uses of the word, it seems, are those that make creativity into a dull and sleek object with magic qualities. An object, because one can learn to manufacture it through specific training, with a sleek production of something new, beautiful, and useful—magic because it turns out to have always been there and is able to instantly saturate life with satisfaction, freedom, and happiness, but dull because its training system is that of fitness for creative capitalism.

Psychology and other cognitive sciences research individual mental activity, build models of creative processes, and analyse creative individuals, creative products, and creative environments. The focus is on creativity as the production of something innovative and applicable.[44] Such studies are put to work in developing 'techniques of creativity' and in working out the organizational aspects that would allow for an increasing number of employers to discover and apply creative capacities for innovation.[45] Creativity, although somehow deeply rooted in the production of the individual, is thus a function that is only perceived on the surface of reality, and as something that can be refined by formal processes to produce dependable higher-quality results. This flattening of aesthetic production into the thin crust of the actualized in fact severs creativity from its teeth, nails, and any other sharp (or vicious) body parts. Such creativity is devoid of thickness, folly, and duration, and what is left *in residuo* is lobotomized optimism.

Another curious trick on creativity is its transubstantiation into the bodily quality of an elitist democracy. Creativity is something every child is immersed in, and as a state that embraces everyone, it is inherently democratic. However, few adults or events in human history are creative.[46] As a result, we find ourselves trying to account for the loops and holes in which creativity gets exhausted and lost along the way. Evidently, when these are fixed, the 'demos' will fatten the ranks of the 'creative élite' (something subsumption theory anticipates as the end of capitalism).

Those who are nauseated by this charade point towards child labour, ecological collapse, increasing inequality, and the reliance of such an elitist demos on the shipment of hard labour to those that are ranked as members of a society to a lesser degree, or geographically—to Asia.[47] This does not help

much in reclaiming creativity. All the different faces under which freedom/ creativity is sensed and lived through under various kinds of regimes include Nietzsche's creativity and are often those that speak loudest in the face of tyranny. Creating and memorizing poetry as a means of survival in the Stalinist camp and 'inner emigration' (mental and spiritual, but not physical emigration) in the Soviet Union are two among many other examples.

There are excellent critiques of neoliberal, post-Keynesian 'creativity,' in which areas of human life previously considered thoroughly personal, communal, and intimate are translated into the sphere of economic transactions.[48] The creative class, creative cities, creative industries are all actualizations of new economic and political orders, social formats, and mechanisms of subjectification devised to stratify and commodify the creative emergence immanent to both human and nonhuman forms of life. This expansion and mutation of modes of production is understood to devour all living energies in order to transform them into denominated flows of capital.

Creativity (and philosophical creativity in particular), as often discussed,[49] is posited in *What is Philosophy?* by Gilles Deleuze and Félix Guattari as being in proximity to a kind of enthusiastic creativity that is more of a marketing or managerial threat to 'being human' than a turn towards liberation. *What is Philosophy?* is both used (by short-sighted users) to submerge into narrow accounts of affective creativity as well as (by users supposedly far more refined) to criticize that creativity, as it is profoundly transformed by capitalism.

However, Guattari provides a transformed and extended reading of creativity in *Chaosmosis*. In this context, becoming creative marks a phase in which the aesthetic register traverses and transforms the style of production of all other registers. The artistic paradigm recomposes as something that makes aesthetic methods mutate until they are able to move into the domains of social and political methodologies.[50] But far from being a mechanism of closure, the arrival of the aesthetic paradigm signals new openings. Not a mechanism, but an aesthetic machine, creativity is autopoietic and remains enabling.

Creativity and autonomy (and the self-organization, collective, 'amateur' production linked into them) need to be reread and recreated to think along with numerous current and recent practices, some of which are referred to as art platforms in this book. Such practices are not without their own kinds of power and work to directly practice something resistant to simply utopian or nihilistic interpretations.

Creativity is thick, chaotic, 'dirty,' and conflictual, and as a force of aesthetic emergence becomes conceptual and subjective only at a very late moment of its unfolding. Such creativity cannot be mistaken for its realizations, artworks, or inventions. Such creativity is core to aesthetic forms of life and self-organization and in order to think it against the dominant, capturing redundancies currently at work, I will suggest the concept of

autocreativity a bit later on in the chapter. Autocreativity may come to be a lucky device, one that is both humorous and distancing, that can usefully be employed to recognize and account for much in underacknowledged contemporary cultural production.

The inspiration for a rereading of creativity comes from certain strands of vitalist philosophy, wherein creativity figures as a movement of actualization, as a process that is differential and emotional. Here, creative advance is a means of the constitution of life as a whole.

The Bergsonian élan vital is found in the pulsional drive of creation, and in matter it struggles to realize its largest possible degree of freedom.[51] For Bergson, creation is becoming itself, deriving, not from the possible, but from the actual; it is unceasing life, experienced in action, a perpetual growth, a vital current loaded with matter. Creativity/invention is found in nature, as an instance in the variation of routine. However, creation, which is a movement of élan vital, is confronted with matter: The movement of matter and the movement of life (creation) run in opposite directions.[52] 'The vital impetus is neither pure unity nor pure multiplicity,' it is the matter the élan vital communicates itself to that chooses. The movement of life that is opposite to the movement of matter creates a vortex, a flexion; it is where it moves freely carrying the weight of obstacles that do not terminate it—and it is where there is humanity.[53] In humans, creation becomes a way to freedom, a triumph of the machine over mechanism (as understanding of the organism as a machine for action that rebuilds itself with every new act).[54] Life, élan vital, is an 'immensity of potentiality,' and these manifold tendencies are actualized in matter and therefore created by such potentialities.

Whereas Bergson is seen as one of the first philosophers to protest against 'noumenal' thinking, positivism, and the mechanistic lightness of classical physics to find a way through to disregarded questions, such as those of duration and space, Whitehead is one of the first to construct a system that would bridge the gap between science and philosophy following their differentiation in early modernity, building a new philosophy of nature. For Whitehead, two centuries of the failure of science and philosophy to communicate and appreciate each other were over with new discoveries in physics and biology allowing for the understanding of human experience as physical existence, as a process belonging to nature with its constant reconciliation of permanence and change.[55]

For Whitehead, process and activity are the matter that has no instant, no primary entities, but for which the essence is transition itself, realized in the 'creative advance.' Creative advance, to cite Whitehead, lies in discriminating 'the actualised data presented by the antecedent world, the non-actualised potentialities which lie ready to promote their fusion into a new unity of experience, and the immediacy of self-enjoyment which belongs to the creative fusion of those data with those potentialities.'[56] The doctrine of the creative advance of the evolving universe implies that creative activity

is found in the very essence of each occasion of experience constituting all forms of life and that is full with enjoyment of actualization from potentialities.[57] Whitehead laid the ground for an understanding that for such a constant transition of a 'community of the actualities' of the world, every emerging factor makes a difference in the nature of every other happening.[58] It is the creative emergence by which the many enter into a mutual immanence.

It is, however, important to stress that creative impetus, creative advance, and creation are not the same as creativity. Whitehead argues that creativity is always its own creature, dependent on the kinds of 'reactions' it acquires from the world, and terms it 'God' because the creatures constituting its changing character function as the 'objective immortality of actual entities.'[59]

The primordial, free, foundational, and self-organizing qualities of creativity and the understanding of becoming as creative emergence owe some of their conceptual legacy to process philosophy and the philosophy of change, but at the same time, the creativity discussed in this book is of a character that makes it more immediately applicable in minor acts, on scales that, although at some stages being asubjective and occurring interstrata, are able to yield an aesthetic amplification that is open to human participation but not necessarily relevant at the level, for instance, of a cell. Such creativity has an aesthetic specificity; not everything is constituted through creative actualization in this context: Governments and protocols, corporate websites, and legislation enjoy their own mechanisms of formation. There is an argument for differentiation that allows for a nuanced analysis of culture, art, sociotechnical, and political actualizations, among others.

In order to reapproach creativity, let's discuss self-organization, something core to creativity in its material genesis. This is a term that has two dimensions, both of them relevant. The first concerns matter, reproblematized after the recognition of nonlinearity, which is not passive and able to exercise its own powers or recognized as self-assembling,[60] as autopoietic. The second passage of the term concerns self-organization in art, cultures, or in software production and is widely discussed these days; linked into it is a discussion of an organizational aesthetics, where self-organization is a process of operating on creative emergence as it couples with other ensembles and produces site-specific and processual aesthetic organizational forms.

SELF-ORGANIZATION

The concept of self-organization skyrocketed in popularity during the early 1960s, when it was increasingly discussed in the context of second-order cybernetics[61] (first appearing in the 1940s to the enquiries of first-order cybernetics)[62] to be shaped as autopoiesis in the 1970s by Umberto

Maturana and Francisco Varela.[63] Autopoiesis was offered as a route towards understanding what distinguished living beings from things that do not posses the enjoyment of being alive. According to Maturana and Varela, a living system produces and reproduces itself as a unity of components that in turn reproduce the processes of their own production and generate their living system through the realization of a network of production.[64] In other words, living systems are those that are self-reproducing, a process called autopoietic organization, which renders living beings autonomous unities.[65] Throughout the 1980s, conferences gathered to think about societal, political, and cultural maintenance and change in terms of the evolution of self-organized living systems.[66] (Possibly the only figure that aspired and managed to do so most elegantly and eloquently was Niklas Luhmann, who turned this branch of the collective academic imagination into his life project).[67] In the 2000s self-organization was, together with collaboration and participation, probably the most frequently met keyword in the discourses of contemporary art, social Web cultures, Internet businesses, and creative industries, where it achieved the status of the magic porridge pot, a sweet spot that if hit, would be the gift that keeps on giving, as in viral marketing.

Still, self-organization remains confusing, both attractive and repellent. It is one of those parasitic concepts that promise the key to understanding the contemporary dynamics of change while maintaining something of the qualities of a vagabond, so that no one is ever completely sure what is meant and where it comes from. When it comes to its originary formulations in science however there are sufficiently precise statements of its qualities. Autopoiesis, as collaboratively described by Maturana and Varela, and developed separately and differently by each, is a framework with a strict structure. An autopoietic system possesses a topological unity. It produces its constitutive relations through the production of the components that act these relations out, and as an autonomous unity it is closed, meaning there is no import or export of components, relations, or structures. In the fields of physics, chemistry, and certain areas of biology, self-organization is seen as a process of the acquisition of structure both in living and nonliving systems through relations internal to the system.[68] Here, self-organization is an emergent property of a complex system, a process of the formation of a pattern at a higher level achieved through the relationships among lower-level components on the basis of local interactions. Theories of nonlinear systems often use the concepts of self-organization, complexity, chaos, and dissipative structures—all popular currency in contemporary cultural theory. The disparity, though, between demands set by the precision of the term in the exact sciences and the adaptations it needs to undergo to fit theorizing culture is marked by everyone who starts thinking seriously about societal and cultural self-organization. Self-organization has become a meeting point between different inquiries, one that acts as a launch pad that is useful to take flight in a variety of directions.

What is interesting about self-organization is exactly the same thing that makes the project of cybernetics paradoxical, and thus, attractive. Cybernetics is memorable, among other things, as an enterprise to be continually torn apart by the shift to unpredictability or, as Andrew Pickering describes it,[69] from epistemology to ontology on the one hand, and aspirations for improved efficiency and perfected control as traced by Brian Holmes on the other.[70] Cybernetics, not only in theory, but also through devising objects as a way of thinking (an exemplar being Ashby's homeostat), searched for a form of open-endedness imbuing human and nonhuman entities with agency and performativity (in Pickering's vocabulary), where 'cybernetics had a sense of humour.'[71] Self-organization inherited this trait. Following the partially technocratic scent of cybernetics, through game theory, operations research, and action analysis, self-organization also became a neoliberal construct of self-enterprise and new economic models (in which the market is self-organized). The paradox typical of such a contemporary narrative is that self-organization is also a weapon with which to fight this condition. It is self-organization that offers a whiff of the promise of freedom and suggests an understandable mechanism for creating a difference: A variety of routes have emerged through which self-organization is chosen and accommodated to enhance insight into the constitution of autonomy, difference, and ways of aesthetic operation.

Another genealogy for the term is in politics. The self-organization of workers in political struggle has been known for more than two centuries. Both the British and French cooperative movements of the nineteenth century and modern socialist theories, especially those of Robert Owen, theorized and practiced cooperation and self-governance. Marx's image of the possibility for workers' control of industry recognized a certain phase of the development of the figure of the proletarian in which each worker would have full knowledge of the workshop or factory, and thus have the capacity to take part in the governance of the process of production. Recognizing such factors, Kropotkin and those following his example in the radical technology movements of the twentieth century, looked for appropriately scaled technologies that would fit with the knowledge practices of self-governing communities, encouraging systems of comprehensible and decentralized manufacture. Over time, a variety of radical groups and movements have held self-management as among the core principles of organization, with crucial questions on the appropriate form of political organization dividing around both the figurations of the self that is implied and the ways in which it might be mobilized.

Explicit collaboration (and self-organization) in aesthetic practices is arguably as old as modernity itself, a practice in which, according to Gregory Sholette, artists envisioned the future society, giving 'expression to modernity.'[72] The term reappears in the participatory, collaborative art based on sharing and co-composition that became a focus of the last decade.[73] Perhaps even more volubly, discussions on the participatory and

social Web, introduced above, throng with a variety of accounts of self-organization.[74]

Niklas Luhmann was not alone in applying the concept of autopoiesis to societal structures. Gilles Deleuze and Félix Guattari felt free to take the poetic richness of self-organization and shape it into a tool with which to think the morphogenesis of stable structures, of singularities.[75] Guattari in particular suggests that when human beings join the constitution of machinic assemblages together with technical machines, institutions, and fields of the possible, they may form autopoietic forms.[76] The question of constraining autopoiesis solely to organism-scale systems exhibiting no input/output is solved here, as the possibility for a different formulation of autopoiesis appears—one based on disequilibrium and complementarity in relation to the exterior. Such autopoiesis operates in relations of alterity; machinic assemblages produce their consistencies in singularity, something that cannot be articulated through any unifying grammar but which is produced in relation to structures, other components, and other machines without being locked into these entities. Thus, autopoiesis is 'collective' and operates in potentially infinite forms of machinic alterity (the alterity of proximity, of material consistency, of formal consistency, of scale, agonistic alterity, and the infinite variations of these alterities).[77]

Guattarian autopoiesis differentiates ecosystemically (functions in relation to other machines and elements), phylogenetically (positions itself in relation to future machinic mutations),[78] and creates a zone of 'self-belonging' ('machine/universe coupling'[79]—some actuality rather than pure virtuality), while being a threshold to cross for a 'machinic assemblage'[80]—one plane, one scale among others. In this way, autopoiesis becomes an interface for 'embodiment,' upon which a richness of various systems of value (rather than the dominant, capitalist value system) depends for continuous existence in complexity. Birth, as a process between 'the necessary actual' and 'the possibilist virtual,'[81] is autopoietic.

Such senses of the term are probably the reason why in certain discussions, self-organization has come to replace or modify some of the prior conceptual tools of revolutionary action, such as cooperation and mutual aid, that themselves also seem to be based on rather cybernetic feedback mechanisms or those of collective self-rule and self-government that are conceptually a few centuries older. This promise of renewal through complete dissolution like a butterfly self-assembling from a soup produced by a caterpillar (while still in relation to DNA, ecology, weather and individual variation) stirs up interest in ideas of self-organization that articulate change, alternation, and assembly on a much deeper level than those any radical ideas of management can offer. If the metaphor that the Internationale anthem builds on is the demolition of the old world—an architectural and industrial figure—self-organization belongs to chemistry, physics, and biology and looks at cells, neurons, proteins, and thermodynamic systems far from equilibrium. Such self-organization is embryogenetic and,

as such, it includes aspects of uncertainty, the 'miracle' of the becoming of something that although emerging in relation to certain codes, still cannot be entirely circumscribed. Self-organization becomes a 'scientifically approved' concept that retains the magic flavour and the sense of power of the ontological operation of becoming in the world.

APPLICATIONS

Autopoiesis characterizes the life of autonomous organisms/entities: It operates to independently produce the entity through relationships of alterity able to enunciate change; thus, it is hoped to be a free and liberating process. As an update on the political rhetoric of struggle and difference, self-organization becomes an operation and a device with which to think political potential and autonomy within a variety of aesthetic and cultural systems, and one that is resonant with the idea of direct action, or of the Gandhian idea of being the change that you want to see.

In art, self-organization suggests the possibility of reconstituting the social, whereby the autonomy of art gains a contrary form of entrance into the social and the political.[82] When the public sphere shrinks through enclosure, the active life, in Hannah Arendt's understanding of novelty production and political participation, only becomes manageable through the acquisition of agency in multiple public spheres,[83] many of which are constituted through self-organization.

Such agency is also effectuated by becoming active, the social and the political transformation inherent to the becoming of new levels of skill, proficiency, and capacity in networks. The professionalization of the amateur (and vice versa) is a collective process, and here collaboration joins participation to become a current that is off to the side of the concept of self-organization. Amateur creation is a scale of a different value, and it is linked to production that is socially open, if not necessarily collective; as such, it is always a political action. Self-provision and self-sufficiency, social openness, and (geek) craftsmanship—these powers and desires feed self-organization, again cutting across both conservative and radical political imaginaries. At this point self-organization links to grass-roots, DIY, amateur, folklore, vernacular, silly, bedroom production, which will be examined further in the chapters of this book.

With the decline of the public sphere and welfare state, with amateurization and collective production, self-organization acquires the status of a medium and guarantor of sufficient difference to resist art run as business, the neutralizing effects of culture industries, and of neoliberal projects,[84] although curiously it is a term that all of these fields share. Alongside the hunger within the cultural sphere to achieve self-organization as a privileged state, it should not go unrecognized that machines of stratification and representation producing hierarchies, the stable and self-reinforcing

repetitious mediocrity may themselves have a self-organizing consistency. Here, self-organization can usefully be seen as a procedure that operates to engender various assemblages through difference, but also through mundane processes of stratification.

Thus, self-organization operates aesthetic emergence, but it should never be taken to offer a reliably ever-ready means to flip into transduction. The self-organization attempted in art, such as famous food offerings and other gatherings of people and projects that depend on the participation of the audience and that urge them to perform themselves as the project, seeks the magic moment of crossing the threshold and engendering a different ontological scale. However, self-organization is never guaranteed. It may indeed be hindered or elided by being the thing aimed at too frivolously or too heavy-handedly. Sometimes one has the feeling of stepping into a phylogenetically different branch of self-organization in which all the required factors are there, but remain static. Self-organization can be merged, emptied into a participatory project, into a work of art, into a project of restricted subjectification. The relational aesthetics of Nicolas Bourriaud[85] makes this mistake of collapsing an abstract process into a particular procedure that is then fetishized. Bourriaud is infamously and deliberately ignorant of media and new media art (fields that, with people and technology at hand, would perhaps seem more promising for relation-rich constructivist energies) for precisely the same reasons: Zooming in on the dynamisms he chooses, he collapses both self-organization and different forms of participation into what they become in specific cases.

Self-organization is not about a degree of external control, relationships of input and output, or costs. It is about how media ecologies emerge to become networks that are specific and perhaps distant from each other in relation to their common process of production. But it is also a form of cultural advance that allows us to imagine a typology of things and processes that may share relational characteristics.

Aesthetic self-organization is a precursive dynamism; it is a drive to the emergence of something else that may be reciprocated in an urge to trigger, witness, or be involved in such emergence but is not reducible to it. Aesthetic self-organization, as an operation of becoming, an interface to Guattarian machinic assemblage, is virtual, in the sense in which it allows for a heterogeneity of values to come into being at the same moment it is itself actualized. What if what happens is not self-organization, but is rather a certain mutation, a tentative form of open organization, a staging of participation without any internal auto-driving energy to it?

It might appear to be worth drawing distinctions between collaboration, participation, and cooperation.[86] Self-organization corresponds to some degree to self-determination but doesn't necessarily rely on the figure of the unified individual as the 'self' in question. When it is not a form of cultural outsourcing or offloading, participation can be produced through the same process: It constitutes itself through and arrives at self-configuration

and self-transformation. When collaboration becomes the main paradigm of production, and participation is pushed as the paradigm of democratic governance, it is through self-organization that this new aesthetic mode tries to operate.

Despite these appearances, however, such a mapping exercise might be seen as pointless as the desire to enumerate all the diversions that need to be followed in order for the notion of autopoiesis to be applied to social systems. On top of that, even in its differentiation such an approach may homogenize radically different conditions of operation. What is more thrilling is to understand how the force of self-organization, the core energy of its patterns of growth emerges and maintains itself. If self-organization differs from a variety of forms of organization through this drive that propels its advancement single-handedly, without reliance on external forces (in fact, it is impossible to securely stage or trigger self-organization), then the question is: how can we understand such a process?

How is it possible to distinguish self-organization and to track its recursive relations with the technical ecology and factors that effectuate it while at the same time keeping it open, that is, irreducible to enumeration and the repetition of 'necessary conditions' for it to occur? What are the scales that participate or are caught up in the process of self-organization, what are the actors and the special or mundane dances they take part in? How does self-organization articulate the couplings of humans and technical machines, biosphere and mechanosphere in a way that allows them to arrive at something different?

Alternately, are we setting off on a search for a 'true' manifestation of self-organization with these questions? Certainly, there are modalities of self-organization and there are forms of organization that, while being operators in the aesthetic paradigm, still lack the lively energy of autopoiesis and the point of threshold crossing achieved when self-organization mixes with something else. The relationship of art platforms to self-organization is far from simple, but it is through art platforms, along with other forms and means, that self-organization effectuates a difference.

So what are the roles of art platforms, and where are they in this process? If art platforms are a certain kind of a human technical nexus, which are themselves constellations of processes and forces, if art platforms are obstacles that are encountered as objects to think with, spaces that are materially conceptual, a funneling, a strong current that digresses and effectuates self-organizing aesthetic emergence, then what is it, this point in self-organization that art platforms are able to engender? How can we hold together the embodied composition of art platforms and the autopoiesis of aesthetics? At the same time, how or in what ways does the autopoiesis of art platforms co-occur?

One of the ways in which the autopoiesis of art platforms can be understood is through the idea of autocreativity. Self-organization works autocreativity through art platforms, tendentially achieving a moment of aesthetic

brilliance. Autocreativity is understood here to mean the genesis of creativity at individual, social, and preindividual scales, assuming a dynamic interrelation between the technical, imaginal, and cultural, flowing through a recursive process of self-constitution. What interests me in art platforms and the self-organization of autocreativity is not nascent becoming through repetition, but amplification to the point of brilliance, of the differentiation art platforms can produce. Because an art platform is always in some ways devised, negotiated, and redefined, it short-circuits itself and traverses the energies it works becoming contaminated and inventing its own ways of self-organization.

In fact, one could say that if the platform is not traversed by currents of self-organization occurring at different levels, from the generation of cultural forms to the interaction of contributors, the art platform remains a hollow framework. Because their becoming relies on a combination of factors, art platforms are saturated with elements of self-organization, or triggers towards it, that appear not randomly but in a way that cannot be exactly planned. Art platforms arise if they happen to enter into relationships with elements of self-organization and develop through these energies. But these elements, these processes stream from the self-organizing flow of autocreativity, rather than being applied as instruments to it. It would be more precise to say that art platforms work with different kinds of organization that autocreativity may feed itself through, with self-organization included among these, and as such, art platforms operate a certain organizational aesthetics.

Self-organization cannot be forced to occur; it is a process of embryogenesis, of ticklish layers that can affect the process at any moment. There is a risk of adding up to become something never completely predictable but expectedly, suspiciously mundane: A project does not always achieve its promise. It is not enough. Autocreativity is not enough. A variety of elements may couple with the process of self-organization to launch chains of reaction. Self-organization does not go unaided; indeed, aid may come from things such as 'tools' fused into codes or social fits of hysterics. One of those kinds of things is an art platform, but there are certainly also other technical objects and processes that engage with the self-organization of autocreativity.

Such a condition became particularly evident with the rise of the social Web, in which new social tools are seen as generating sufficient momentum to allow for certain hitherto indistinct or unrealizable forces to reach the surface and offer themselves to be immediately employed as something longed for (as interpreted in Clay Shirky's popular account, *Here Comes Everybody*). Such social tools are formed in the couplings between networks, repetitions, protocols, platforms, software functions, and cultural habits, degrees of being public and social, which all coconstitute self-organization more self-evidently, but perhaps not any more necessarily, than before.

Self-organization, like turbulence, is not random. As a 'self-valorising, self-empowering, self-historicising social and productive force,'[87] self-organization is one of the concepts with which to think art platforms and open culture (together with free software) on a more abstract level without loosing coherency or empirical usefulness. Another concept, whose moment of introduction has come, is autocreativity.

AUTOCREATIVITY

Autocreativity is autopoietic, autonomous, and 'automatic' creativity that propels aesthetic emergence in the constitution of the human, the cultural, and the social, and in the processes of subjectification[88] and actualization that are not solely locked into anthropomorphism but play out dynamically and recursively at the scales of the technical, natural, and preindividual. Such autocreativity feeds the operation of organizational aesthetics that art platforms coconstruct, while also being perturbed and effected anew by it.

The twist of the concept of autocreativity is in its double superfluity. First, I introduce autocreativity in order to make life easier through distinguishing between creativity as a functionalist category, an ontological quality put to work in the mines of the production of the new by creative capitalism and a creativity that cannot allow itself to be simply located, to categorize itself, and that does not allow itself to become a training program (so the term can be seen as superfluous). Second, autocreativity is superfluous in itself. Operating as a machinic production, it is self-organized, abundant, and heterogenic. As a force of becoming rather than being, which operates from the presubjective to move through many kinds of layers including those of art platforms and organizational aesthetics, autocreativity shares the condition of superfluity with the sun's energy, biodiversity, madness, and desire.

Guattari uses creativity to think the root of every differentiation, of the fields of work and of thought, of what lies between them, and necessarily, of art.[89] As much as creativity ends up in the production of distinction, art is made and operated by forces that are not always so eager to keep themselves open in relation to creativity. And on the other hand, aesthetic production thriving on (auto)creativity does not necessarily result simply in the generation of art. Autocreativity has the energy to cross thresholds, to effectuate a change, and to divorce itself from the plane of any current stratum. This does not mean, however, that autocreativity has the structural functionality to execute a great work of art. As something 'pre-', something making the world up, autocreativity transcends diverse states and horizons as something to be joined in with, discovered, followed and worked with in order to become. Autocreativity is a machinic creativity that is not smoothly talked to; it does not operate in terms of mundanity or newness. It is self-organizing because this is the way it processes itself, the

way it advances. But as it advances, it can also take on and harbour forms that are other than autopoietic.

Autocreativity is an action that is impossible to localize. The potential of autocreativity is not simply located on the biological level, as a potential of labour power, inseparable from a living body, a potential that acquires the status of a commodity.[90] It is found distributed within technical systems, objects, human beings, the fields of culture and of society. In digital networks, it is a dynamic process occurring in the relationship between network systems, software features, events, cultures, objects, and human beings. Unclean, outside in all weathers, and stained with the mucus of different births, autocreativity traverses art platforms.

The concept of autocreativity does not lock creativity into humans, nor does it locate it solely in inorganic systems. Autocreativity allows us to think creativity as a process of becoming that lies between the human, the technical, and the social, and to investigate the parts performed with creativity by the assemblages of these things. The preindividual quality of autocreativity does not lock out the possibility of talking about the subjective and the social, and its technical dimension does not make it deterministic. With autocreativity, we can move across such scales to enquire into the unfolding of aesthetics, to account for different actors or roles being performed. Autocreativity is a tool to think aesthetic genesis in its changes in state and position. In becoming a vehicle to move across the domains of technicity, subjectivity, society, and the production of art or nonart, the concept allows for sliding between 'pre-' and 'meta-,' the scales of micro and macro, hardware and software, art and folklore.

Autocreativity produces aesthetic brilliance through particular combinations of forces: Art platforms work as one of its reservoirs of amplification. It is through art platforms that, in their specific cases, a traversal of the common, the agreed, and the domestic is not only induced but enunciated, publicly and perhaps cooperatively performed. Art platforms work autocreativity through mechanisms that are not defined or assigned but develop themselves to be passed on to the environment and that produce a moment of difference.

As autocreativity is about becoming, proliferating experiences of the aesthetic into a number of possibilities, it is, among other things, through art platforms that people and things can become something they do not expect, want, understand, or require. Here, to paraphrase Lacan on love, art platforms create something they do not possess and give it to someone who does not need it. Autocreativity can be as catastrophic as love in its creation of spaces that are as much alien as dramatic in their full indeterminacy. Such amplification spreads out extra spaces, other worlds, kinds of beings where the construction of value and meaning is enabled without operating according to any prior logic. Autocreativity lays out a handful or a myriad of spaces of possibility rather than annihilating them or offering them up for immediate co-option. It is a process that establishes a possibility of

something else, of heterogeneity, where the self-organized dynamics of the unfolding of additional realities is the basis for freedom.

This certainly does not mean that every user is creative and autonomous or every creative act or project is 'free'; neither is the previous meant as an anthem to art platforms. As mentioned, autocreativity cannot be pinpointed and located in human beings, objects, projects or machines; rather, it is evident in their interrelationships, in between. Autocreativity is dynamic, as are art platforms that continuously invent and redo themselves, exhibiting a continuity that has nothing to do with speed or a fast turnaround. It is through these couplings of autocreativity and art platforms, together with other processes, that multiplicities can be engendered and experienced.

Art platforms are attempts to enact different forms of reality. What we witness is not a closed cycle of revolution and restoration, nor of pre-subsumption, but a dynamic of emergence, affecting the ecology within which it is born. Such scuffles and ruses of aesthetic enquiry and stratification wrestling with and wriggling from each other, the amplification of autocreativity, manifestations of aesthetic brilliance, and human-technical assemblages of living cultures, of curiosity, humour, and anger—this is the right context for understanding art platforms in their full potential. Such circulation, simultaneity, and multiplicity are a means of understanding the potential for another aesthetics, culture, and society, all of which are both impossible and readily existent.

2 Aesthetic Brilliance and Repetition

> Could anything be more improbable or more absurd than the co-existence of an endless number of elements created to be co-eternally alike?
>
> (Gabriel Tarde, *The Laws of Imitation*)

> Because: until then the life had only been work, the house, the household, the girlfriends, work, the work at home and the work at the dressmaker's . . . , a false or incomplete life therefore. . . . [W]ork, the house, the household, the girlfriends, work, the work at home and the work at the dressmaker's are admittedly still there, they don't go away by themselves from one day to the next, but apart from that love is here now too, hurrah, the most imp. thing in human life and now the most imp. thing in paula's life. . . . and she MUST do everything properly, otherwise love will just be gone again, or it will be driven out by work, the house, the household, the girlfriends, work, the work at home and the work at the dressmaker's.
>
> (Elfriede Jelinek, *Women as Lovers*)

The sociocultural circulation of energies in art platforms and on the participatory Web has its routines, whether they are economic, statistical, or symbolic. It also produces its organizational aesthetics, sometimes involving self-organization, nourishes on autocreativity and navigates through certain technical objects and human technical couplings to transduce the geometry of its states. How exactly does such transduction[1] take place? When autocreativity, driven by desires, some of which are aesthetic, couples with an art platform, or the mechanisms and drives that it aggregates as one, condenses and bursts open with some aesthetic brilliance, how can we develop a sensibility to recognize exactly what is happening and also account for processes that do not go this way? In other words, how can we dare to speak about the brilliant and the mundane, transformation and stratification, or to articulate what is different and repetitive across scales? Having made an approach to the economically and socially deterministic cartographies of platforms found in post-Marxist and liberal thinking, I'd like to look for ways to stage the relation between the commonplace and the striking in affirmative rather than negative ways. Creating a means to speak about what is grey and banal on the Internet allows for a recognition of the brilliant; and such a means of cautious differentiation may likely turn out to develop a sensibility for a set of interesting tendencies rather than dispensing with the developments in new media as reign of banality at large.

It is a difficult path though, marked by the rises and falls of Adorno and Horkheimer's culture industry and British cultural studies, the attentiveness of Lefebvre and de Certeau, to mention a few traps and odes. If an 'elitist' Adorno cursed the culture industry as a means of maintaining an all-too-certain conditionality of workers' lives between their factory hours without any hope for escape except for a 'Great Refusal,' CCCS (Birmingham Centre for Contemporary Cultural Studies) produced a conscientious mode of looking for symbolic resistances, imaginary spaces, and against-the-grain 'decodings' operating at different (class, race, and gender) levels of cultural machinery. Whereas hegemonic domination became too globally indistinct, frantic, and multinational to be identifiably resistant to, 'ordinary people' acquired fluid identities, hybridity, apolitical sentiments, mobility, hyperindividualization, and other characteristics. Reassuring that online fanzines and soap opera lovers are reassembling their complex identities in the miniscule creative performances of everyday life is what an enterprise started by the composer Berg's former student leaves us with.

It seems to be appropriate to pause here briefly among this recollection of notable academic achievements of the last century to tell an anecdote. A few years ago, during a seminar at the Moscow Institute of Philosophy, the discussion lingered on television for some time, providing a nonreductionist and generous analysis of the same. After a while though, someone mentioned that he had not owned a television set for about six years. As it turned out, not a single participant had a television set, nor did they watch TV at home.

This anecdote can be considered telling by taking into account the social status, sanity level, or the likes of philosophers, but I would like to use it to stage a series of enquiries into how the avant-garde relates to culture. What is, actually, the difference between an aesthetic movement of self-organized autocreativity and normative, stereotypical, and unkind chit-chat?

It seems to be the case that we need a cultural theory of difference that would lead us conceptually beyond negation, what is bad or good, representation and reduction while at the same time creating ways to approach aesthetic complexity. Certainly, a cultural theory of difference is a twisted paraphrase of the philosophy of difference, set up in Deleuze's *Difference and Repetition*. However, I would like to start with Gabriel Tarde, an acknowledged influence and an inspiration to Deleuze.

Gabriel Tarde published his *Laws of Imitation* in 1890. Alliez, Latour, Thrift, and others who have recently put effort into bringing Tarde's oeuvre back into academic circulation[2] have written about Tarde's scientific fate: Professor and chair of Modern Philosophy at the College de France in 1900, a somewhat more successful colleague to Bergson,[3] he posthumously lost to Durkheim in the project of sociology and remained only an object of consistent ridicule[4] lingering on in 'dismissive footnotes.'[5] The main reasons for that being the same as those that inspired Deleuze: his philosophy of society as monadology, an approach to microsociology, a theory of

possession rather than identity, the elaboration of ideas about economic psychology, and invention and imitation, among others. Tarde refused to recognize human society, inclusive of abstract laws governing social forma- tions and human individuals reproducing the laws, as a distinct category to build a discipline around. Instead, he thought of human society as an assemblage of monads (as well as a society of atoms or plants, that was even more complex: the 'ambition of germ, cell, tissue to form an organ [is the] same as ambition of enterprising man in a creation of a club'),[6] where monads are interlocked (only by the façade) while at the same time escap- ing into other assemblages. To understand such a society, one must look at the micro level, where one finds not a single entity but multiple agencies invested with desire.

To extend this poor summary of Latour's vivid introduction to Tarde into a question of imitation or repetition, one could cite Tarde himself: 'All homo- geneity is a likeness of parts and all likeness is the outcome of assimilation which has been produced by the voluntary or non-voluntary repetition of what was in the beginning an individual innovation.'[7] An individual inno- vation here is the success of one monad in infecting others with its desires and beliefs.[8] Because no larger phenomenon can have a principle of existence other or more complex than a single act, a difference is the result of some- thing that can only be looked for in the interaction with the many, where one sort of such interaction is imitation. 'Society is imitation. Organisation is the means for which generative or imitative repetition is the end.'[9]

Invention and imitation are basic social actions, whereby an invented thing is endowed with desires and beliefs that are sensational and also social qualities.[10] But for Tarde, the desires and beliefs that invention and imitation actualize, and thus make real, exist virtually prior to that, origi- nating 'far below the social world in the world of life.'[11] There is a struggle, articulable as a movement in two directions, wherein invention becomes both a promotion and a disruption of desire, a substitution leading to accu- mulation. Imitation triggers the emancipation of invention without the destruction of the environment, where desire is transformed into imitative states and phases and also into invention: Imitation occurs at the same time as invention.

Having said that a desire to imitate is itself born by imitation and, more- over, that imitation is a form of desire itself, Tarde still intones a notorious phrase: 'Imitation is somnambulism.'[12] Perhaps rather than read this as a denunciation of imitation as opposed to active invention, we must think it in terms of this word's relation to ideas of hypnotism and trance. As Lisa Black- man puts it, Tarde, along with Bergson, was a member of the Institute for Psychical Research in Paris and thought imitation through concepts inspired by research into hypnotic trance, spiritualism, and psychic phenomena.[13]

Kierkegaard's concept of repetition, as a transcendental correlate of the 'psychical intention of contestation and resignation,'[14] accounted for by Deleuze is a firmer link to Tarde in the construction of the immediate that

is universal and singular (re)united (for Tarde: desires that virtually exist below the social world and actualize into imitative states). One can get closer still to Tarde after having read Deleuze, whose repetition, though, owes more to the Nietzschean eternal return; I will trace a thread of these connections in the following.

Repetition is not a law of nature, rather it is a better way of enacting change (a statement attributed to Tarde and Péguy).[15] In this context, it is useful to imagine repetition as being akin to meditation or different religious practices of praying, as a way of performing a disassociation on the self or a milieu; in such cases, repetition is a transgression: It repeats 'the unrepeatable.'[16] It is a way for a new to come about.

Deleuze starts off his own meditation on difference and repetition by differentiating between repetition and generality. Repetition is singular, a quality by which it differs from generality, although occasionally processing itself through its own routines. To sense Deleuzian repetition, one could approach it in the manifold forms of ecology, where a substance such as fog is repeated as a dew, stream, sap, urine, tears, milk. Such repetition is a movement that is affective and is interwoven with distinct actors as profoundly as it is different within itself. To move, create, produce, and destroy is to acquire repetition.[17]

The Nietzschean eternal return is a 'test' of becoming: Only the excessive, energetic, or different can pass through this trial, can indeed return, be affirmed and realized.[18] The eternal return is the difference in 'permanent revolution' that is affirmative, light, and able to change all states. Such an extreme is not achieved by the intensification or the negation of the average nor crystallized in an historic moment; rather, it is the univocity of difference established by the eternal return.[19] Here, repetition would be a 'formless being of all differences,' a mere positioning in relation to something, a 'difference without a concept,' an indifferent difference. Repetition consists of masks that disguise the difference and that are enveloped into one another.[20] Understood in such a way, the eternal return is not about the repetition of determination or an achievement of the same, rather it is an affirmation of the differentiating different, of the chaotic, that is not linked to any origin but is a 'pure difference' in itself. Something that is repetitive could only be the effect of the systems performing eternal return.[21] A condition in which multiple relates to multiple, developing dynamically is the difference enveloped into repetition.

By now it should have become clear that such repetition and difference are operators of the ontological becoming of the world, relating to the actual, virtual, and real. Whereas a more specific and rather unrelated use of it will be made in tackling repetition in aesthetics, I would dwell a little more on the structure of such a transcendental empiricist ontology to map out traps to avoid.

Subjects acquire positioning in relation, a realization through repetition, in which actual and virtual come into reciprocal relation and also change

themselves. Virtual intensities of pure difference are indivisible from actual things in the construction of the real, of the becoming, and they connect and change their relation dynamically through repetition. There are three kinds of repetition: a repetition of habit (physical), a repetition of memory (psychic or metaphysical), and a third (ontological repetition) that undoes the previous two.[22] The first two are conditional repetitions, whereas the third repetition is one of the eternal return that precludes the return of the first pair.[23] The negative, the similar, and the analogous repetitions banned from return by the last one, are practiced through the first two kinds of repetition. The first time is one of negation, where one repeats because one doesn't know or cannot do and becomes equal or similar through becoming identical, acquiring an identity as fixity. The second time is when one embraces the disguise (habit) and while having already become capable of action, 'wants to become equal to the whole world' and to the 'whole of time.'[24] These two repetitions are performed in a close intertwining of comedy and tragedy. The third time of repetition is an act of pure difference that overthrows the previous two and reconnects the subject to intensity, which is also a catastrophe, a rupture that is a difference.

Deleuzian repetition is the ontological operation of the production of the world; it is a door to his philosophical project that is staged to provide an alternative to Western metaphysics. How can such difference and repetition be used to talk about aesthetics?

In his book on Francis Bacon, Deleuze wrote: 'Too many people mistake . . . a plagiarism for audacity, a parody for a laugh, or worse yet, a miserable stroke of inspiration for a creation.'[25] He also talks about clichés: 'Clichés are always already on the canvas.'[26] Here, the technical vocabulary is different. The same, similar, and identical are arrayed as figures of the stereotypical, clichéd, the commonplace, banality. Banality, though, is not on opposing terms with the outstanding because, as we know, the outstanding (which is anyway present) appears through (ontological) repetition, another effect of which is banality.

How to try and spin sets of figures with which to write about what is stale and brilliant in organizational aesthetics? Art in general has a power to thrive on all three kinds of repetition, to make them all merge, work on top of each other, disjoint and repeat for a difference to be extracted.[27] But what about things that have not yet become art, aesthetic in-betweens, try-outs—constellations of linguistic, sensational, and social forces? What about a cultural movement becoming an aesthetic current, a process that may be as unpleasant and annoying as it is luscious? When aesthetic brilliance is discussed as an aesthetic transduction occurring in art platforms, through the unfolding and amplification of autocreativity, how can one, first, account for it as an affirmative multiplicity across scales, and second, avoid the optimistic pretence of such occurrences being omnipresent and uniform? How is it possible to reserve the ability to speak about the distinctive and ordinary, singular and regular, vigorous and dull? Deleuzian difference and repetition

assists means of speaking that do not spill out as negation (precious and meaningless), identity (identical and graphomaniac), representation (original and imitation), but are affirmative and plural (something that, to be fair, is attempted in certain aspects of early cultural studies) but which is, nevertheless, empowering towards the amazing, not the banal.

Maybe, though, it is not such a difficult task. After all, art has an 'internal power.'[28] Art extracts, discovers, relates, reverses, and displaces. Movements of amplification may even destabilize the aesthetic enough to implode ordinary banality into the creation of its own world.

Amplification is a means of the production of aesthetic brilliance. Such amplification is a process of aesthetic actualization that fluctuates between, with and through the preindividual to individual, to social, artistic, cultural, fokloristic, and technical, all porous, along with repetition. The scales at which amplification occurs may include, but are not limited to, societal niches, linguistic formulae, artistic devices, or cultural identities (clichés). However, through its augmentation of such scales it becomes able to shatter processes of stratification into scattering structures. While displacing some perspectives, it also develops acuity, intensities that are focused as well as blown open. The amplification of autocreativity intensifies its becoming to reach the state of catastrophe, a comingling of creation and a disappearance, precision and folly.

Certainly, amplification does not centre solely upon the human or a particular aesthetic work; it is thick and multithreaded. Vocabularies, phonemes, devices, styles, concepts, methods, social figures, technical ensembles, relationships can amplify with the ramifications of such processes feeding back onto the dimensions and scales at which they operate. Here, intensive words or concepts, operations or objects are born within certain ecologies of repetition and move along, but travel on to disrupt them, produce new ones, escape such productions, and gather to become something of a hole, a tear in the fabric of production. And to tear something apart, a whole apparatus of differently directed movements of unlike kinds is often called for.

Such a process certainly happens with and through the technical—hence art platforms. Amplification is a dynamic that can evolve within the process of the aesthetics of organization, within a technical actualization, and through such couplings, disjointed, melodic, or grating, result in various kinds of processes producing a rip, or a 'new world.' Whether art engenders this new world as 'the unheard of,' 'the incision of an inaudible presence into well-heard presence'[29] as it is for Lyotard; or 'the inflection of the state of things,' a new reality with 'unprecedented, unforeseen and unthinkable qualities of being'[30] as for Guattari, it is the sense of rupture and alterity that manifests something crucial about aesthetic brilliance.

Lev Vygotsky, an early Soviet psychologist, grounded his work *Psychology of Art* (1925) on such a disruption in the flow of artistic work that makes another world. It is a particular point in its duration or a set of

relationships that collapse the movement of unfolding of the work of art which simultaneously produces it as an artistic phenomenon. One can no longer see anything; there is a radical shift to another plane.

In *A Thousand Plateaus*, Deleuze and Guattari derive intensity from the work of Gregory Bateson, for whom it is a plateau that may not be disrupted or built towards a climax. (Bateson suggests that in Balinese culture, sexual or aggressive energy is worked through with such rituals.)[31] The artwork as a climax and as a thing that has a finality of achievement is, from such a perspective, a particularly Western concept. Aesthetic brilliance, as it is drawn, through a radical change, by Vygotsky, is not about climax (nor catharsis) but deals with the unfolding of an artwork, of language, of reading, of the human, and of different ensembles it enters into with other strata, to talk about the emergence of a new world.

Such movement creates a chaos that finds a rhythm in itself, a reflexivity. Rhythm here would not be necessarily something of a representational character; it cannot solely be expressed through the formal qualities of writing, for instance. Rhythm is a characteristic of 'another world'; it evinces and establishes a mode of being, a reflexivity, a sociality, a technical sensibility, all generated with the new world that is instantiated by the work of art.

Such reflection on aesthetic brilliance would be trivial if it did not suggest ways to tackle art platforms and their formation of an organizational aesthetics in order to reveal their specificity at various levels of becoming. An example I will dwell on at length in this chapter is a clear-cut art platform that produces aesthetic amplifications of unlike kinds—as literary, linguistic, technological, network, and sociohistorical phenomena—while at the same time maintaining them as a univocal current through its self-generation as an art platform.

KREATIVS OF MALE LITERATURE (MATE LIT)

Udaff.com is a very popular Russian language platform for a variety of practices related to literary creation, from prose and poetry to reports and reviews. Although the creative writing practiced across this platform has little to do with normativity of literary institutions, and although it is a resource that comes across as something closer to a porn site and a swearing reservoir than anything else, it creates a literary phenomenon that is peculiarly interesting in its aesthetic metabolism.

Its main avenue of participation is in the writing of *kreativs*,[32] a special kind of short story, a literary genre of its own. The *kreativs* (or the 'dicking guys,' the *othas* (authors), as they also call themselves) and their *camentin* (commenting) by the *svitchers* (switchers, i.e., readers and viewers) are the vital pulse of Udaff.com. It is there that the participant receives approval (the *otha bu-urns*, the author burns, i.e., touches) or disapproval (the 'dickshit').

Technically, Udaff.com as an art platform is as simple as it could be. The project was launched in 2001, during the pre-Web 2.0 era, and is administered by only one person, with the help of a technical assistant.[33] To post something to the website, one still needs to send a piece of writing via email personally to the administrator, who then decides if it is of an appropriate quality and uploads it to the server. There is a posting and a commentary thread on it, all stored in the database, and before 2006 there was not any voting or other text evaluation method through the system of rating or featuring available. There is no classification structure; the most recent writings are published directly on front page. There were not even password-protected nicknames and registration until the sixth year of Udaff.com's existence. The same year, Udaff.com started organizing literary competitions, announced a literary prize with a fund of $10,000, and finally opened a new section of 'the best' *kreativs*, as well as publishing them in print anthologies.

Udaff.com was formed 'in the footsteps' of the earlier project, the IRC channel #flex and the site Fuck.ru. Skeletron and Scripter were the founders of #flex, whose policy was to generate flame wars and abuse of opponents. The swearing language *mat* (which will be discussed later) was not banned on #flex, and it quickly became a very popular channel. When the amount of users became too high, Skeletron made a website, Skeletron.ru, which the users of #flex jumped towards with eagerness because all the discussions could be stored in the database. Fuck.ru replaced Skeletron.ru in the second half of 1998, and it quickly became one of the leading sites, leaving behind online libraries by number of visitors.

It was at Fuck.ru where the format of the *kreativ* and its language were invented. It ran from 1998 to 2000 and achieved wide resonance on the Russian Internet: One of its authors (Sumerk Bogov) received prizes for his *kreativs*.[34] Within two years, Fuck.ru started to slow down, no longer

Figure 2.1 Udaff.com: logo.

updating *kreativs* until it disappeared in 2000. It seems Fuck.ru was a much more closed system than Udaff.com, and it had an elitist ideology, trying to become some 'elite venue' for the Russian Internet.[35] Fans of Fuck.ru established a number of similar sites, none of which became as popular as Udaff.com; why this is so is an enigma, an answer to which lies in the ways Udaff.com operates as an art platform.

Considering the basic organization of Udaff.com, it comes across as a breathtaking large-scale[36] aesthetic phenomenon, generating vocabularies, devices, ways of writing, distinct projects, social responses, and sets of relations—all in all, amplifying autocreative emergence to the point of overthrowing its constitutive repetitions. As much of its aesthetic secretion is looped into the stereotypical, configurations of the world that are heavily gendered and stratified; and only seeing a differentiated complexity linked and leaping into radically varied strata allows one to recognize the processes Udaff.com produces and participates in.

To sense the energies playing out in Udaff.com and the registers that get plugged and unplugged and fed back into it through the metabolic cocreation of social figures, literary concentrates, words and concepts and their performances, their practice needs to be followed closely, with attention to the genre and language of *kreativs* and to the contexts in which they arise.

Kreativs participate in a common literary process, employing devices or situations as they envelop a world they produce while making and losing sense of it, 'reclaiming' reality through their genre.[37] As such, it is a specific literary form, contributing to the creation of male literature, mate lit. Usually *kreativs* tackle the manifest subjects of Udaff.com: alcohol and marijuana, sex, and generally, the relations between men and women. If the novel format 'for women,' so-called 'chick lit,' is based around relationships, Udaff.com literature is based around (often male) orgasm, extensively and verbosely described (hence the name 'mate lit'). It is full of rather traditional characters, such as the *revolté*, destroying himself with alcohol, fearless and capable of experimenting with his own body; the macho man in need of numerous sexual contacts and a great number of female partners; a 'demonic' character disappointed in life and surrounded by either stupid and self-imposing or incomprehensible and irrational women. *Kreativs* are quite often stories about parties and the seduction of women, periodic memory flashes, sexual relations, hangovers that are accompanied by the recollection of physical and emotional details, and so on.

Possibly, such mate lit relates to brutalism, where figures like Charles Bukowski's 'renegade hero,' a sexually active, antisocial, and alcoholic single man crosses roads with lad culture and punk. One could probably look for brutalism in the same manner as for large movements such as 'Sturm und Drang' literature, if it were not so intricately interwoven with gender, Theweleit's 'male fantasies,'[38] folklore, mass-scale amateur creative production, pop and celebrity culture, education and family policy, and sets of industries producing an octopus one would have to severely amputate in

order to fit into a historically neat box of style. One would then also need to look at the arts of opium, absinthe, and alcoholic delirium as well as absurd literature in an attempt, perhaps a vain attempt, to position Udaff. com on a cultural plane.

Now, what is so exciting about this literature? As repeatedly chauvinist as it partly is, it is also an example of a digitally born literary current of immense power. It is about the subjectification of writing and a democratization of creative writing that pushes itself a long way, too far to remain within the homebrew hobbyist realm.

As an art platform, Udaff.com creates a whole artistic movement that acquires a voice through processes of organizational aesthetics. In a finely tuned assemblage performing itself at the intersections of reading, writing, the act of sending an email, pushing a button, but also in building a human-technical network of servers, requests, reactions, memories, dialogues, mailbox trash bins, laptops, antennas, bills—all engendering a plateau of a mediated aesthetic becoming that operates along the lines native to the Internet, Udaff.com writings amplify to create some brilliant worlds.

As strong as individual stories might be, it is the whole phenomenon of mate lit that this art platform endows us with that is thrillingly powerful. Such amplifications do not mean, however, that any work you encounter at Udaff.com will make you sing. Or cry, for that matter. As amplification is a movement, there is a dynamism, a mixing of sensibilities, and feed-back loops that ensure readers experience a mixed feeling of excitement and disgust, delight, and the fatigue of repetitive banality. As much as it is a literature that is being born in a grey zone between culture and art and maintains intensive connections with its aspirations, ambitions, habits, and flashbacks, it also enters cycles of amplification to overthrow repetition and produce an intensity of a few trajectories.

'WORD INTENSITY'

If we are concerned with what happens at Udaff.com, we take our leave from the domain of literature per se and come into closer interaction with the main avenue of influence exercised by this art platform over contemporary Russian culture: its language. For although Udaff.com's language certainly does play out in the literary formation, it also injects itself far beyond that.

The language of the *kreativs* is remarkable. It makes use of DIY vocabulary; virtuoso and abundant swearing (*maternyī* language, otherwise known as *mat*, as I refer to it in this volume); and elegantly, purposefully wrong orthography. The language of Udaff.com—its combination of spelling, vocabulary, and syntactic constructions—is what has penetrated the broader layers of the Russian culture and the Russian language and where acts of usage do not necessarily or almost never retain the conceptual link

to the source. For example, one can buy the 'guffawing-can't-stop' logo for the mobile phone. 'Lukashenko, drink some poīzon' was seen on banners of those protesting against Belarussian president at a number of political events.[39] As such, this art platform becomes a shadow plague spot, a hidden language power motor.

The orthographic 'naïveté' of Udaff.com's language is not about 'writing as you hear.' It is rather a lexicographic parody, whose performers know perfectly well that the words are not necessarily written as they are heard and who remember rules or spelling but purposefully confuse them. One could remember here a parallel maxim of Velimir Khlebnikov, 'the misprint is the freedom from the given world';[40] and it is probably worth recalling Julia Kristeva's carnivalesque discourse, which 'breaks through the laws of a language censored by grammar and semantics' and where there is an 'identity between challenging official linguistic codes and challenging official law.'[41] Such a discussion of the disruptive usage of language comes hand-in-hand with the adoption of the nonnormative vocabulary, *mat*.[42] Here it must be noted that the degree of nonnormativity of *mat* does not have any correlation in the English language and might be hard to imagine for an English speaker.

Mat constitutes a quite independent layer of the Russian language. According to the definition of Alexander Plucer-Sarno, the core of *mat* usually amounts to thirty-five nonderivative units; or according to a more narrow view, to seven lexemes and their derivatives. The obscene vocabulary, which possesses its own system of taboos, also adjoins but does not coincide with *mat* and has a markedly independent lexical nest.[43]

Commenting on the relatively independent character of *mat*, Igor Levshin writes: 'The "mat" in our country owes its vitality to the fact that it can form a practically closed and fully valid separate language. Its bearer, rarely crossing the boundaries of this language, will share his opinions not only on the quality of beer, but on his relations to the material and the ideal worlds as well.'[44] Vladimir Rudnev discusses the situation in which one can have a fully valid utterance, compiled solely of the derivatives of one word, *huī* (dick), in his introduction to the first volume of the *Dictionary of Russian Mat* by Alexander Plucer-Sarno, which is solely dedicated to the aforementioned word: 'Every inanimate object can be denoted as "huīovina." . . . Every abstract noun can be denoted by the derivatives of the word "huī." . . . Every quality or characteristic can be denoted as an adjective. . . . The verbs "huīarit'" and "huīachit'" have a universal pronominal meaning . . . similar to that of the verb "to do."'[45] *Huī* can also denote an animate creature, a man.

Universality, its tabooed characteristics, and as a consequence, the power of the effect of the Russian *mat* cannot but attract the masters of the word. The participants at Udaff.com single out and value their own language, and they often discuss both mat and their broken orthography: '[the] word 'Huī . . . is the most censored of the words, and still any teacher of the Russian language would admit that

The word HUĪ is THE BEGINNING OF THE RUSSIAN
LANGUAGE
The word HUĪ is THE END OF THE RUSSIAN LANGUAGE
The word HUĪ is THE BASIS AND THE CORE OF THE RUS-
SIAN LANGUAGE
The word HUĪ, finally, is the Russian language.[46]

The participants at Udaff.com have elaborated their own vocabulary, which contains such terms and expressions as a 'the otha burns' (the author has written a good *kreativ*); 'the pas' (as in exam—the praise of the text); 'the no-pas' (the criticism of the text); 'aftor, drink some poīzon' (the criticism of the text); 'ai craid,' 'switcher,' 'to switch' (to press [a button], to read, to look); 'huīarit'' (to dick, to write): 'hel's burn over' (great party); and others that can be approximately transliterated as follows: 'nofucking,' 'gothic-like,' 'glamour-like,' 'guffawing-can't-stop,' 'raīt,' 'throw-it-in-the furnace,' 'PR-it,' 'couldn't-reed-et.'

Here, amplification occurs across the scale of language that Udaff.com operates within and at a tangent to. Word intensities, when certain words or lexical structures acquire a force that distinguishes them from other words and systems, the amplification of tendencies, the force of taboo, all ally themselves to engage with the language as oriental spices, as anonymous but brilliant language formulae that enter the construction of our linguistic bones.

As a perfect example of collective aesthetic creation, the language of Udaff.com goes beyond particular works and enters into the (re)production of means of thinking and relating that are largely social yet intensely forceful in creating coruscating aesthetic presences in the habitual language environment. The vernacular couples with the individual, occurrences exchange places, the generation of text is interrupted with a performance that then becomes an algorithm in its own right. Naturally, digital literary materiality leaps into the linguistic, to the cognitive, to the expressive, to the social.

SOCIAL FIGURES

Another amplification to talk about in relation to the fertile material Udaff. com presents us with is the one occurring across catastrophic social histories, networks, concepts, and actors. Udaff.com responds to, extends, and transforms social figures with the power that is accumulated in their networks of production and that reciprocally produces this art platform and the particular form it acquires. Social histories and contexts in which Udaff.com members operate include the demise of the figure of intelligentsia, and it seems this particular concept, a social phenomenon, a historical formation, can shed some light on the performance of this art platform.

The participants in Udaff.com call themselves 'real skumbags' and possess a certain kind of self-consciousness in their fidelity to a triad 'fuks, votkas and pot' (almost 'sex, drugs and rock-n-roll,' but adding literature instead of music). The skumbags frequently write of themselves as people with broad views on life, free from all the stereotypes and conventions. Consider, for example, this quote: 'Simply, the padonki are the people not limited by any tiresome stereotypes. Normal people, who live, fuck, smoke pot, read books, watch movies, work, dick-around and they do not make a cult out of any of these. Neither a workaholic, nor a loser nor any damned stoned drug-addict can be a padonok by this definition. They simply won't have broad enough views.'[47] Udaff.com repeatedly announces its provision of a platform for protest, or at least an alternative free space.[48] The question of the relation of the Udaff.com culture to a 'counterculture' has been brought up for discussion more than once on the site as well as in the press. Udav himself has, more than once, used it in his interviews: 'In less than a year the Udaff resource has become that which it is today—the major resource of the counter-culture.'[49] 'Resistance' seems to be one of the most appealing characteristics of the Udaff.com subculture for its adepts: 'To gou at the demo-fucking-stration? The resors is very naturally fighting with the fucking masskultur, that shits into our brain. . . . We have everything: literature (prose, poetry, criticism), photo-art, painting, music, and all that is counter-cultural, and what other fucking "else" there should be? What does the "aftor" suggest? struggle? This resors is exactly it: OUR STRUGGLE!'[50] Although it is coupled with a quite thorough apoliticism, a large chunk of commentary on such protest seems to be concerned with countering acceptance of the corporate culture of the new capitalist order and its effects. Consider, for instance, the following postings:

> The skumbags, smart and educated, are traiying to protekt themselves from korporateeve kultur. The managers are asked to crack their asses for the saike of the firm. You sit all day in some tuf totalitarijan fraimz. You iven don't have a rait to have a bad mood at the offis. Iven if yo faivarit kat was kild by a tramm and yo wife's a hor, and yo son's a loosa. The norms of condact are taiking ova yo imotions. It's sum fucking fascism.[51]

> My dearest! As I can see nobody claims here a status of the civic movement for the simple reason that they understand: there is no society and can never be and all movements, sooner or later, become senseless. Here all the emphasis is placed on understanding and realization of the senselessness of everything, as I see it, and the purpose of all this is the search for a little sense in at least some eternal values, such as: an internal smile in the most 'posh' situation (hi, white collars!), also, fucks, drinks etc, including communication with some like-minded people.[52]

It might be useful to interpret Udaff.com subculture in terms of the ideas of transgression and the carnivalesque that are widely applied in cultural studies.[53] But what seems more appealing is to follow an argument for a 'pop conceptualization' that theorizes Udaff.com participants in terms of contemporary white-collar workers' figures, unacknowledged descendants of the Soviet intelligentsia.

Who are the Udaff.com visitors in real life? It is a bit of an old-fashioned cyberculture task to interpret the connections between 'virtual' personae and 'real' people, also taking into account the deep trouble of using the adjectives 'virtual' and 'real' in this context.

However, even the Udaff.coms like to socially classify their users. Consider this one, for instance:

1) A 'little skumbag'. A frequently met site-species. The first stage of the long path of evolution from the man into the Udaff.com visitor. Age 14–16. Hence, still at school. And this is worthy of respect as such, for all the most disgusting things are done and being done exactly there. The little skumbags are attracted by the mix of the naked women's pictures and the mat, used by the representatives of the later evolutionary stages.

2) A 'typical skumbag'. A more rarely met species, but some very impressive personalities. Age 20 to . . . till they get their jobs or marry. They are the bearers of the real skumbag ideology which is the mixture of . . . dicking around, punk-style and asceticism.

3) An 'office skumbag'. The most widely spread type of the virtual skumbag. Age . . . from the time they are married and go to work till the elderly weakness. Very bitter with life and brutal. Are very sensitive to the theme of fucking and pot, think of themselves as of real skumbags, hate both the first and the second types. Consider the little skumbags as children and are envious of the typical ones. [54]

The forum of Udaff.com contains a questionnaire concerning education (which also gives an idea of the approximate age of the site's visitors) and the professions of the participants. In general, 80% of those who answered the questions have a postgraduate education or scientific degrees. Approximately 12% have obtained higher education and around 8% secondary education, i.e., they are currently students or have just finished secondary school. A large portion of participants are occupied in IT.

It is often assumed that Udaff.com presents the possibility of initiation into the adult world for teenage schoolboys, whereas the adult members visit Udaff.com for other reasons, prime amongst those that are acknowledged being to 'relax.' In the commentaries there is a great number of direct indications that the Udaff.com visitor is reading the *kreativ* at work, expecting from it something they call 'the positive.'[55] Judging by the abundance of similar commentaries, a considerable portion of the users access the site to

'energize' in the mornings in the office just before getting down to work. A *kreativ* is almost always short or comes in a series; defined by the platform's apparatus of exchange of requests and retrieval of results, it should be read immediately, on screen, online, and perhaps responded to in the form of a comment as well. Such rapid engagement helps neutralize the unpleasant collective and the working environment:

> Each morning djuring two manths alredy i start with svitching to
> udafcom.
> I gather all my helthy cynycism before the fucking hard day.
> After a half-an-hour syrvey it is so much easier to tell all the noisy
> motherfuckers to fuck off.
> And generally I get an uncomparable pleasure. Respect to you all![56]

The 'white-collar' theory presupposes that office workers, tired from their rigidly regulated labour, are 'reducing their stress levels' by consuming obscene cultural products, communicating within nonnormative collectives, and engaging in 'countercultural' creativity. Moreover, as such white-collar workers are largely a product of an overproduced Soviet (technical) intelligentsia, whose aspirations have been sharply bitten by the wild 1990s, the more bitter and cynical, and in turn, talented and inventive their response is.[57]

Isaiah Berlin mentions that it was customary to think that the intelligentsia was a specifically Russian cultural phenomenon.[58] The Russian intelligentsia, first and foremost, embodied spiritual values.[59] 'Intelligentsia is composed of those people who professionally care that humanity survives as a species.'[60] Boris Uspensky suggests the intelligentsia is a product of the Russian Orthodox parish tradition: The absence of celibacy gave rise to a situation whereby the priesthood became a heritable occupation. The elder son or the elder daughter's husband would inherit a parish whereas all the other progeny, poorly provided for but well educated, had no place within the church. This situation contributed to the formation of a new class of well-educated but cash-strapped people from church circles, which became the main source of the intelligentsia.[61] Because the role of the church in society has weakened since Peter the Great's reforms, its place has been filled by the intelligentsia:

> The intelligentsia, which can be viewed as a kind of cultural élite, cannot
> by its nature belong to the social élite: it can never be rich . . . can never be
> in power. . . . Just like the monks, the representatives of the intelligentsia
> refuse everything secular and concentrate on the spiritual (although the
> notions of the 'secular' and the 'spiritual' acquire the new content).[62]

Narodniks, Marxists, and scholars of liberal-religious orientation have all turned to the notion of the intelligentsia. During Soviet times it went

through some crucial changes. Marxist-Leninist theory defined the intelligentsia as a class layer existing between the two classes of workers and peasants; much effort was put into exterminating it, changing it, or shaping it. But the notion of its own mission remained unchangeable: The intelligentsia was to serve the people.

After the Russian Revolution of 1917 a considerable percentage of the educated people either left Russia or died in the course of the Russian Civil War and repressions. From the mid-1930s, Stalin's programme for the creation and education of the Soviet intelligentsia was put forward. Growth in the numbers of high-school students began. In particular, this growth impacted the engineering and technical professions. The second cycle of the shift to mass technical education began in the mid-1950s. The necessity for the advancement of the technical potential of the militarized economy demanded growth in the numbers of technical workers and scientists; between the 1950s and 1970s, the number of scientific and technical workers rapidly increased. By the end of the 1980s, the Soviet Union had formed an enormous body of scientific specialists (around 1.5 million people), more than 80% of whom worked in scientific research institutes, that is, they were asked to concentrate on applied science, not on tuition nor on the 'pure' university science of primary research.[63]

In the 1990s a part of this enormous 'overproduced' tribe of scientists emigrated and continued to work in the countries of Europe and North America; those left behind had to change their qualifications. The prestige of the intelligentsia rapidly dimished. Their place in the public consciousness became occupied by the new notions of 'elites.'

The theory of 'brutalized white-collars' explains Udaff.com literature as written within the cultural horizons of people with degrees who are aged thirty years and older, who spent their childhood in the former USSR and absorbed its system of vital and professional self-definition, a kind of existence which was later destroyed. Brought up to become the intelligentsia of the USSR, and because there is hardly a place for such a class in the new Russia, they 'mutated' into 'disillusioned,' unsatisfied Udaff.com members. Had the historical development taken another turn, this particular Udaff.com demographic would likely be working in the scientific research institutes, within which the 1.5 million scientific workers of the 1980s were gathered. Following this, it would be in the tradition of cultural studies to suggest that the frustration of Udaff.com users might originate from large-scale social dislocation and the collapse of the entire system of the production of the world, of the behavioral patterns and life trajectories of the USSR, and the emergence of a radically new ontology.

But if we put aside such overarching causal explanations (not that they lack interest, but because they do become lossy compressions in the recognition of social complexity and the recognition of aesthetic distinctiveness and materiality), we could look at the social figures of the intelligentsia and of Udaff.com users as being in a process of a certain social amplification.

Here the amplification is into bitterness and despair. The relationships that construct social figures are profoundly transformed; the phylogenesis of figures and networks that produce them is operated upon by a high level of radioactivity. There is a certain conceptual irritant, however, that replicates while mutating and disseminates into networks of production and the actors generated, a social figure to amplify. Amplifications unfold to embrace the black moon, the hysterical strain, and anguish.

The art platform Udaff.com is rooted in the making of culture; it becomes an organic unity reacting and triggering reactions in the life cycles of genres, styles, social movements, linguistic change as inevitably as more mainstream agents and institutions. The organizational aesthetics of the art platform makes the materialization of certain cultural movement possible; it works towards the amplification of autocreativity, of social and technical figures, of concepts and objects.

Udaff.com replays the literary stereotype to overthrow it; it endows language with the intensities to transform itself; by repeating the social repetitions, it creates a fabric of social disruption capable of taking a cliché to the level of an illness. At the lines and threads of which it is composed, Udaff. com repetition mobilizes the oppressive, repetitive, harsh, and deranged to move into an amplification of production, something that is aesthetically rich, radical, linguistically intensive, and socially ill, while at the same time not making it something inevitable, a routine of its own.

GAZIRA BABELI IS SECOND LIFE

Udaff.com is an art platform in its 'classical' form: It is a technoaesthetic entity that can be described as a unity from a variety of perspectives, whether they are aesthetic, technical, organizational, linguistic, or social. Its coherence, though, is not to be overestimated. Any art-platform's form sets off rhizomatic relations that are not only productive of it but which also lose it and create interruptions to avoid stabilized perspectives.

To look at how an art platform operates at a deliberately lower level of stability, let us examine a number of practices in Second Life. Second Life is certainly not an art platform per se, but it encompasses human-technical, event, interaction, and code-based ensembles whose ways of performance form networks, platforms, and occasions that can be viewed as an art platform.

Second Life does not need a lengthy introduction nowadays. It is a 3-D environment that is rather rarely called a gaming platform, as its main difference from similar or previous kinds of 'virtual worlds' lies in the abundance of possibilities of engagement it offers its users. Once its sets of preconditions are accepted, the environment of Second Life is architecturally, biologically, anatomically, culturally, ecologically, and geographically built by its residents. It has become commonplace to list things that take

place in Second Life, from live concerts to real-world bicycle prototyping, from sport to literature readings, from retail sales to games.[64] The ability to create objects and own such code-based creations in order to possess or distribute them, whether for Linden dollars convertible to cash or for free, is a foundation of SL's success. Literally, when people can do whatever they can do, they tend to stop 'griefing' behaviours (temporary disruption of simulator control) that have overpopulated other 'virtual worlds' such as The Sims Online.[65]

Cybersex retains the top position among activities carried out in virtual worlds similar to Second Life. Peter Ludlow reports that at times in The Sims Online, the most visited place would be a cyber-brothel; different kinds of erotic clubs populate Second Life, where many users of massively multiplayer online games migrate.[66] Ludlow explains that in The Sims Online the creation of objects and behaviours is restricted to the owners and producers of the environment, and this results in users exploring the limits and capacities of the game in order to make it produce unplanned behaviours. Here, cybersex might involve instant messaging while avatars are placed together in a bed (nothing much they could perform there) or made to walk towards each other in a narrow corridor, an action which results in them repeatedly bumping into each other.[67] Second Life with its expanded possibilities not only results in avatars carrying around built or bought penises that can be mounted on anything they'd like to have sex with, whether a tree or a block of flats,[68] but also in wilder and more complex imaginative constructions. Whereas a large part of cybersex is comparable to, or is part of, the sex industry and is often referred to in the same terms, that is, as prostitution and an income-generation feature of 'virtual worlds,'[69] there is certainly a part of sex-related explorations that are highly ironic, poetic, and literally open source.

Second Life orgy locations present a series of direct reenactment of science-fiction literary descriptions or film scenes, such as H. G. Wells's flowerlike mutated human sexual organs having vegetative intercourse; *The Lawnmower Man*'s high-tech, enhanced-brain sex; and rather unique opportunities to have sex with stone sphinxes, centaurs, unicorns (enriching a partner's inventory with a unicorn's foal), spiders, octopuses, bees, dragonflies, seaweed, and phallic tulips, Second Life hereby enables a more productive dynamic than the one Udaff.com demonstrates in its interest in sex. The rather radical performing objects of Second Life lead to the final discussion of this chapter, artist Gazira Babeli[70] and the art group Second Front.[71]

It is simultaneously easy and difficult to introduce Gazira Babeli. A creature of Second Life, she is one of the most exciting artists of recent years, a programmer, a performer, a disruptor, a comic, and a maniac. Second Life can seem gigantic for those who are in and irrelevant for those who are out, but Gazira explores the materiality of digital media in profound and radical ways to produce sets of objects, tests, performances, sculptures, and

behaviours that rework art and new media art to take it to other places, to extreme and new reflection, sensibility, and perceptivity.

As a commentary on cybersex, Gazira Babeli developed a plinth entitled *Come Together*, or what, when operated, she calls a group sculpture performance. The plinth is surrounded by balls, activating a range of animations that cause the avatars climbing on it to perform sets of dances and behaviours. The avatars involved are drawn into a shared centre of gravity, in a manner that allows them to traverse each other, generating the production of a multisurface merger, a formalist realization of this common trope of sex.

Here lies the power of her work: She deeply engages with the digital material, 'painting on a computer's graphics card,'[72] to transcend the boundaries of the environment. Whether she is hurling her body at a speed of 900 kilometers per hour (*Come to Heaven*) or scripting a 3-D model into a 2-D plane (*Avatar on Canvas*) to make avatars able to sit down at a chair in the middle of a Francis Bacon-like painting on the wall, which would disjoint them to produce a fully operative but rather abstract body, she explores the stuff of which her world is made to detach from it, to overthrow it by creating the possibility of a distance.

Her coding or hacking is not the end of her artworks, however. The code is performed, is lived, and makes sense as a part of action taken through it.

Figure 2.2 Avatar on Canvas. Gazira Babeli. March 2007.

Figure 2.2 Ursonate in Second Life—Monument to Kurt Schwitters. Gazira Babeli. March 2007

In her own words, she makes scripted narratives, performances or actions, sculptures and paintings (to be inhabited by others as well) as if she enables their production in ontologically similar ways to those of the real world.

When I invited Gazira Babeli to hold a workshop with my students (she offered her Second Life island, Locusolus, as a meeting point), I witnessed them getting stuck in avatar-sized Warholian Campbell soup cans that jumped as they tried to get out and from which they had to be teleported by their peers to escape. I saw them flying away with hurricanes if they spoke the forbidden phrase 'new media,' heading for the chair in the painting to find their avatars Guernica-style and getting squirted with ketchup by a school of pizzas singing 'O Sole Mio.' Gazira's griefing is overpoweringly exciting, whether she reenacts Bunuel's film, attacks spaces with self-replicating bananas and a rain of Super Marios, or builds the most beautiful modern digital sculpture (*Ursonate in Second Life—Monument to Kurt Schwitters*).

Gazira Babeli is a complex assemblage ordered by a few cardinal lines. As her art goes through processes of becoming, viewers are guided in its intensive production through the layers of life, art, or culture it digests in order to unfold. These manifold systems of referencing make it a rich experience, while at the same time her mode of operation produces something that is completely different, grounded in its own material exploration and a specific, very sharp and precise logic. Gazira explores a wide range of Second Life behaviours and real-life cultural contexts, fusing them together with the process of her artwork, a style that is located, craftily done, almost minimal.

Here, an art piece is both wild and reserved, acting on the participant in a straightforward sense of the word: disrupting the avatar, the expectations, sensibility, imagination, or knowledge. It has been said that Gazira is a glitch, a ghost in the machine, a supernatural being, one of Serres's parasites.[73] As a parasite, she does not only interrupt but produces the entire Second Life herself being a weather front as well as appearing as one digital object.

Gazira Babeli (together with numerous Gazbots) is a member of an 'avatar performance art group,' Second Front. Second Front is a network of avatars/artists, although it seems to be rather closed in terms of joining possibilities (unlike a multiple identity such as Luther Blisset that anyone might choose to inhabit).[74] Second Front's performances range from planned gatherings and wildness in front of unprepared audiences to reenactments (especially of works from the context of Fluxus, the Futurists, Situationists, and Dadaists) and to improvisation. They started off with disruptions of a Second Life stock market by pizza delivery (*Pizza SLut*) and *Last Supper* and are now regular guests of events with different degrees of association with art institutions.

There is a sense of the fragile accretion of an art platform in the relationships between Second Life, Gazira Babeli, Second Front, and their various structures of operation. Here, an art platform could not be identified as easily as in the case of Udaff.com; however, there are relationships formative to an art platform that are played out in the intersections of the fields of operation and ramifications of Second Life as a technical ensemble and sets of cultural plateaus; Gazira Babeli as a parasitic force, glitch, and a transduction into reflexivity and abstraction; and Second Front with its collective use of the first two, which extends and ends them, makes them real, and links the two in a way that compels them to open at another end.[75]

An art platform is a manifold of relationships that operate to amplify aesthetic emergence through coupling with technical, organizational, social becomings; and there are various degrees and kinds of resonance that may occur between these factors, allowing for the different forms into which art platforms may evolve. Second Life offers an ecology of servers, screens, cards, simulators, polygons, textures, scripts, behaviours, objects, constellations of labour, emotions, finances, bodies, speed, crashes, and

many other organic and inorganic life forms and abstractions to create a background against and through which autocreativity actualizes, undergoing aesthetic formation.

Gazira Babeli can be seen as a force of estrangement that at the same time, rather than operating by distanciation, gets very close—almost too close for the system to continue operation. Whether she acts as sets of sensibilities, abstractions, instructions or scripts to take, or an entity engaged in the production of the space for others, she is an element in the operation of an art platform that could be compared to a human-technical filter or administrator in more standard art platforms: She measures distance by going very far and touches on richness to move the horizon a bit further. Second Front acts as reinforcement, a collaborative attack on structures of normalization that make a platform for others to estrange themselves while adding conceptual and reflexive dimensionalities. An art platform that is the interplay of all these processes produces Second Life art.

The art platform that produces Second Life art is relational, and as such, it is not unusual.[76] Although it takes flexibility and imagination to account for the networks that constitute the production of such an art platform, what needs to be taken from such an analysis is the nonfixity as well as the precise materiality of art platforms and the organizational aesthetics generating them. Such materiality, which is technical and human, and the action of organizational aesthetics with and through it is something that leaves a challenge to be understood.

3 Organizational Aesthetics, Digital Folklore, and Software

Software art for you and me!
Software art for girls and boys!
Kremlin, vodka and software art
Sex, drugs and software art
Peace, love and software art
I love you all/software art
Software art for fun and profit
Got software art?
(Suggested slogans for Runme.org, from email exchange)

The processes by which something becomes art, especially if its actualization is not manifested merely in an individual project (although it is never that finite) but is instead a set of practices, an artistic current, a cultural movement, or an aesthetic storm, inevitably connect to the question of organization in one manner or another. Organization in this sense is the manner by which art reveals itself and speaks, a modality of formation that is collective and political. Agents of such organizational processes differ drastically, from museum operations, curatorship, soirées, and journal maintenance to garage and café gatherings. It was argued that the homage to the lunatic artist, unnoted while alive and celebrated postmortem, as the mode of operation of the dogmatic museum gave way to the mode of curatorship in the beginning of the twentieth century. It is then that an overthrowing of traditional organizational tendencies was first sensed through the 'accomplishments' of the avant-gardes whose bodies of work could themselves be seen as a 'series of collective gatherings and exhibitions.'[1] Such autopoietic ambitions were further unfolded in the course of twentieth-century art, though not univocally. However a cultural current produces and operates itself, there is an ontogenetic tendency involved that has an organizational dimension to it.

To address the complexity of organizational aesthetics here, it is worth recalling Latour's rather ironic account of sociology as a troubled field that, while trying to account for the macro, fails to embrace the micro, and vice versa. The whole Tarde-Durkheim debate introduced in the previous chapter refers to this problem: In an attempt to account for society as a structure providing a relatively stable framework for operation and reproduction, in the course of the development of the classical science of

at least the first half of the twentieth century, the search for 'general laws' won over microsociology and monadology. To look at it from a perspective rooted in antiquity, the problem of organization can be seen as one founded in the question of hylomorphism, a perspective that interprets the production of the world through the imposition of ideal forms onto matter. The metaphysics of organization then performs a similar operation, of making happen and making sense of/structuring instances of matter while being materially separate from them, if materialized at all, whereas the matter would not be preformed in any manner.

The theory of the artistic field developed by Pierre Bourdieu can be seen as an example of such an organizational model. His figure of the cultural field as a subfield of restricted production[2] is organized hierarchically, existing as a structured space with its own laws of functioning, independent of but reflecting the laws of economy and politics. It is formed of positions (established by defining the sets of problems, instruments, and references applicable to the field) and governed by relations (the relations among the positions occupied within the field and the relations among the 'position-takings'[3] in the area of works). Two directions of struggle define the structure and development of the field: the opposition between the subfield of restricted production and the subfield of large-scale production (economic capital, fighting to define the positions of art and artist) and the struggle within the field of restricted production (among the positions) between what that field constitutes as the consecrated avant-garde and the new avant-garde.[4] The latter struggle takes the form of questioning the essence of the genre and establishing a return to its origin, thus providing a history of purification as the narrative of the field.[5] Such manoeuvres coexist with relations that are agents in the field, relations in turn mediated by the structure of relations between institutions possessing authority.[6]

Such structures of relations and interrelations can be made palpable through certain historical colorations, and it is certainly possible that Bourdieusian analysis has its uses for vintage archives of cultural performances. *The Rules of Art*'s tidiness and pretence to completion is admirable as much as any 'universal' theory, which like most of this kind ultimately exhibits a tendency to become a conspiracy theory where forms are preset and imposed onto matter that exhibits no potentiality. The reality of cultural production is much less clean and prescribed and much more entangled with the advance of particular aesthetic material.

Organizational aesthetics is a concept conceived to address the emergence of art in a way that does not start with the end product and the structures within which it is embedded but instead unfolds through aesthetic production, through autocreativity to actualize culture. Here, there is no prior distinction between the project and the network, inside and outside, artist and organization. Moreover, it is increasingly difficult to withdraw a cultural phenomenon from its networks of subjectification; and it is through and with the relations that are reciprocally produced in such a

domain that the grey zones of art and culture emerge, seethe, and actualize particular artistic phenomena, forming and changing the very relations or networks through which they become done and undone.

Certainly, with organizational aesthetics it is more convenient to address contemporary cultural movements at times when organizational relations become core and what used to be the core becomes the outside. Whereas the ideal forms could not be infected, an operation of becoming that is inside and outside at the same time is more interesting as it is liminal, wide open, turbid, and prone to contamination with manifold parasites. A well-connected network of relations is vulnerable, but it is also these very parasites that produce it. In types of production that depend on creative self-expression, playing on the processes of organizational aesthetics has become a commonplace technique of the creative industries. And the same processes have led to large-scale grass-roots cultural production transductively energized to become new kinds of art, new lives of art, to unfold new kinds of organizational aesthetics.

Technological and cultural subjectification grow through each other. There is no organizational aesthetics without technology as one of its threads, mutated together with the autocreative. The philosophical project of the inclusion of technology into the ontogenesis of humanity at large is not new. Gilbert Simondon plays the role of grey eminence behind it, whereas Bernard Stiegler is possibly the single living philosopher who has most meticulously engaged with the history of Western philosophy, from Socrates and Plato to Kant, Husserl, and Heidegger, to prove and establish technics and technology (as a *pharmakon*, a form of memory, a force of individuation core to psychical and collective individuation of the humans) within continental metaphysics.[7] I will not take a philosophical approach to this matter but, instead, will let myself be guided by the empirical. The projects examined in this chapter, in particular the one dearest to me, Runme.org, are especially conceptually strong because they emerged in a time when hardly any discourse for such practices existed; through practical engagement with their organization and digital material, they became a way of thinking, of making a cultural reality unfold in sophisticated and relatively unconfined ways.

Quite often, the collective becoming of art is associated with curating. Curatorship produces art by displaying and writing about it and by putting art into relationships, spaces, organizations, and markets. As new media changes the constitution of these spheres and the energies feeding them as well as the networks of production of the works themselves, curatorship as a practice finds itself transformed and seeks new concepts to catch up with the phenomena unfolding at full speed.[8] 'Distributed curating,' 'immaterial curating,' and 'computer-aided curating' are all terms designed to tackle this change. To my mind, the problems of such terms and the theories they put forward originate from a move to account for the previously rather disregarded part that the technical plays in the subjectification of art, while

at the same time finding themselves locked in the narrow confines of a particular historically defined area of practice. With the development of digital media, the grammar of the reciprocal genesis of the technical and cultural changes, and such change spreads in domains and dimensions beyond the field of art. Indeed, the possibilities and articulations of the very constitutions that propagate into and change the fields of art, urban life, or economics are engendered through technology, as the technical constitutes itself at the root of the genesis of being and forms.

At the same time, the technical here should not be regarded in any deterministic or essentialist manner, and the growing sensibility of the role of the technical or 'automation,' for the sake of the argument, should not cloak its actualization with and through the human, the social, and the political.

Much of this chapter will look at an art practice dealing with the particular actualization of the technocultural: software art. Within the organizational aesthetics of the ecologies of artistic practices, networks, media objects, figures, and performances, software is assigned not only agency[9] but also an eventlike potential for transforming the movement of aesthetic, social, and political morphogenesis. Many of the regularities in such processes are linked to or associated with software. Such association may be direct, in the manner of particular capabilities of systems and programs, or in coded algorithms and control languages[10] and the functions derived from them, whether as interface, database, loop, or otherwise. These can be seen as new agents and concepts to be assigned roles in the production of power, value, and sensibility. To say this is both to say too much and too little. It is certainly possible to wrongly assign software the energy of a genetic code and to miss the subjectifications, new aesthetic powers, social models, and ways of living that are enforced and saturated by software.

Software is code and algorithm, vernacular language, something that is compiled and run. But it is also sets of relationships,[11] functions, usages, concepts, that are coded while still leaving us, by and large, indifferent to how in particular it is done. Such a statement might seem blasphemous, but a lot of code appears simply as ready-to-use objects. And a lot of software, when it is at work, leaps into domains, concepts, and problems that are as much reliant on software as on the functioning of other spheres, whether aesthetic, cognitive, or political.[12]

As Adrian Mackenzie puts it, within software-saturated domains, not everything results from code but everything 'boils down to code.'[13] Such code is not a training behaviour, a DNA. Code is formal, but it does not mean that any formally describable relationship is coded or is code itself. Rather, software can be seen as a possibility, a 'means of mutation'[14] whereby alteration can be worked at every level, including code—where code can be seen as a process that is buggy, undergoing a process of becoming, intertwined with other emergences.

Every art platform runs through software-based relations; many of them deal with cultural phenomena feeding on energies brought about or

managed by software. Collectivity, self-organization, and autocreativity in art platforms inevitably go through some form of actualization driven by software and are fattened by relations running through it, a combination of networks, choices, back ends, discussions, production and communication tools, but such dynamics also number among themselves a capacity for humour and the folkloristic, the vernacular as a precious ingredient. This chapter is built around the enquiry into the formation of the field of software art through Runme.org and on the analysis of the organizational relations interweaving technology, humour, and folklore, among other things, in art platforms. It concludes with tracing art-surfing clubs as some of the potential art platforms of the social Web.

Interface and structure, all the strata that make up an art platform: database, administration, an accept/reject email template (if used), titles, uses, relationships, dynamics, amplification of aesthetic endeavour, humour, mass-scale autocreativity, all come together in variable combinations as the regularities of organizational aesthetics, playing out in the unfolding of digital forms of art.

RUNME.ORG

Runme.org is a 'software art repository.'[15] Whatever this might seem to mean, Runme.org was not created as an archive but to test a format that would be something between an out-of-scale festival, a distributed salon, infinite exhibition, an open collection, sets of samizdat books, and sets of relationships—all in all, an art platform in the making.

What Runme.org became to software art is multilayered. It is an advocate and a club that engenders enough energy and irony to produce a dynamics for the field to unfold with in a way that would run perpendicularly to dominant, possibly redundant modes of structuring an art current; at the same time, it provides the field of software art with time and space for its unfolding to be frivolous, abundant, and relatively unconstrained.

Software art is a minor art field. It is built at the intersections of divergent practices, but it also struggles to gain its own coherency, a plane of operation that would suit and sustain its particular ecology. The production of such a plane for software art was in part carried out through Runme.org. It is with Runme.org that it became possible, largely through developing certain sensibilities and intensities, through openness and humour, to equip the movement with multivalent lenses or points of entry through which to draw links to varying strata, from programmers' folklore cultures to conceptual art to Google hacks, and while cutting across fields, to construct itself as another art movement.

Runme.org is built in a way that is similar to software download repositories.[16] One of the inspirations for Runme.org was Sweetcode.org, a repository for 'innovative free software' (launched in autumn 2001). The 'About'

section of Sweetcode.org read: 'Software reported on sweetcode should surprise you in some interesting way.' Sweetcode.org linked free software projects, many of which could be labeled as software art or at least could be referenced as unusual or absurd pieces of technology; it was down for a while and now functions as a 'normal' repository. Making such a conceptual link was important for Runme.org as it aimed to establish connections between artistic and software worlds and to extend software art beyond art.

Runme.org has a rather straightforward structure: categories with subcategories on the left side of the screen[17] and keywords in the form of a cloud on the right, similar to the more recently popularized 'folksonomy';[18] and a Web upload function, which allows any registered user to submit a project through a clear sequence of steps.[19] The platform is moderated: Submitted projects are queued and wait for the administrators' approval. Apart from filtering out spam and inappropriate projects, the Runme.org administration also filters out projects that would not fit its understanding of the current state of the field or material that is considered unexciting; there is a transmutative process of sieving and choosing, and the level of permeability or choice fluctuates depending on a wide variety of conditions.[20] What can seem a technically automated setup is in fact a loaded structure that

Figure 3.1 Runme.org.

is proactive while being hidden away. The most common mistake of theorists that have not made such things themselves is the metonymic action of extending a narrowly understood model of the technical over the horizon of all actualization. Often this is done to account for changes leading to more open forms of production at times when a more delicately nuanced account of the reciprocal constitution of the technical and organizational, the political, and humane is needed.

The last characteristic of Runme.org is 'featuring.' A group of theorists and practitioners in the field were invited yearly to feature what they individually saw as the best projects, building a library of texts about software art pieces that could participate, together with the *Text-software art related* category of entries to the site, in the construction of the self-referentiality of the movement. As Runme.org grew from a series of art festivals (discussed in the following), the use of features was initially sought as an overthrowing of the usual art-festival prize system by placing multiple projects and perspectives in the limelight,[21] but it quickly became a key venue of discussion and site for the conceptualization of software art.

Substituting the position of winners with the process of featuring commented on a situation in media art, a field that is itself beset by an over-reliance on this organizational form, wherein the best works can usually only be found in the 'honorary mention' categories or the like. To sketch a picture of the digital arts of the late 1990s, it is worth browsing through the honorable mentions of .Net category in the Ars Electronica festival to spot the most influential projects (taking into account the fact that some are still left out, often because artists find it unbearable to enter). The entries that won the festival's highest award, the Golden Nica, would most likely not be recalled by active participants or specialists in the field.

Runme.org's featured works appeared in the 'Featured' section and were included in festival catalogues. Many of the authors of featured works were invited to these festivals. Each year, the same Runme.org database would be used, with new projects uploaded after the previous edition, possibly alongside projects that had already gone through the selection process. For the first annual cycle forty-seven projects were selected and featured. Having forty-seven winners is a radical concept for a festival, but not surprising for a platform/repository, wherein 'featuring' becomes a form of organizational aesthetics.

Whereas the mechanism described above might seem quite simple, the organization of Runme.org interfered with and played out at the scene of art events and institutions as well at the plane of an art current emerging with force and significance. Projects and practices gathered to collectively form and participate in the differentiating movement, the amplification generated to enunciate software art. As an attractor, Runme.org caused transformative reactions, whether to hierarchical fields or to the region of related language, to thinking about an art practice, or of making art. Even solely used as a reference point, a place for flanêurs, a space to immerse,

to ramble around, it became a site of difference and brilliance, fun and excitement, leading somewhere else, disjointing something. People drawn by the contemporary politics of art or attracted to 'bizarre' or techno-savvy things found Runme.org a forceful catalyst and an environment with multiple entries that did not lock them down but tried to provide a collective language, the expression of certain kinds of beings and the politics of a cultural movement.

For the sake of context, the festival for art and digital culture, Transmediale, launched an 'artistic software' category in the year 2001, and software art became the hype among the media art communities. It can be maintained that software art grew from the net art movement, rooted back in the early and mid-1990s.[22] At least, projects such as alternative Web browsers started to be written back in 1997 (with *Web Stalker* by I/O/D, a thread continued by *Web Shredder* by Mark Napier in 1998, and *Netomat* by Maciej Wisniewski in 1999), and was often labeled with the new term 'software art' or, alternately, 'online software art,' as found in *Introduction to net.art (1994–1999)* by Natalie Bookchin and Alexei Shulgin.[23] Engagement with the code of Internet Web pages (HTML) and the material of the networks, characteristic of net art, included tackling the materiality of the software running or searching through Internet servers, personal computer applications, and its embeddedness in hardware, be they sound chips or suitcases. The practice asked questions about what software is and what it does in relation to objects, subjects, ways of doing and making, agency, sensibility, and culture. How does the aesthetics of code couple with the artistic, medical, managerial, or teaching culture gated through software? What are the concepts and forms of software that become dominating forces in the practices structured by software?

Software art is an aesthetic current, sets of objects, processes, concepts, and figures, that focus on software (that goes all the way down to hardware, layer after layer) as means of symbolic and material expression. Software expresses power dynamics, runs systems of profiling and segmentation, creates and circulates sensibilities, lures into specific kinds of sociotechnical interaction. It also includes technopolitical collapses, major challenges, and revolutions as its conceptual cores. In a way, sociopolitical and economic systems of today are all expressed in software. Such 'expression' is certainly two-way: It is through the expression in software that such systems and orders are not only run and changed but also created, imagined, and extended into potential futures. Software here not only has agency, but agency so powerful that, coupled with other human-technical ensembles and processes, is able to bypass numerous other interests in the construction of society.

Software art engages with such expressivity of software, as something that is or should be made open and available for entry, assembly, mutation, and thought. Whether critical, subjective, humorous, homemade, or businesslike, software art focus on the materiality of software as an open

potentiality. For software art, software is not only a reality to learn to live inside of, to break out of, to sink into to the extent of modelling its regularities and boundaries, to reassemble, to take pleasure in and destroy, but it is also an open concept loaded with currents across the fields and practices of mathematics, biology, finance, avant-garde, politics, secret services, birth, decay, and many others that are worth being questioned, mediated, organized, and reorganized with software as they are saturated with and, in turn, yield software. Here certainly, besides software, software art does not only deal with hardware, networks, languages, and algorithms but also with the histories and relationships of which software is a product, agent, and provocateur.

Artists started off the problematization of software,[24] but the 1990s could not be seen as the only breeding time for software art. Aesthetic engagement with or response to behaviourist, algorithmic, ideological, and mechanistic structurations of reality of the twentieth century can be exemplified by currents such as Dada, surrealism, and Fluxus; mail art and concept art. Florian Cramer and Saul Albert in particular have argued that Dadaism and conceptual art are important historical references for software art.[25] Jacob Lillemose reconceptualized certain strands of work in conceptual art as productive of information tools, means of challenging and changing 'information society'—something followed in its pathos by software art.[26] Because software can be defined as a set of formal instructions that can be executed by a computer, or simultaneously as 'code' and its 'execution,' a history of the precursors of software art, including permutational poetry and experiments with formal variations and execution of instructions, can be retrospectively built.[27] Inke Arns, Amy Alexander, Geoff Cox, Adrian Ward, and Alex McLean wrote very productively about performativity of code, speech-act theory, live programming, and generative code.[28]

But even taking software as coded algorithms, it cannot be perceived separately from its production and conceptualization within the domains of academia, hardware, politics, economics, the availability of source code, cultures of usage, humour, experiment, cracking, maintenance, and discarding. Hackers' aesthetic experiments with software date back to the 1950s, when the first high-level programming languages were created[29] and when the first mainframe computers were bought by a few large universities.[30] The first and subsequent generations of hackers, a circle of people for whom ontological experimentation with the boundaries of their own inventiveness, competence, and persistence was carried out through interaction with a computer, created one of the crucial modalities software art draws from. Hackers, in fact, are partly responsible for both the formal development of computer science and the software industry and for their exciting deviations and rhizomatic passages, such as free software, alternative games development, a culture of jokes and hoaxes, gimmicks, hidden features and poetic competitions in code, among other amazing things.

With an energetic charge similar to that of bastard philosophers and poet-criminals, hackers and geeks (further attended to in the chapter 4) build a social and political dimension of engineering and computer science drop-outs,[31] self-taught masters, and pacifist coders that fundamentally changes the domain of technology in its relation to politics, education, power, art, and humour.

The idea of the open database that later turned into Runme.org was conceived in Moscow, in late May 2002, the day after Readme, the first software art festival, was held. The first, and at the time the only software art festival had just taken place. It was a disputed art practice, and even descriptions of what the festival was looking for sounded unsure back in 2001.[32] An institutional software art 'boom' was about to happen.[33]

For the first Readme festival, an open database with all submissions was created and stayed online but was closed to further contributions after the submission deadline. It was clear that a new database needed to be opened for the second Readme (held in Helsinki, 2003). When Runme.org was in the making, it was supposed to serve as the festival submission platform.

As mentioned above, Runme.org was conceived of as a mockery of a traditional festival submission system. All the entries were to be stored in an open database and could be viewed at any point. Nonartists and especially programmers could be lured more easily into uploading their pieces to a software-database-like website. On top of that, it would have too many categories and 'winners' to make orderly sense of them all. Such joking conceptualization did not mean to foreclose the long-term independent development of Runme.org. Although being partly funded through the link to the Readme events,[34] Runme.org quickly outgrew the festival in prominence and, establishing itself as an activity in its own right, allowed people to form personal, unmediated relations to and through it.

'Software art' as a term signifying certain practices was still at the stage of becoming familiar back in 2002, and inheriting from net art traditions, exhibited a high degree of sensitivity towards institutional forms of organization.[35] Given this, it was duly suspected by some to exhaust a cultural current by postproducing a few names and projects.[36] Runme.org aimed to think about software art and take part in its emergence while trying to preserve the irregularities and chaos of the area: all in all, while making art, to go beyond the known confines of art. It was decided that Runme.org should start off with a large number of 'categories' that would be diverse, contradictory, and funny to work as creeping roots that would let the plant grow stronger. For instance, on the 22 October 2002, Florian Cramer writes: 'I strongly favor the creation of categories in the first place because they make people more aware of the full range of entries that is possible. (Too many artists simply misunderstand «software art» as synonymous of either «[audiovisual] software tools for artists» or «algorithmic data visualization»).'

On 23 October 2002, Amy Alexander replies to Florian Cramer: 'it's a tricky issue. as we saw . . . people are understanding software art to mean

more than that now, but new clichés are arising. so i think somehow we should use the categories to encourage a wide range of work, rather than to encourage—or whine about—new clichés . . . the field seems to be in a very delicate state at this moment . . . our curation system should help get more entries, but that's really just a crutch; things need to flourish on their own. especially if we hope for more involvement from the non-art software community, i think we should put forth a really positive image, and not an overly-critical or artworldish one.'[37]

The initial intention of creating an overlapping, inexact, funny, and inspiring taxonomy can be traced through the current categories, which cover a wide range of approaches from projects that create critical allowances for modes of writing and textual cultures that are constructed and maintained through word-processing software in the *text manipulation* category to that of browser art that critically engages with the genre of browser software as a mechanism that constrains and limits the network to windows that appear in a browser window. Alternative browsers explore the meaning of network connections, datasets sourced and held, and introduce 'perspectivalism' in relation to the Internet. Art *games* create game worlds of symbolic, expressive, and political order radically different from those in domination, inheriting from hacker and artisanship scenes, whereas the projects of *system dysfunctionality* and *digital aesthetics r&d* often deal with the aesthetics of error as a genuine computer aesthetics[38] (and as a core function of the computer, to error) and with low-tech, based on the creative use of limiting, obsolete, free, or low-cost algorithms and hardware. Such projects poke at the boundaries of digital material to force it to exhibit its structures, processes, languages, and metaphors that are often obscured by desires to normalize, imitate, update, make 'seductive,' or make digital technology disappear. *Hardware transformation* projects (initially *hardware deformation* projects) either produce damage or a demand for redesign; and *bots and agents* projects list pieces of software that, like normal bots, crawl the Web to gather information or perform other tasks but, unlike them, harness discarded data, reveal hidden links and link clusters, and take on imaginative roles. *Artistic tool* projects work towards providing new software models for expression, production, and collaboration; they are sometimes made in spite of mainstream interface models, drawing on the heritage of early hobbyist software. *Data transformation* projects add to it by creating tools and aesthetic patterns that work for and by transforming the data they handle, i.e., rendering an audial image a visual one, merging words with images, and revealing connections among algorithms, databases, search engines, and so on. *Generative art, algorithmic appreciation* and *code art* projects (with the sarcastic category *bouncing balls* as a certain kind of interactive art ultimately left out) work with the 'beauty' of code and aesthetics of its execution (*Classicist Vomit* was one of the proposed names for it), sometimes inheriting ideas and practice from the traditions of programmers' folklore.

Some categories overtly question or invite sabotage of the political, social, or economic orders as inscribed through dominating families of software: *political and activist software* lists useful activist software and projects that undermine some of the operations of global capitalist society and neoliberal ideology, particularly as they are embodied in software; *existing software manipulations* projects present clever hacks or misuse of software; and *social software* works towards providing environments for social interactions, often nonnormatively framed, or more widely assays the development of software as a social praxis.

Runme.org's taxonomy is not a 'proper' classification. In the initial taxonomy, as well as in its subsequent revisions, phenomena of different levels neighbour each other. Here, the rhetoric of works or their formal methods were put side by side to comments on systems of curatorship (*text about software art* and *game deconstruction*, *crack/patch* and *best festival jury*); self-reference and irony (*competition for suggesting categories*), reflection on the features of repositories and their use and abuse (*manipulating voting*), aesthetic charge (*software as culture*), software characteristics (*hard to use software*), sensibilities (*minimal code, beautiful crash of the system*), software type/genre (*demo category, viruses, best artistic re-packaging of existing tools*), art history perspective (*Jodi plagiarism*) were all intermixed.

The open-armed and chaotic embrace of software-related art practices seen in the categories was held as a strategy of collective declaration that was foundational to the movement. On the other hand, a politically understood becoming of the field constituted areas of quite different intensities within it. 'Categories' were included or omitted, carefully named, filled in with projects (that administrators often searched for and uploaded themselves) or left to themselves depending on their power and function towards the emergence of software art.[39] For instance, the category *demo scene*[40] was not included as engagement with such a well-established and large sphere was considered to invite a distorting potential in regards to aesthetic engagement with software. *Flash category* was also omitted because although it allows 'programming' with Lingo, Javascript or ActionScript, the plague of Flash-based 'worms' (shapeless, oblong, or round little things that move, rotate, and jump) featuring some basic interactivity that populated various media festivals were not particularly inspiring.[41] Amy Alexander wrote the following about Flash-based software artwork (14 October 2002): 'I wouldn't personally want to make a generalization about Flash itself. I don't mind Flash, but rather I mind the similarity of most (not all) Flash projects—and that they mostly aren't too convincing as software. Of course that part is no problem when they don't present themselves as software, but I'm talking about when they don't go beyond the conventional Flash conventions, and then they say, "this is software."'

Some of the more ironic categories were not included either, for instance, Pit Schultz's *emulated modernism* (software art that generates countless

copies of Mondrian, Kandinsky, Malevich), *pixel paint* (every piece of software art that uses the visual quality of pixels as the main trick to impress its viewers), and *pixel soup* (the impressionistic/animated version of pixel paint). The proposed categories, such as *trivial software, obsessive software, best software poseur, best physiological reaction*, and even *the algorithm is the message*, were also left out.

To give a taste of the humour of Runme.org's foundational rhetoric, I will provide a few more examples:

01 November 2002, Matthew Fuller proposes:

- Arms Race (software that outpaces military developments, from a civilian source)
- Best Grant Hoover (Software that gains X amount of funding by simple use of keywords, i.e., 'software', 'interaction', spurious art terms whilst maxing the yawn-rate)

02 November 2002, Pit Schultz offers:

- artistic vapourware (dusting away in the cupboards)
- modem art (according to what i remember every digital art using only very low bandwidth)
- dead data (unreadeable code, code made unreadeable, code too uninteresting to read, destroyed digital art)
- weibelism pr pranks (software art which wouldn't be possible without the press and extensive marketing efforts)
- e~flux (a version of pr pranks almost entirely based on email promotion)

From 10 October 2002 to 18 December 2002, Amy Alexander suggests:

- most pompous artist's statement; i.e., artist's statements that talk up a storm of artspeak none of which is realized in the project.'
- software cemetery / left for dead: abandonware, abandonware repositories (with subcategories such as)
 > the undead: software that's dead, but doesn't rest in peace. i.e., people still use it as though it were alive—e.g., wordstar
 > the grateful dead: if only this software were as beloved in life as it is in death . . . this can include retro-nostalgia/"dead media" type stuff that nobody paid attention to when it was alive but now it's a cult classic.
 > born again: software that died but came back as a religion. this subcategory will i'm sure be won by unix::linux, i mean unix::gnu/linux but runners up will include ascii art.

The *Jodi* category was included in the list during the first offline discussion as a category for art created by the famous artistic duo Jodi, whereas '*Jodi plagiarism*' signified works following the aesthetic/formalist path established by Jodi's work. The category that later became digital aesthetics was first sketched as a joke, a commentary on the type of the new-media sensibility the couple almost single-handedly developed in digital art.[42] It was rather seriously discussed, however, as Jodi's aesthetics had become so internalized that it seemed worth differentiating and emphasizing the significance of sensibilities, produced by them, for the software art movement.[43]

The taxonomy was conceived as open to a degree and determined to be constantly changing in accordance with the works submitted or the amount of works collected. Every user could suggest a subcategory while uploading her piece, and the suggestion then waited for approval from the moderators. There was no such option for the categories, but a category could be suggested by emailing the administrators. For instance, in 2003, *Whitespace* (a programming language working only with space) gained a new artistic subcategory, *programming language*, solely for itself, within the *code art* category. An ironic category, *artistic tool—useless* (referring to the affordances of technological age such as reuse and remix of abundant visual material) was turned into the more affirmative *data collage*.

This relative modularity of Runme.org was supported by the policy of the submission of found objects. A large number of projects that maintained the irregularities in the movement of software art were found and uploaded by the platform's administrators, invited artists/writers and other people with an interest in the field. The category of *digital folklore* (discussed in the following) was largely filled by such 'objet trouvé' submissions, whereas in spite of the high numbers of projects listed under the *generative art* title, the team members in that category hardly ever submitted a project.

The previous discussion demonstrates the dynamics of technically mediated influences on software art brought about by the larger Runme.org team. Beyond administrators, the larger team, and invited 'experts,' the art platform's crew included the entire group of artists and nonartists that made Runme.org the way it is. An art platform cannot create a cultural movement single-handedly, and although its role might be rather formative in the dynamics of such a becoming, it does, in a way, always come later in the unfolding of autocreativity, in the actualization of an aesthetic practice.

The organizational aesthetics of Runme.org proceeded through very intricate reciprocal formulations of software art and the energies feeding it and the organization of the art platform. Neither would be the same without the other one. The collective and political enunciation of software art was partly carried through this art platform, but such a process also formed it. Here, the amplification of aesthetic intensity took place in the network of relations between the movement and the art platform. The devices of the art platform's operation in such an amplificatory dynamic are technically embedded gestures and thoughts (categories, uploading, filtering,

featuring). Through the linkage to the Readme festivals, but also with work, love, excitement, Runme.org charged the atmosphere to form a wind favourable to the minor practice of software art. Cutting across a variety of spheres and functioning between them, Runme.org could work towards some kind of amplification of autocreativity while avoiding the trap of centralization. Runme.org was very significant but remained minor.

The term 'minor art' is drawn from *Kafka, Toward a Minor Literature* by Deleuze and Guattari. They speak of Kafka, writing in German for the Jews of Prague during the period of the Austro-Hungarian empire, in terms of his belonging to a 'linguistic Third World zone,' and I wonder what it means for today's state of the world. What are the deterritorialized languages of today that hybrid minorities, professional gypsies, and amateur nomads are speaking online, in dialects accented by technology? What becomes their expression, their empowerment, their castle? Given the background established by Kafka and the range of political urgencies, pain, and radical multiplicity of networked minor fields of expression, my proposition is to look into folklore and its humour.

DIGITAL FOLKLORE

The term 'folklore' belongs to the time period of a Hegelian becoming of nation-states. The first rounds of attention to folklore were significantly politically informed and served the development of strong national identities.[44] Moreover, the term 'folklore' can be seen as inscribed into the hierarchical and essentialist paradigms of framing cultural practices and processes as they are measured against a grid of counterpositions, such as art versus nonart, professional versus amateur or artisan, precious versus waste, oral culture versus written/visual/print culture, individual versus collective. As such, 'folklore' has played its specific roles in the performance of power on the political scenes, and in the cultural and artistic arenas of the nineteenth and twentieth century.

For instance, in the 1930s, while abandoning the early Soviet studies of folklore, including the classic formalist works of Vladimir Propp, folklore became heavily politicized as a part of the ongoing processes of 'Russification' and was identified with poetry and literature located in the past.[45] It is not only in the Soviet academy, however, that the field of folklore was conceived as exotic due to its origin, age, and aesthetics. Folklore was distinguished as an ethnographic object, as a culture of the Others that expressed the fundamental ideas of the origin of the world and other archetypal myths; and the most 'valued' folklore rested entirely in the nonliterate oral past or was sited exotically overseas. Contemporary studies of folklore regard their subject as an always-present part of human culture, be it a lifecycle ritual, a dance or game, a story or image. In this context, 'folklore' refers to the creative life of groups and individuals based on tradition and

oriented by such groups as an adequate expression of their cultural or social self-consciousness.[46] It is collective, anonymous, and politically informed to maintain the integrity and consistency of cultures. Such folklore is no longer exclusively traditional or verbal, but is still essentialist enough to be located and defended as 'intangible cultural heritage.'[47]

Folklore is a very loaded term, but its history helps us understand digital folklore and the ways of becoming and making that are mundane, repetitive, and scattered across various digital routines, while at the same time producing the energy that drives much of software art and digital culture. Digital folklore must not search for an authenticity of different sorts, but instead must be made available for conceptual operations that endow it with a means of enunciation of certain sensibilities. Such folklore is naturally 'born digital' and curious about the world in which it lives. Digital folklore is not simply transmitted through or displayed within the digital media and networks, does not merely make use of digital technologies, but is a part of a deep engagement with the materiality of the digital.

Digital folklore exists in relation to groups of programmers, designers, informed users, and others worldwide, and it cuts across the scales of age or kinds of training and production or, indeed, the varieties of technical systems. Such folklore is connected to human-technical relations established while working, taking leisure, communicating, learning, and breaking through, among other things on the human side; and on the technical side, while glitching, running, performing, producing, and breaking down. The kinds of junctures between the two and the relationships they form trigger

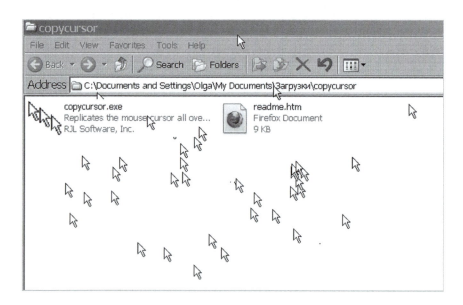

Figure 3.2 copycursor, by RJL Software.

and embed digital folklore. This is something rooted in the everyday, in the sociality of certain professions, hobbies, passions; in the rise of some new figures in culture; in the modes of production and existence as they tangle with peoples' ways of coping with or enjoying them. The emotions of users in relation to available computer operations—for instance, frustration at the 'blue screen of death' (the error screen displayed upon encountering a problem that makes the operating system 'crash') or fear of loosing data during disk formatting—or in relation to clunky or seamless interface or interaction design, the idea of animated mischievous machines, and the charisma and omnipotence of hackers are all addressed by digital folklore.

Folklore is supposed to remain in the sphere of certain traditions, within 'digital orality,' and is based on 'informal' means of production, dissemination, and usage. It is expected to be 'ritualized' in one or another manner: It exhibits specific connections to repeated actions and cycles of work with or of computers without necessary directly reflecting on those.[48] Resonant of folklore, digital folklore is organically embedded in the life with computers. Traditional genres of digital folklore might include creating pranks for colleagues, tricks for inexperienced users, or including ironic commentaries or hidden features in lines of code, which is in a way coordinated with

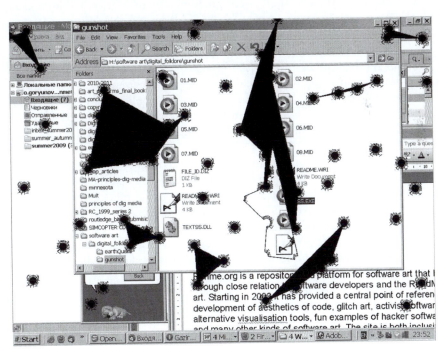

Figure 3.3 Gunshot, by DOKA Company, Dmitry Korolkov, Eric Alekseev, and Alexander Kochetov, 1994.

repeated situations vis-à-vis the computer. Here, repetition is encountered again, to be amplified into something else via humour.

As with classical folklore, digital folklore also reworks elements that are to an extent typical. Thus, one of its features can be its variability: repetition and change of figures, devices, genres, poetic languages, functions, etc. The forms of organization of folklore include relatively stable genres as well as flexible forms and one-off projects. Pit Schultz, for instance, listed the following genres of digital folklore: 'There is the field of gimmicks, nerdy tricks and playing with the given formulas, the eyes which follow the mouse pointer. . . . there is the useless software production, insider gags, Easter eggs, hidden features based on mathematical jokes, the Escher-trompe-l'oeil effects of playing with perception.'[49] The list could be expanded: there are musical hacks of the system, making the floppy drive sing songs or orchestrating motherboard beeps and fan sounds. Various ASCII art traditions can also be referred to as aspects of digital folklore.

Such folklore is exemplified by anonymous software ephemera, such as viruslike minor prank programs of the 1990s, which would flip the desktop upside down, shake icons, change interface colours, let all desktop folders drop down, and fill the screen with dozens of pop-up windows. Fake viruses would display warnings about the system preparing to format the hard drive and block the keyboard (these were predominant in Norton Commander times). With such little programs, one was able to gun the desktop or start a snow flurry on it (a little animation with snow falling down the desktop and piling up at the edges of open windows and the bottom of the screen). Many of these aesthetics are presently incorporated into large commercial successes. It is now easy to flip the desktop upside down with CTRL+ALT+↑ key combination in Windows Vista, for instance; application windows that elegantly slip away is a common feature of operating systems since Mac OSX; and most humourous animation-based interactions have made their way into iPhone apps and new paradigms of software design in terms of 'funware.' Today's digital folklore moves towards performances on YouTube.com and the exchange of links through Twitter.com; however, such evolution does not make digital folklore less interesting or telling. Digital folklore can result in an abundance of waste material, in a test or experimental work, in art, in mainstream software or, indeed, in the hackers' 'canon' of pranks and cool things. It is through the engagement with such practices that some core qualities of digital material performances and the vectors along which they pull software-based social life can be understood.

Digital folklore is a way of living with and making sense of technology, whereby such a sense is affective, habitual, digitally crafty, and funny. When digital material is habitable and populated, it is through its problematization as a playful exploration that it unfolds and multiplies to employ tempos and methodologies of various kinds of doing, enabling it to differentiate and spring across to other domains, which may in turn become art, design, education, organization, and idling.

Making use of various forms and languages of material, be they executable or other files, lines of code, instructions, emails, network protocols, browser windows, or desktops, creates a body of practice and a way of producing it that is exciting (sometimes really idiotic) and largely invisible (or neglected). The current of digital folklore in software, being a wide layer of cultural unfolding below the radar of art, inspires many artistic practices and informs research into digital objects. Software art in particular drew its lifeblood from programmers' and other users' cultures, and channeling such energies was an important part of the organizational aesthetics of Runme.org.

A special Runme.org category, *digital folk and artisanship*, was created early on and hosted a number of projects that Runme.org's team fished for in the debris of networks. A rather 'impolite' policy of linking to or uploading 'found objects,' whose authors would probably never consider including them in an 'arty' resource, established a certain manner of thinking that made such practices operable at different levels of visibility. Being inspired by them correlated with the widening of conceptual and technical operations of inclusion, learning, and transduction. Runme.org's attention to digital folklore made way for the rethinking of art and set out modes by which software art could balance the challenging dynamics of widening art's boundaries while also establishing an art field.

Runme.org has featured a few projects within the folklore category. *WinGluk Builder* by an anonymous author, for instance, is a collection of pseudoviruses and a tool for building them, an objet trouvé that was awarded an honorary mention at the Readme 2002 festival.[50] The project is representative of the cracker culture of 'revenge software' that produces the impression that the computer is affected by a virus. Running the program would crumble the icons or make the screen blink in every colour it can produce. But as an ironic metacommentary on the all-powerful cracker culture, *WinGluk Builder* is also a program for custom making such 'viruses' for users' own disposal via specifying, through a menu, the effects one wants to produce and simply pressing the 'generate' button. The project also makes fun of the Windows-like standard application interface that, coupled with a mockery of functionality, makes aesthetic interventions into software design and functionality from niches buried deep in the 'dark' Web.

Tempest for Eliza by Erik Thiele is a hacker's canonical digital folklore work that was found through 'browsing' and linked on Runme.org.[51] ('Browsing' is a now-forgotten and largely impossible activity because the reign of the Google page-rank algorithm and personalization hinders such flanêuring from stumbling across obscure and non-popular sites. It has been entirely replaced by surf clubs and reposting of links, as discussed in the following). *Tempest for Eliza* is a classic, brilliant 'joke' that is dazzling when taken as a nonart piece of experimentation. The project explores the physical qualities of computer systems: Electronic devices emit electromagnetic waves, which can be caught in order for the original data to be

reconstructed. *Tempest for Eliza* demonstrates this in a very precise manner: The software displays black and white stripes on the computer monitor ('one for each note in the song'), whose particular combination and rate of change generate kinds of signals sufficient to constitute some well-known pieces of music, which is played by shortwave AM radio. Not only does the project playfully undermine conventionalities of what constitutes information, where information is to be located, and the conditionality of usability, it is also a hands-on demonstration of the ways in which TEMPEST is possible. Telecommunications Electronics Material Protected from Emanating Spurious Transmissions (TEMPEST) is a secret service code word coined in the late 1960s/early 1970s for the use of and defence against 'compromising emissions.' As a way of putting myth to work, *Tempest for Eliza* did more for the aesthetics of digital materiality than for security. Redefining, by making visible, the complexity of the ecology computers produce and are part of, this project that is made for fun, represents an intensive aesthetic endeavour occurring outside of art.

Bringing such nonartistic aesthetic forms of life to Runme.org and the context of software art is a specific strand of work within its organizational aesthetics, in terms of its conceptually, politically, and technically nuanced unfolding. It is by the power of such leaping propelled by the organizational mannerisms of Runme.org that certain flavours of software art could be intensified.

ART-SURFING CLUBS

Digital folklore drives more than software or software art. Similar modalities of practice are inscribed into the passage of autocreativity and into the actualization of the technical. With the boom of Web 2.0, through participatory platforms and networks of devices that enable kinds of circulation of immediate creative, folk, and funny statements and cultural responses, the human-technical grammars protocolling how autocreativity arises, what the meanings and values of digital folklore are, and how aesthetic brilliance can come about stand out as requiring reconceptualization. This exploration guided the previous chapters through the concepts of autocreativity, self-organization, aesthetic brilliance, amplification, repetition, and organizational aesthetics. And because at this point only a small vocabulary has been developed to tackle both the massive range of cultural production on the Net and the new modes of the formation of art currents, I would like to look into some rather recent movements that explore such questions empirically.

Such currents are sets of websites that, to continue the unfolding of art platforms 'propaganda', are fragmentary or molecular: art platforms reassembled to deal better with particular kinds of aesthetic production. Compared to Udaff.com or Runme.org, they would appear only to employ

fragments of such art platforms' organizational aesthetics while augment-ing them to include new kinds of self-developed human-technical mech-anisms that allow the profound destabilization of aesthetic obesity. The relationships that constitute an art platform may be partly present here, while the scales, ratios and vectors of autocreative emergence shift. It is in the ethos of my argument to imagine art platforms as something uncapped, unrestricted to specific arrangements of human-technical ensembles for the conditions of their aesthetic becoming. The kinds of relational art platform found between Second Life, Gazira Babeli, and Second Front is joined here by a flanêuring and methodological kind of art platform, artistic-surfing clubs.[52] The kinds of aesthetic force that surfing clubs amplify can partly be addressed through a certain 'digital media idiocy.'[53] Such idiocy car-ries traces of Dostoevsky's holy foolishness, manifesting a specific aesthetic that, although highly limited across a terrain of sensibilities if not purpose-fully simplified, is able to cook up a kind of performance absent from exist-ing enunciations. Idiocy here is not meant in a derogatory manner; rather, it is about looking for what the Web and digital reality is technically and culturally made of in these days after the coup of Google, Apple, and Face-book, and being able to appreciate its manifestations or discoveries.

A surf club, or a 'pro surfer' club, according to terminology originating around the website NastyNets.com[54] usually refers to a group of people who post objects found in the paraphernalia of the Internet onto a website, often organized as a blog. Such found objects could be something from YouTube.com or other kinds of video, captures of online performances, software operations, digital objects, images, advertisements, Flash files, pieces of html or other code, or 'digital junk.'[55] Art surfers can reposi-tion the objects by equipping them with a title or commentary. Marisa Olson reports that two members of NastyNets.com developed *Pic-See*, a Web-based tool that 'makes it easier for internet users to plunder images archived in open directories.'[56] Plundering, a device in their organizational aesthetics, here means that the 'original' location is referenced while the object is positioned within a different set of contexts, sometimes to enhance its aesthetic valence.

Artist surfers claim to undergo a certain fetishization of surfing, an ecstasy in front of an infinite data pool and a human massivity to add to the scent of artist groups blogs.[57] One (at least I) cannot help but sense a certain chemi-cal enhancement in the 'rambling sessions of Web browsing'[58] founding such projects, and consequently envy their youth, perhaps providing them with the time and intensity to pursue such exploration. This kind, rate, and habit of work is certainly all about economies of attention and production, but it is important not to lose sight of other charges guiding such work.

How is an art-surfing club different from a buzzy exchange of links via email or Twitter or collected on an individual blog? In fact, it is not very different, and that is precisely the source of its force. Found objects and projects made of or with them form the basis of the art-surfing club, which

together with its members, explores the material and the aesthetics of the digital. What they work on is a profound engagement with the creative unfolding of digital culture as it occurs in all its gory detail. Pro surfers wade through the muddiness of mass-scale autocreativity, through folklore that may be stereotypical, funny, bad, exciting, and stupid, and what they produce through their selections tells one more about digital culture and art in their processual self-assembly than any dismissive top-down or overly optimistic explorations possibly can.

Early net art threw itself into browsing, repositioning found objects within an art context with projects, such as *Bla-Bla Sites* and *XXX* by Alexei Shulgin (1996).[59] Much of its philosophy comes from a respectful appreciation of others' creativity, especially that of nonartists or 'bad artists,' and also a respectful appreciation towards automatism. Whether the former would suggest that there are too few ideas for too many brains so that duplication is necessary, the latter would indicate that if a monkey spends a hundred years with a typewriter randomly pressing its buttons, it would have eventually typed out *War and Peace*. The net art kind browsing went through a period of decline to be reborn again with the massive creativity of Web 2.0.

NastyNets.com, NetmaresNetdreams.net, Supercentral.org, Loshadka. org, SpiritSurfers.net, and Double Happiness, among others,[60] in their fishing for digital folklore and nonprofessional and professional art alike, intensify certain qualities of the organizational aesthetics of art platforms while dropping some others. Thus, a methodology and kinds of attentiveness to the qualities and relationships through which digital material come about may allow for a nuanced formulation of the changing constitution of digital aesthetics. Art platforms can be cross-platform or technically almost nonexistent, they can be seen as close to online curating or nonart and as essentially idiotic, but their operation thrives on a digitally nuanced aesthetic exploration and amplification of what is happening, through means of repositioning, referentiality, intensification, promotion, sociality, and humour.

4 Geeky Publics, Amateurs, and the Potency of Art

Then there is the power user scene, rather born in teenage-suburbia than the universities and war-science-labs . . . their standards mostly the musical ones, modules, is still a model for 'open source' music production, folkloristic indeed, based on chart hits but distinctively different from what electronic dance floor music became. They are made in and for the bedroom.

(Pit Schultz, 'Computer Age is Coming into Age')[1]

Cool cool cool

(low-tech music by high-tech people)[2]

[espestro:] diagnostic: waiting for myself!
[work:] work please!!!
[captaincash:] antisocial intolerantropology
[gwem:] look at the idle time—it can give you important info
[sinusjog:] we want [erzatz] we don't want the authentic originalz
[pippilina:] sad songs are nature's onions
[demoneyes:] hey baby can I ring your modulator???
[neutralino:] I'd rather have a bottle in front of me than a frontal lobotomy.
[marieke:] ladies, dudes without humor are a big waste of your time!
(Jan-14–2004)

(Microtalk at Micromusic.net)

Art platforms assemble objects, networks, technologies, and desires to work in culture and make art. Such assemblies perform as coherent entities, but their performance is also logged in other ensembles and processes, be it production or subjectification that they are an integral part of. Although art platforms operate at a certain level of autonomy, establishing and performing according to their own laws, they do comply with, challenge, and change larger machinic groupings. In fact, in a certain way they are part of the operative processes of such larger machines, and their potential for rearranging relations between different flows while making up a perceptive, a human, a societal, a political component rests in such native acquaintance. Such a claim draws on a Guattarian concept of aesthetics and microrevolutions as well as on the experiences of projects and practices already attended to and on those to be explored in this chapter.

It seems that the political power akin to the one an art platform may accumulate from or with which it can charge its productive constituents has

been previously thought through a few disciplinarily unrelated concepts, mainly those of community, publics, institutional critique, and through a slightly different angle, free software. The main issue to understand here is where the kinds of political force appear, in which ways it is aesthetic, and which arrangements can bring its manifestations about. A few arguments to consider: first, the political power of the publics organized temporarily around objects (Latour and Marres); second, the political potential of art depending on the inclusion of its own networks of production into its expression or antagonistic commentary on such networks (institutional critique and collaborative practices in art); and third, an understanding of publics as an entity constructed through technological networks and collectively taking care of the networks through which it comes into being (Kelty). The issues that these touch upon in relation to art platforms bind together the aesthetic, technical, and political and help to understand art platforms not only in their internal dynamics but as operative assemblages across larger domains. The previous chapters have not necessarily been disengaged from this, but such concepts, methods, and perspectives may help gain kinds of understanding that have remained concealed under previous investigations.

In certain strands of philosophy, 'community' in a traditional sense has more of an ontological flavour to it, whereas the terms 'people' and 'public' play central roles in thinking the political. A few well-known and contemporary thinkers on community have been drawn into discussions concerned with contemporary and media art practices to provide tools for understanding collaboration, resistance, participation, and critique as art forms, methods, and politics. Giorgio Agamben and Jean-Luc Nancy are probably the most widely cited among these. Community, in their accounts, is as much about being many rather than becoming one as the multitude, a concept propelled by different sets of interests. Virno claims that the term 'multitude' developed by Spinoza lost out to the conceptualization of 'people' by Hobbes exactly in terms of the latter's usefulness for the constitution of state sovereignty and protection.[3] However, multitude comes to replace 'people' when distinctions between private and public, individual and collective, production and communication fade out. In this context, multitude is a way of being, and of being political, as well as a means of what Virno calls 'metaphysical individuation.' His figuration of the multitude does not become a political community or public, but it exhibits features of new kinds of sociopolitical formation that have come to replace those.

At times emotionally charged with opposing drives, the coming community of Agamben; the inoperative community of Nancy; and the multitude of Virno, Negri, Hardt, and Terranova share certain commonalities. The concept of 'inessential community' 'that does not unite in essence, but scatters in existence,'[4] highlights the dissolution of ideas of shared identity or common state space as the basis of the formation of community. A plurality, the communication of singularities untied together is, for Agamben, characteristic of the 'coming community.'

The dissolution of former kinds of community, whether Christian, national, or communist, together with the disposal of the metaphysical subject, is also the starting point for Nancy. However, Nancy argues against the mourning of true unions positioned in a past. Rather, community only appeared with society as we know it and must be understood as undergoing processes of construction.[5] For Nancy, 'being in common is not a common being,'[6] and singular being only exists through 'exposing to an outside.' It is communication through such exposition that draws a singular being into appearing. Because a being is put in motion by plurality, it becomes singular through the mediation of its singularity within community.[7] That a being becomes singular by means of bordering, 'coming outside,' crossing a 'threshold of the exterior,' 'pure exteriority' is a claim also maintained by Agamben.[8]

The being of Nancy encounters the impossibility of community through the death of the other, which fulfills, makes community happen. It is always such loss that reveals the community of others. In an unintended way, such loss, or problem, is echoed in Marres and Latour's account of publics that come into existence through a relation to a problem, an issue, an object. Community as a 'clinamen,' an inclination that comes as a relation and puts in relation, thus 'undoing the absoluteness of the absolute,'[9] produces, for Nancy, an 'essence' of and as a community. Such recursive powers of community also manifest in a form of representation beyond representation, for example, Nancy's account of writing, which is the experience of sharing of the community that it constantly undergoes, a process that constitutes the political.[10] Such communication, however, always resists completion, and such 'opening community to itself' through 'unworking its communication' is the political motion of community.[11]

To sum up, community appears to be a burdened term. Community often emphasizes human subjects at the expense of other living and nonliving beings and processes, and it rarely accounts for the role of the technical or aesthetic in the coming together and operation of community and the constitution of its political power. At the same time, the term persists as it gives ground to thinking human groupings as a multiplicity that acquires coherence and a force and promotes regularities to maintain the production of such multiplicity. It is a poisoned chalice that sociology and political philosophy send to reflections on culture; and to deal with it, it is imperative to focus on the processuality and technoaesthetic complexity that feed and operate at the root of the constitution of the community, and on what it and its political resources becomes today.

The reciprocal constitutions of communities, economic and political actions, and other sociotechnical phenomena in dynamic relation to other or larger ensembles and processes will constitute a refrain for this chapter. The sites and roles of aesthetics in such entanglements is to be searched for, together with an answer to the question of what is capable, and under which circumstances, of challenging the processes of the constitution of

the world away from certain capitalist, sexist, representational, and other kinds of normalization.

To start with the introduction of a technical sensibility into thinking of the community or public it is useful to turn to a concept put forward in Christopher Kelty's *Two Bits*, that of recursive publics. Kelty is interested in what binds the 'geeks' together, what a geek is, as well as why some geeks produce free software and, generally, fight for what they fight for. Kelty finds an answer in his idea of a 'recursive public,' crystallized around the technical. Geeks form a recursive public that comes into being through a shared concern for taking care of the technical means that bring them together as a public.[12] A recursive public, thus, is a public that manifests through sets of practices of maintenance and development of actualized technology as well as the processes of its actualization, which roughly correspond to Kelty's technical and moral order. A moral order would in this context be an 'imagination' of political and economic operation, an imagination that must remain deeply technical in order to be inscribed into the technical and thus enable certain kinds of performances of the political and the economic, coded by technology, or in order to make the political and the economic inhabit technologies in a way that is properly ordered. In Kelty's account, geeks come up with ideas that are at the same time 'infrastructures' because new ideas can only be formed in conjunction with and communicated through new technical means. Such infrastructures measure the complexity of the publics that imagine and make the space that enables it to imagine and make it.[13] And certainly, infrastructures are also a part of the imaginary themselves.[14]

How is it possible for a public to be created solely through a shared concern and collaborative work on technoimaginary infrastructures? Whereas Kelty's recursive publics made of cyborg-geeks still retains the sense of a shared lifestyle and an ideological component of some of the traditional ways of thinking the community, Marres and Latour produce a concept of a kind of flash public, although one that may endure, that is radically heterogeneous and coheres only by a concern that needs to be put through.

Latour adds the concept of a thing, an object, an issue to the discussion of the community or public.[15] He asks whether it is possible to get away from the subject and imagine a public that is only assembled to care for the problem uncared for by anyone else. Such an assembly is carried out by different means and paces, with varying emotions and antagonisms, but nevertheless exhibits a 'hidden coherency.'[16] Latour's starting point, as he acknowledges, is the research Marres carried out alongside the former's preparation of the exhibition *Making Things Public*, one that the aforementioned article makes an introductory statement to. It is worth mentioning that the show and its catalogue are admirable examples of research carried out in close conversation with practice, where thinking objects as nuclei of publics went hand-in-hand with enabling such artistic, scientific, and political objects make their statements through the matter and genre of the exhibition.

Noortje Marres reintroduces the role of objects in politics, under the name of object-oriented politics through the close reading of the propositions of Walter Lippmann and John Dewey.[17] In Marres's interpretation, it is Lippmann and Dewey who introduced the concept of the publics as being called into being by a problem, the public whose enabling condition is a failure. Much as Kelty's recursive public is born through care for particular sets of problems that have defining influence on the technosocial constitution of reality, Dewey's public is constituted by concern for something left uncared for by the governing forces of democracy in technological society. Thus, such a public is actually a means to enable democratic governance in a society where the quality, organization, and presentation of information implode with the explosion of networks and other information technologies.

It seems that idea of the public springing from an emergency is offered as a concept emphasizing unsteady and dynamic grouping that disassembles into a 'mysterious' nowhere from which it gathers together and where it is supposed to reside.[18] Marres argues that such a public is not a community, or rather, that it is a 'community of strangers' related to each other through an issue. Marres reminds us that Dewey's public is distributed, and it is the effects of the spread of the problem that turn it into an object and launch the constitution of publics.

The assembling or self-realization of the public/community is, in Nancy's account, also launched by failure. However, whereas such failure is death in an inoperative community, in the Lippmann-Dewey argument, it is technical progress and the networking of technological society that cause the failure of other forms of power to adequately relate to a problematic issue; and it is the fast-spreading networked urge to take care of the problem that becomes the driving force of the constitution of the publics. To top it up with Kelty's offering means to understand such publics as not only triggered and maintained by the network but also as imagined and carried out through technological means that in turn stimulate and change the constitution of the technical network itself.

The questions, then, in relation to art platforms, are the following: How do their communities, or publics, if applicable, come together? Through which technoaesthetic and social mechanisms that art platforms beget or share with other ensembles do they constitute themselves, and what does this coming together make them capable of? If art platforms, to paraphrase Latour's speaking of objects, connect people in unique and specific ways, through the 'constant crisscrossing of apparatuses, procedures, instruments and customs,'[19] what is it that this technosocial assemblage of collectives can do, through aesthetic brilliance or various kinds of engagement—and through which grammars and relationships is such potentiality constituted? Moreover, it might well be thought that it is the publics that assemble art platforms, to come together as publics, constructing their own 'states'[20]—publics that include art platforms as an infrastructure of their

imaginary.[21] Then, given this absent and Gargantuan public, a mysterious creature[22] indeed that gives birth to technical networks through imagining them and building them in order for itself to appear, what kinds of issues does it engage with? How do the dynamics of art platforms couple with other strata to produce action that, although born within a purpose-built alternative structure, exhibit a capacity to transform other fields of societal operation without getting locked in them?

The omnipotent imaginary of such publics (which is itself a shared imagination)[23] that includes speaking, writing, and building, as well as circulating and reuse, is described by Kelty, following Taylor, as social.[24] But such social imaginaries of shared ideas that result in 'new subjectivities' and structures eerily resemble the understanding of art as it is developed in accounts ranging from Ranciére to Guattari, from movements such as Russian Constructivism to artist groups such as Collective Actions. Art is believed to historically carry out the function of imagining the different for it to come into being. With a progressive dissolution of the boundaries of art as well as of other formations, and with the coming of the aesthetic paradigm as a major mode of operation for contemporary society, such imaginary publics and the imaginary of such a public becomes profoundly aesthetic. As the operation of domains outside of art assimilates aesthetic principles, how does such a situation change the political and the political of aesthetics? This is a question to be asked of the projects discussed in this chapter: How do aesthetic publics create their own sociotechnical infrastructures whereby art produces, inhabits, and spreads in its singularity, as well as generating a political effect across other networks and domains?

If, as in the case of art platforms, the technosocial constitution of problems, publics, and infrastructure is coupled with the aesthetic from its very foundation, and it is in the working out and through aesthetic endeavour that sociotechnical (aesthetic) community comes together in their search for aesthetic brilliance, and in ways of operation that would allow for their aesthetic formations to grow sociopolitical power, how does the aesthetic host the political in relation to the technical? How does a sociotechnical constitution of aesthetics that is political happen? Are there moments of accumulation during which the aesthetic turns political, or is it a technical production of the aesthetic that yields politically potent artistic force?

Art practices posited the questions of the transformative sociopolitical power of aesthetics, of the subjectification of human and technical and the constitution of publics through collective production and participation, or open questioning of art's production, valorization, and circulation throughout the twentieth century and earlier. Russian Constructivism, and its 'laboratory period,' evidence of which can be found in the work, organizational activity, and writing of Varvara Stepanova among others, addressed such issues through the concept of 'artistic labour.' Irina Aristarkhova draws on archival materials to show how, for Stepanova, a changing 'relationship to the elements of artistic process or changing these elements themselves' led

to focusing on the collective nature of the process of art making, which through meeting sites such as a laboratory became an open and experimental process of socially active creation with the participation of artists who were rather becoming the 'workers of artistic labour.'[25] It is 'art as a production of life,' a motto of the organization Left Art Front (LEF), which became the model to construct and question the making of art as a political making of society and whose journal Stepanova and Rodchenko actively participated in. For John Roberts, who draws on the work of LEF member and theorist Boris Arvatov, collaboration and the general character of the production of art, whether in technical or social terms, becomes the 'question of cultural form.'[26] Such 'form' is in questioning and changing the process of the production of art in ways that are made explicit in the entirety of an artwork.

LEF's programme focused on what Roberts, through Arvatov, describes as a 'liquidation of the barrier between "artistic technique and general social technique,"' on art working out models of organization and convergence that would directly participate in revolutionary social practice; today this is often read through the prism of an artist critique of dominant modes of production and used to illustrate the history of collaboration as a 'melding of the function of artist and non-artist' and 'idea of art as social research.' Roberts, in particular, directly claims that 'collaboration is critique of relations of production.'[27] Eve Chiapello's 'artist critique' contributes to thinking artists and their work as part of the resistance to the capitalist valorization and mode of production, although for her, it is assimilated by now into the dominance of creative class.

It is the problematic relationship that becomes clearer by such bibliographical wandering, between positioning art as a political critique, even though as a practice of alternative forms of production and art as a direct action and participation, which leads to further arguments concerning the sites and means of operation of the sociopolitical power of art. A lot is packed into this scarcely holding counterposition: the question of capitalist internalizations of aesthetic principles of making and of alternative structures, the degree of such subsumption; the return of art into art systems for its valorization as art, again, if it holds; the potency of art's autonomy, if there is any.[28] Art itself as the unheard of, a system of techniques of expression and valorization that brings about ways to imagine different kinds of emergence, art as critique of existing systems of normalization, art engaging with forces of production using its own or alternative techniques shaping its development or art outside of art as a direct engagement with construction of reality—these sources of the political in art appear to be the instruments at hand.

The group Bureau d'Etudes in 'Resymbolising Machines' clearly specifies that artworks should include a reflection of their production and reproduction. For them, artists as producers of symbols manufacture machines of resymbolization (as opposed to dominant machines of symbolization),

which include assembling alternative systems (like a popular university or parliament, in a fashion related to Latour's, Marres's, and Kelty's publics) that are able to produce autonomous meanings, ways of feeling and ways of producing meaning and feeling. As exciting as it sounds, such 'autonomous production of symbols' is partly done through mapping out and changing the production 'lines' that manufacture (re)symbolizing machines.[29]

A collective artistic endeavour of specifying particular laws and organizations of production that are made transparent and transformable is, for Brian Holmes, a strategy for constructing machines that reconfigure society and allow the imaginary to work in ways that are tangential to existing ones.[30] Communities, publics would build such idiosyncratic machines, which are not only communication, production, and technical machines but are in fact human, medial, and technical assemblages that not only produce artwork but work a collective imaginary.[31] In this context a machine that a public assembles exists, not to take care of a specific issue, but to interfere with the production of societies and public imaginaries through the production of that very machine, making explicit and opening the making of art. And it is in particular through the constitution of such machines, for Holmes, that art can 'exorcise' the forms of capitalism that he sees as having assimilated experimental arts around 1968.

Zepke is one of the critics who disagrees with Holmes for what he perceives as depriving art of its own aesthetic force as the source of the political.[32] The dangers inherent in such discussions are either the disregard for art whose practice is found outside of explicit political activism as a form of aesthetics, or a rather retrograde understanding of art as enjoying an absolute autonomy in which it cultivates inventions of alternative becomings that are contagious but cannot be captured. In this context, art is political either as it produces ways of making, seeing, and understanding that rupture the dominant machinic coherence and are practiced as gashes, constructing a new way of being in the constitution of such machines, or in an ecological existence as itself, where its alterity produces semiotic, subjective, political effects that mobilize social processes from their remote autonomous plateaus. Both such approaches would call upon the theoretical work of Guattari, for whom art participates directly in the social. The Guattarian aesthetic paradigm tackles art that functions as life, and in constructing its own machines it exercises its alterity in relation to other patterns.

The difficulty of interpreting a Guattarian understanding of the political sense of the aesthetic paradigm here lies in the understanding of the aesthetic paradigm's functioning itself. For Guattari, art can be in science, thinking, technology, or anguish, or in art as we know it. It is, in fact, rather difficult to conceptualize Guattarian productive machines in a manner that would allow exclusion of any of the productive components or processes it puts through to produce meanings, subjects, territories. Guattari explicitly writes about revolutionary processes that can 'take charge of the ensemble of productive components,' and in this context all machines must be used,

'whether concrete or abstract, technical, scientific or artistic,'[33] as they can not only challenge the world but 'completely re-create it.'[34] To imagine such processes, it is worth turning away from art's proper sites and looking into the amateur, folklore, nonart production, into things barely noticeable but immensely powerful, into publics absent from public discussions but busy coding in their own bedrooms, into low-tech and 'dork,' into wondering outside of the serious.

Here, machinic processes include aesthetic exploration and its means of organization, ways in which things are imagined, made, presented, passed around, and reused, structures of assigning meaning and value, of assembling practice and publics together, of economic and communicational battles but also humorous and flirty chats; this list is never finished. A militant practice, Guattari claims, establishes a 'continuum between political, social and economic questions, techno-scientific transformations, artistic creations and the management of everyday problems, with the reinvention of singular existence.'[35]

In relation to art platforms that are themselves such machines and that join in with other machines, it is not only their means of structuring that enhance or circulate their aesthetic endeavours and change the imaginary, or the other way around. It is, at a fundamental level, their art that includes all its networks of assembling a public, a platform, an aesthetic; technology to run a platform, to maintain a public, or through which publics maintain and make art; means of amplification, kinds of infrastructures of circulation as envisaged and shaped through such human-technical coupling; displaying, valorizing, and archiving; and discursive or affective formations among various relations to other economic or institutional machines that as a totality make an art platform's practice enunciate a change both in the way its aesthetics is lived and in the ways it dyes the threads it is linked to which constitute other machines.

The force of the concept of art platforms, as compared to a singular work, is in the understanding of their very extended constitution in progress as multiple and processual that enables us to think them and similar phenomena as a complex assemblage of art, networks, technologies, politics, autocreativity, publics, humour—all amalgamated, related, but not frozen together in their operation. Such an aesthetic machine, as well as involving an expressive or processual component, thrives on work, social relations, and desire as they all develop creative affinities,[36] but is not withdrawn from nonaesthetic, nonart societal processes that have a political potency as well. Here, aesthetics are politically militant, not necessarily or solely through resistance or withdrawal but through the production of aesthetic machines that work across domains beyond aesthetics.

Art platforms are produced as assemblages for specific kinds of aesthetic practice to come into being, publics around a set of problems and works that are artistic, or not quite, and inseparably techno–political, with different degrees of energy that may be invested in various cycles of work.

Further on, while carrying out their aesthetic (and technopolitical) endeavour, and through carrying it out, art platforms are coconstructed in ways and networks of making, subjectification, and valorization that are relatively autonomous. Art platforms coconstruct such ways and networks as they become part of the aesthetic work carried out, forming a coherent whole. Such ways and networks are the means through which art platforms constitute themselves and their art, while also being products of art platforms and part of their art or being their art themselves. The political and technical potential of art platforms, as well as the question of their publics, shall be regarded here through such spiral understanding of their organizational aesthetics.

Making aesthetic enunciations, art platforms are created by and make networks, publics, and actions. Being an assembly for an aesthetic practice to come into being, they constitute technopolitical processes of making, knowing, and showing that are inclusive of the ways in which they are logged by or change these processes in other strata. The differences among art platforms as structures and procedures are thus due to the differences among their aesthetic enunciations in their own birth and growth.

The two examples this chapter will look at, that of a 'low-tech' music platform called Micromusic.net and a network of people 'doing strange things with electricity' named Dorkbot, are all about art that produces aesthetically vibrant machines and networks and that, through changing themselves, change the networks that they become part of and which they are constructed from.

MICROMUSIC.NET AT WORK

Micromusic.net is a Web platform,[37] established at the end of 1998,[38] that presents itself as a label and a community focused on 8-bit music. It has published more than eight hundred tracks, a few vinyl and CD collections, counts about fifteen thousand registered members,[39] and has held hundreds of concerts around the world.[40]

Through Micromusic.net, 8-bit music became a strong current of the audio cultures of the 1990s and 2000s, one based in a style of sound revived from early geek practices to achieve a communitarian visibility and power to push such aesthetic exploration in and to new kinds of sociotechnical production[41] and its political accompaniment. Indeed, such is Micromusic.net's strength that its name is synonymous and sometimes interchangeable with the genre it nurtures.

The mechanism of releasing music at Micromusic.net is rather standard for an art platform of a 'classical' sort. Users upload MP3 files they have created, which are filtered and the most appropriate released. Micromusic.net's database—'up-/downloadz'—is structured in a number of ways: by time of upload ('latest micromusic releases') that are subject to people

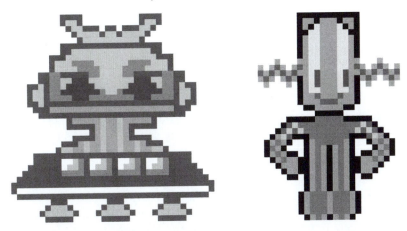

Figures 4.1 and 4.2 Micromusic.net bots.

voting (they get 'pointz'), by number of downloads ('download_chartz'), and by author.[42] There is also a 'hall of fame!!!' with the top fifty tracks (ranked by total downloads). Micromusic.net filters the incoming data to this section.[43] Users find the quality filter system (QFS) a very important mechanism and an especially successful one because of the specific qualities of the personalities behind it: 'Of course all this works not only because of the structure, but because of the human touch it has. The Sysops make it special, it's really a good thing that they are cool.'[44]

Generally, Micromusic.net is held together not least of all by a party-style atmosphere that's 'cool,' flirtatious, and humourous, coconstructed by design features such as microtalk ('a classic 'who-is-online' list displaying logged-in users, but with an extra feature: a user can send messages to any user via the browser's pop-up-alert windows')[45] and a handful of other funny little details, whose liveliness is simultaneously founded in emotional and labour investment and the ease with which they are implemented and removed. For instance, 'microswopper' was a script that ran for three months in autumn 2001, following September 11, swapping words in real-time in the platform's chat microtalk. Here is an excerpt from the announcing mail and a further reaction to 'LSDswopper':

> This microswapper was activated because we thought it would be helpful to make adiscussion about the world_situation even more easy . . .
>
> swapped words:
> bomb <-> cake bin laden <-> stockhausen
> war <-> sex budget <-> savoir vivre
> geek <-> pornstar i want to marry you <-> hello
> dsl <-> digital subscriber line vote <-> buy

cu, bye <-> God Bless America
music <-> ice_cream
drum'n'bass <-> acid house
micro <-> LSD
samples <-> pr0n
. . .

marines <-> nazi
Sony <-> Atari
idm <-> progressive rock
cubase <-> ascii
sorry <-> fuck you
. . .

this microswapper is very funny at first—but ultimately sucks because guests want to marry me and I keep giving respect to Sony. . . . ;->[46]

Various style features visualizing low-tech aesthetics otherwise embedded in sound, such as text-only elements and animated gifs,[47] the kind of writing referring to the first experiments in 'adapting' writing to technical systems by specific shortening, humorous phrasing, and idiomatic spelling[48] intensify and update on the geeky sense of the Micromusic.net platform. But it is also through the mechanics of the art platform that the aesthetics of 8-bit music and its geeky publics coconstruct and amplify each other to reach a change in state through which a difference to modes of making and thinking can be enunciated and put across a variety of domains.

Micromusic.net is constructed and held together by a shared aesthetic pursuit in 8-bit sound, which is backed by a thirty-year history of geeky exploration and certain developments of technology, politics, and economy that trigger, support, and impede the makings of an amateur musician. One could say that it is brought together by an issue that a self-named public collectively provides a means of subsistence for, and by fortifying it aesthetically, creates its networks of production, appreciation, and persistence. The humour and seeming ease with which Micromusic.net operates glues together the aesthetic machine and social memory of geekdom, propelling the making of this aesthetic current. Such forces cut across a radical range of strata, tracing their own characteristic ways of subjectification; valorization; technical, economic, and social practices; and of making politics with and through their aesthetic endeavour in ways that are positioned to enunciate a specificity and alterity of their own.

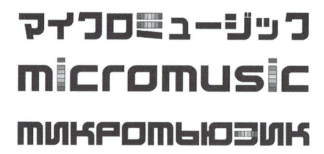

Figures 4.3 Micromusic.net logo.

8-BIT SOUND, LOW-TECH AESTHETICS, AND ITS PUBLICS

Micromusic.net works with the pre- and coexisting realm of 8-bit music. Other terms for this field include lo-fi or low-tech music, microsound, and chiptunes. The term '8-bit music' refers to the sound of early video game consoles and home computers, which used sound chips that were difficult to tune.[49] In the early 1980s, some manufacturers produced their own audio chips, most famously the Television Interface Adapter (TIA) for the game console Atari 2600, which controlled both video and audio, and the Sound Interface Device (SID) for the Commodore 64 home computer, which had a dedicated graphic chip next to it. Such microchips, which allowed some control over timbre, had to be programmed in assembly language and produced a very specific sound that became a musical style of its own, characterized by 'soaring flutelike melodies, buzzing square wave bass, rapid arpeggios and noisy gated percussion.'[50] For example, TIA had four-bit volume control (sixteen values), four-bit wave-form control register (sixteen values), and five-bit pitch (thirty-two values). Thus, only two voices could be produced at the same time, and sixteen settings described the possible sounds, some of which were similar to each other.[51]

The name '8-bit' also describes the generation of computers with eight-bit microprocessors (such as the home computers Atari 400, Atari 800, Commodore 64, Apple II, Sinclair ZX Spectrum, and BBC Microcomputer, among others). The Commodore Amiga, for instance, had a sound chip with eight-bit resolution. The number of bits is the sample size: The more bits, the more data-space is available to describe the sound sample. A larger sample size gives a range capable of reproducing or performing more sounds more accurately. For instance, if an eight-bit chip holds one sample value, then the sample range is 256; the variety of sounds this chip can produce can be represented by at most 256 amplitude variations. By comparison, a sixteen-bit sound sample range is 65,536. Compared to the smooth sound variations of current sound cards at thirty-two- or sixty-four-bits range, eight-bit sound is very distinctive.

The specificity of eight-bit sound is located in its 'naïveté,' in the distinctiveness of its limitations. The musician has to compose with a restricted set of instruments, but such scarcity, like hacking (solving a complex computational task that overcomes the limits of either thinking and/or computer system), tends to create or reach the state where 'the boundaries of technological restriction' are overcome, similar to the previously cited Nietzschean figure of creativity being 'loudest by the side of tyranny.'[52] The paucity of resources in microsound and the virtuosity it requires to create a complexity of aesthetic dimensions in a seemingly flat plateau produce a special aesthetics, that of skilful, knowledgeable, and romantic imperfection, of complex simplicity, the aesthetics of low-tech. Moreover, the distinctively reduced and specific qualities of such sound can pull inside out the cliché-like character of many habitual melodies and patterns, opening up a new 'sincerity' in overused patterns.

Although the style of Micromusic.net may originate from early computer game soundtracks, when compared to some of the original games' sound collections that have been released, it is far from pure in fidelity to its ancestors: usually, microsound presents a hybrid of 8-bit sound and modern sound.[53] Micromusic.net musician DRX describes its history, context, and aesthetics: 'The speciality about Micromusic.net is that it breaks with some ideas that computer freaks and Internet idealists have or had. The trick is a combination of knowledge and style from the computer kid culture and pop music culture. Everybody knows computer kids are stylish, but sometimes they stick to traditions not working anymore. . . . So Micromusic.net is an MP3 label which not only makes it better accessible, but also really asks for a crossover of home computer music with different styles, through this bringing the whole thing forward.'[54]

In relation to microsound, the 'computer kids' phenomenon DRX refers to constituted the first generation, sitting in front of TV screens in an attempt to create musical tracks 'that would have been as cool as in Arkanoid.'[55] As the founding member of Micromusic.net, Carl describes it: 'I can remember fighting with my father about the television set. He wanted to watch the news but I needed it as a monitor so that I could write my programs in Basic.'[56]

The culture of the demo (briefly referenced in the previous chapter) and tracker music add to the cultural history of microsound. Demos, initially intros to cracked games or software, were used to represent a cracking group competing on the level of best programming skills, and are characterized by multimedia presentation with complex graphics, scrolling text, and sound. The sound was often made using tracker software,[57] a type of music sequencer software that originates from *The Ultimate Soundtracker*, developed in 1987 for the Commodore Amiga. The software graphically represented the four channels of the Amiga sound chip and allowed users to compose or arrange samples stepwise on a timeline across those channels. Over time, tracker music matured through its specific file formats, which contained samples and patterns. As reported, tracker music files, when opened, laid bare the patterns and samples used in a form that allowed them to be read and reused, thus building a powerful culture with shared resources and ways of learning and making.[58] The tracker communities, rather large during BBS (Bulletin Board Systems) times, did not migrate to the World Wide Web but refound themselves through the new wave of interest in microsound, such as with Micromusic.net.[59]

The specific history of geekdom is one of the foundational forces of Micromusic.net. It is in the tension between experimentation, skill, devotion, and power over one's own thinking coupled with technology, the social novelty of the new figure of the geek, and the smouldering political awareness such activity sustains that a certain 'coolness' is ascribed to geekdom. According to Carl, the founder of Micromusic.net, micromusicians are all 'computer freaks. You used to have to defend yourself for

spending time with computers. A lot of people laughed at you and thought you were weird. That's why the computer scene, which has been huge for a long time now, was never really noticed by the general public. But the success of the Internet has given computer freaks a certain self-confidence in the last few years, and they're stepping out more often now.'[60] 'Basically computer kids see the spirit of home computing in this project; that is why they flock around it.'[61]

Digital folklore (briefly described in the previous chapter) and geekdom come from related sources. There is a certain terminological confusion in understanding the figures of hackers and geeks. Micromusic.net's geeks do not qualify as geeks for the rather purist judgment of Christopher Kelty and some other scholars of programmers' communities who might pick up the term to describe their object of study. Kelty specifically talks about 'geeks' as being those who 'are not the ones that play with technology of any sort,' 'are not script kiddies,' but are the ones whose 'political lives . . . have indeed mixed up operating systems and social systems in ways that are more than metaphorical.'[62] Being a geek is a 'mode of thinking and work- ing,' and there seems to be little place for humour or playfulness in such a serious matter as making an operating system an agent of social change. Here, Kelty refers to the figure that was traditionally marked as a 'hacker' (say, by self-reference, that of Richard Stallman).[63]

Certainly, the Micromusic.net geeks do not interest Kelty for their aes- thetics-based endeavour. Such geeks are more like Guattarian 'machinic junkies,' people feeling—but moreover, reorganizing—the organizational aesthetics of the machines that produce them. Their whole formation is based on the operation of particular techno-human ensembles whose bursts of activity produce very specific technocultural settings and objects. Such settings provide 'possibilities for creation, changes of life and scientific, economic and even aesthetic revolutions,' but the same can also 'kill them slowly over a low flame.'[64]

The figure of a geek is part of the same process that constitutes a hacker. The fact that their circle and effect of operation is interpreted as different is, in fact, a part of the debate introduced in the beginning of the chapter, fea- turing the discussion of what constitutes the political power of aesthetics, if there is anything of the sort. The aesthetic powers of geekdom constitute the political in ways that diverge from the free-software operators that Kelty focuses on. The creative emergence traversing the aesthetic forces brought about by Micromusic.net geeks imagines and acts through the making of 8-bit music that enunciates alternative figures of cultural producers, at the same time erecting networks through which a precise aesthetic genesis undergoes subjectification and valorization, assembling publics, practices, and systems of learning, making, circulation, and appreciation.

It is through the art platform Micromusic.net that such aesthetic force could achieve a level of actualization sufficient to sustain wide recognition as a cultural phenomenon and to participate effectively across technological,

social, and political domains in the enunciation of new practices and ways of living. The art of Micromusic.net does not simply contaminate such other domains but self-organizes its own machines of production, through complex mechanisms of human-technical desire, autocreativity, aesthetic amplification, and differentiation, and through small gestures, technical devices and jokes, which acquire the power of autopoietic machinic genesis to produce new roles taking part in and changing other ensembles.

The amplifying aesthetic machine the Micromusic.net art platform is associated with, and its technosocial performance, deals with (among other matters) the development of the international 8-bit community, a public, and an aesthetic current, which together offer a reconceptualization of the amateur as a figure with which to understand the ways that autocreative machines take shape and acquire the capacity to participate in the technical, economic, and political strata on renegotiated terms. Such redefinition can be seen as being in line with the cognitive capitalist reliance on the extension of labour beyond traditional subjects and sites of work, but must not only be regarded as the pre-subsumed exploitative driver, as argued in the first chapter. It is within such new figures and their practices that the future is born.[65]

TECHNOLOGIES, THE MUSIC INDUSTRY, AND THE AMATEUR

Generally, as with other art or cultural practices, the relatively recent mass-scale manufacturing of hardware and software radically changed musical practices and music itself. The 'industrialization' of music and the resultant arrival of new kinds of music occurred along a few lines: The production of hardware and of software[66] intertwined with the new practices of making, listening to, and passing around music, the changing condition of the industry, and the rise of new figures, most notably, that of the amateur.

Music has always been marked by its technocultural phylogenesis. The particular ways in which new music-media technologies informed the development of musical forms and worlds is a well-covered field of research: from the two-page-paper format and the three-minute-record format that, along with the acoustic recording technique of the late nineteenth century, favoured the production of short pieces of music with loud noises from brass or accordions, to the study of the Sony Walkman and its complex repositioning of everyday life.[67] The invention of dub versions, 'spins,' or even samples through experiments with sound systems and studio technologies in Jamaica of the 1950s and 1960s is possibly the most well-known episode in the mediation of music,[68] along with writing for words (Plato's *Phaedrus*), and lithography and photography for images (Benjamin's *The Work of Art in the Age of Mechanical Reproduction*).

Technocultural changes in music making, listening, and circulation occurred in parallel to structural changes in the music industry. After the Second World War an unprecedented growth of transnational corporations

in media and culture took place.[69] Industry consolidation has led to the emergence of the major record labels, currently the 'Big Four'—Sony BMG, Universal Music Group, EMI, and Warner Music Group—that, depending on the year, account for more than 80% of all record sales.[70] Such a concentration of capital has given the majors unprecedented weight and possibilities in constructing 'the consumers,' homogenizing music production, and controlling music distribution. Building an extensive system of promotion that repeatedly brings attention to a record and increases its chances of being sold, music industry contributes to the system of a star cult and the escalation of payments to star musicians while simultaneously lowering other musicians' income.[71]

From here, the argument usually departs in two directions: towards alternative systems of production and distribution, most notably towards the 'indies' (small independent record companies), the MP3 file format, file-sharing networks, and also towards the figure of the producer, the nonstar, the amateur. All of those routes can be seen as enhancing the industry by outsourcing production of new music and crowd sourcing[72] (indies and amateurs), and forcing it to reformulate its ideology and legislation in relation to ownership.[73] The same practices and currents also can be regarded as minor practices that change lives, symbolic spaces, create aesthetic machines, and alter existing procedures in ways that allow pressures to be exercised and diversions to be experienced. There is a certainly a long tradition of music practices that reflect on and include their own cycles of production into their aesthetic performance (something Brian Holmes seeks out in contemporary art), that dismantle and attack symbolic systems dictating the perceptive allowances (echoing Bureau d'Etudes' work), and that contain political diversion as an integral part of their aesthetic form (tracing Zepke's argument, discussed earlier). Such practices make new frequencies for voices and trace some lines along which an aesthetic urge can assemble platforms and publics to gather around practices and bring their aesthetic force to existence through means that it tacitly finds out about while building them.

Net art, among other art practices, played around with the idea of domineering voices, aping the manufacture of celebrities, or of 'classics,' and attempted to ironically undermine their production by turning everyone into artists.[74] But creating filters and enabling communal activities rather then focusing on individual projects was also one of the focus points of early net. art. The Micromusic.net leader, Carl, is a former member of the ETOY group, active participants in early net art that became famous for the *Digital Hijack* project (1996) and a noisy publicity fight with the Etoy corporation (1995), among other things. This is how Alexei Shulgin, another net.art scene actor and Micromusic.net participant, described the power of Micromusic.net:

> It seems that the success of Micromusic.net is due, among other things, to their refusal to play success. . . . These people . . . came to . . . an

understanding of, firstly, the real cultural and ideological value of low-tech music, and secondly, of the importance of the correct organization of communication space. In other words, they came to the idea of the refusal of an individual careerism for the benefit of construction of an open community of people sharing common interests. That brigade, basically consisting of designers, unemployed and programmers, carried out the construction of the Internet portal for the entire movement, building special tools for teamwork and communication online, for the exchange of files, for work on holding virtual and off-line events by the forces of the community. The most interesting thing in such an approach is that despite the seeming utopianism of ideas behind it, the system works perfectly.[75]

Whether it is communal or not, there is a particular sense to the publics that are assembled through building an art platform for a multiplicity of voices to speak about an aesthetic issue. Often, such a sense operates in what I previously called grey zones of culture, busy with practices below the artistic radar, doing something that is not quite yet art but becomes such. Such publics were indirectly addressed in previous chapters through the concepts of the literary production of mate lit, artistic practices in Second Life, software art, and digital folklore. It is worth supplementing those with one of the amateur, a concept that offers a more aesthetically differentiated figure, operating across economic, social, and political domains.

In relation to music and academia, an amateur is a figure of a music lover whose rise can be discussed, according to some accounts, as based on the rapid increase in music education in European countries since the 1950s and the 1960s or, more generally, the expansion of music education around the globe over the last 150 years.[76] An amateur, traditionally understood, undertakes musical activities in her leisure time. Such a foundation for a dichotomic distinction between a professional and an amateur claims that the latter can be defined through age, absence of formal education, or by practice outside of institutions. However, the figure of the amateur is central to understanding the acts of listening to music and 'using music' as a practice and as a 'ceremony of pleasure.' Generally, regarding practices and devices brought about by amateurs as mechanisms defining music[77] is a way of thinking that is conceptually close to the philosophy of everyday life explored by Lefebvre and de Certeau, but such conceptual histories of the term can be seen as misleading. Such parameters as age, formal education, and relation to institutions are misbalanced, although not voided, in their power of characterization of the active agents in culture making today. Taking into account just the income that is linked to formal education in a particular field, it is shown that in the United States, for instance, two out of every five music workers are self-employed, three-quarters have a part-time schedule, and most of them have to either find other jobs to support themselves or are 'forced to accept full-time employment in different

occupations in order to make ends meet,' whereas 'the most successful musicians earn far more than the median.' This is a realistic formulation of a star-cult system's distribution principles.[78] Here, when Micromusic.net members' tracks are published on the art platform or in a CD collection or performed in clubs, it is hardly possible to claim that a formally educated musician could structure her professional life differently. Relation to income is not definitive here, but it is exemplary in the disassociation from the formerly valid criteria.

Moreover, aesthetically charged making is singularized in conjunction with a specific quality of digital technology. The digital tools core to music production are, in Flusser's terminology, apparatuses that carry within themselves not only an enormous amount of preinvested labour that is technical, political, and aesthetic, but entire industries and complexes that produce those technologies and the labour and conditions for such production.[79] It is probably useless to claim that mastering the digital technology of music production demands less time and effort than learning to play an analogue instrument or compose for it, although it is quite possible, but it certainly can be maintained that within the domain of digitality the forms of mastery, acquisition, and transfer of knowledge, and of music, happen largely outside of the official institutions of the previous era through routes more akin to playful software exploration then to conservatory-style full-day practice. Such playful exploration, for Flusser, is part of the new character of work and may be the only freedom of movement possible in a panoply of preprogramed interaction with various apparatuses. But it is also characterized by a more vigorous mode: the testing and pushing against the preprogramed that define the play of a hacker, geek, amateur.

An amateur has wonder and enthusiasm, and it is through her chaotic and processual movements amplified by the technopublic dimension brought about by art platforms that such play reconfigures the schemes, circuits, and boards constituting the plane of the possible into reciprocal making, perceiving, taking part. The amateur hacks the black box of the production of her life. Engaging with an apparatus of such production, the amateur creates circuits, concepts, libraries, devices, and objects of her own that can link together behind formal education, skill, access, training to obscure the formal arrangement of apparatuses in order to get processes of morphogenesis started or ignited. Amateur practices call publics to life. They may amplify through an art platform to transduce into aesthetic or other kinds of brilliance, achieving a 'finding a way out' in itself, which together with networks affected by such active platforming lure other apparatuses into further reactions.

It is worth noting that the amateur is not opposed to the professional here. The amateur can be professional (the professional should maintain the ardent love of the amateur)[80] and a professional can be nonprofessional. An amateur feeds on raw autocreativity, whereas the nonprofessional professional works with cooked creativity, servicing the apparatuses.

Certainly, as mentioned above, an amateur is a rather overextended and conflictual figure, one that is used in number of narratives—to cover the proactive consumer as well as to address the economy of contribution in the new brands management—but within this spectrum, there are angles and refractions that can be effectively visible from certain points and that are active in the creation of lively imbalances and diversities that cannot be planned in society and culture.

The Micromusic.net art platform comes in an assemblage not only with an 8-bit music current and geeky publics, but also with networks that make spaces for amateurs to build and spread around their own circuits and transmission lines. Chats, comments, downloads, link exchanges, meetings, concerts, software, charts, and hits are all devices that are carefully and ironically weighted against those of large industries and apparatuses; 'microfame'[81] is one of their effects, whereas the entire art platform can be seen as both straightforwardly producing and passing further on the microsystems of making, perceiving, and taking part differentiated from some of those in domination.

'PEOPLE DOING STRANGE THINGS WITH ELECTRICITY'

It would be impossible to talk about geeks and amateurs without referring to Dorkbot,[82] a network of 'people doing strange things with electricity,' or rather, a figural art platform through which a shared figure of networks of thoughts, tryouts, and people are enunciated and which they form. Dorkbot started off in 2000 in New York, and it is nothing more than an idea (with some server space)[83] available for adoption along with related responsibilities for anyone in the world. The idea of Dorkbot, or rather its figure, as it enjoys a precise sociotechnical and historical materiality as well as the complexity of an imaginary character, is one that cuts to the core of some of the contemporary conflictual dynamics of sociotechnological development. This is particularly so in relation to its actors as they are formed in potent zones of production, efficiency, consumption, annoyance, experimentation, creative labour, humour, hobbyism, geeky seclusion, and disagreement. Through the figure Dorkbot has made available to people, certain possibilities of enunciation, subjectification, and valorization are called into existence; and it is through the magnetic charge of this fantasy, which is at the same time a core unit that the 'real world' operates with, that the art platform of Dorkbot has formed and gained worldwide popularity.

In the year 2000, Douglas Irving Repetto, then a graduate student in Columbia University and subsequently its employee, launched a loose series of meetings for people as diverse as engineers, scientists, artists, designers, hobbyists, and people without any such job description to share their experiments in a friendly, low-key atmosphere. These meetings are organized on a voluntary basis, with no membership, and are

usually structured around up to three thirty-minute presentations by anyone willing to talk about what engages them. Weird experiments, hobbyist reverse-engineering of equipment, circuit tinkering, backyard robots, art projects, tests carried out in scientific style, musical or smart textile projects, among many other things, can all be presented at the irregular and free Dorkbot meetings as long as they engage with 'electricity' (here, referring to the dominant technical civilization relying on the source of energy for its propagation).

The success of the imagery put forward by Dorkbot and supported by the total organizational autonomy available to its adopters is global. There are over ninety Dorkbot 'chapters' in different corners of the world, and new ones are being launched as the tenth anniversary of Dorkbot approaches.[84] Some of the local Dorkbots have periods of high activity, such as London Dorkbot, managed by Saul Albert and Alex McLean for years, which also had Dorkbot camps and Christmas parties, among other things; others are more rudimental, sporadic, or even one-off events. Local Dorkbots grow into bodies of various character. Some focus on music, whereas others that are managed in closer relation to universities use the meetings to showcase students' work across faculties.[85] The organizational aesthetics of Dorkbot is aimed at constructing minimal, lightweight, and open human-technical apparatuses, mainly through DIY and local specificity. It is the modularity of the structure that allows local Dorkbot meetings to develop into something specific while maintaining an ideational connection to the network springing through such locales.

The figure that Dorkbot refers to is that of the amateur generated by the technical pursuit, encouraged by networked communication, mapped by profit-driven energies, and held back by the organizational dominances. A hobbyist, a geek, a nerd, a not-quite professional busy with a small experimental home-brewed endeavour who presents at Dorkbot is endowed with two polar qualities: that of amateur production existing between more generally noticeable phenomena, but in a 'no-man's land' that does not fit in a gallery or a lab on the one hand but that displays a high command of technical specificity on the other. At once dilettante and highly specialized, seamful and advanced, the line of practice presented by such geek activity, when growing itself a platform, assembles a public driven by similar problematic, geeky publics. Such publics performs within an open learning culture (Repetto maintains that he wanted to set up an adult 'show-and-tell' with the first Dorkbot)[86] that relies upon sharing the unfinished, ad hoc, with an audience that is similarly interested in testing the new materials and ideas they embed. The emphasis of maintaining a sense of 'camaraderie' in assembling such a public is carried, in part, through deindividualization, humour ('If you have to tell people you're giving a presentation at something called Dorkbot, you can't be too serious'),[87] a 'high level of technological understanding''[88] and a certain appreciation and feedback generated through presentations and related publicity (for instance, Boingboing.

net, 'a directory of wonderful things,' a website featuring technoculture, often links to Dorkbot's listings or the personal websites of presenters).[89]

The irony within which the name of Dorkbot is formed (one Dorkbot camp was held in the town of Dorking, England) and certain lack of seriousness that may be pedalled at the events comprising it lessens the pathos that can impede, or indeed, obscure the unfolding of a practice. At the same time, such humour seems to be an integral part of a certain technocultural production. Humour as a way of investigation can indeed come closer to grasping some of the core actions and lines of connection through which a technocultural fabric is woven to exhibit ordered patterns. It is also a sensibility, performed in conjunction with other ensembles, in which a differentiation of such patterns can be coded. What Dorkbot produces are possibilities and a range of certain kinds of participatory action, which through a particular kind of technoaesthetic thriving create some horizons where there is normally only flat grey sky.

To conclude, it has hopefully become clear throughout the chapter that the spiral of the making of publics around aesthetic practices that produce differentiated networks of making and enunciation that are directly political and whose production depends on publics assembled of geeks and amateurs whose existence and aesthetic performance is of a political matter as it cuts across various machines and apparatuses both producing and attenuating or blocking them and where in turn aesthetic endeavour is able to create differentiated apparatuses and publics is what an art platform drives.

Publics assemble and speak about their aesthetic practice through art platforms. They also appear through doing so. Art platforms work as machines for production and enunciation, reinventing ways in which such machines are assembled, making new machines through pursuing aesthetic passions in amateur manner. Linking to abstract machines, art platforms construct practices, components and processes that experiment and live revolutionarily. Their aesthetic character lies in complexity, openness, humour, and alterity. Aesthetic emergence and the small gestures of the devices constructing them are the means through which art platforms become able to be assembled by their geeky publics to create other kinds of making, speaking, enjoying, and rushing to what is yet nonexistent or hidden around the bend.

Afterword

This book's project is one of observing and following new ways and kinds of the becoming of cultures that yield art or something describable through the concept of aesthetic brilliance. Here, the subjectification of culture and art is amongst another things, irreversibly technical and the figure of an art platform is required to enquire into such technicity. An art platform is not a fixed entity but a process that is necessarily political in its production of publics and in its general engagement with compositional forces and social figures of different kinds, be they geeks, amateurs or intelligentsia. Repetition and aesthetic amplification are at work in art platforms as elsewhere, to impel differentiation in the scales autocreativity propels and traces. As the production of culture is repetitive and can be deadly philistine, the self-organisational force of autocreativity is needed to undo or go beyond the repetitive towards the brilliant. All of these processes couple with technical gestures, decisions, devices and histories, sensed through the complexities of organizational aesthetics, to achieve the advance of something I refer to as art, through its specific tangles of reflection, dispersal, technology, people and aesthetic thriving. Turbid processes such as these bring in diverse and inter-linked dimensions of digital folklore, humour, or idiocy. Various kinds of art made in such circumstances are what we are rewarded with.

It is worth mentioning, as I did in the first chapter, that the same processes to be found in art platforms can be operated upon by different interests, and it is not very difficult to paint a negative picture using the same pallette. Cognitive capitalism, the creative class and creative cities, culture industries, new branding, immaterial labour are all categories and concepts that can be used to envision the new and exploitative, the fraudulent, impudent and repetitive, and scarily ordinary. I suspect that only very optimistic and vivacious people can write pessimistic books and vice versa. Perhaps it requires a dose of some vigorous anguish to look for things that are outside of a seemingly meaningless totality. It is also in seeing and giving voice to particular practices, objects, and phenomena that brings some sparkles and splits into a greyness one fears to be solid.

This book attempts to carefully construct art platforms into a fragile concept that is broad and very specific, purposefully avoiding things that

are too known, large participatory platforms and discussions of social networks. I would also like to abstain from a type of argument that would conclude by talking about art platforms and things they are not. As I noted in the introduction, there is no strict opposition between art platforms and web 2.0, not the least because they are not the things of the same order. The concept of an art platform can be used perfectly well to enquire into the participatory web, particular phenomena that arise within it and forces playing out through its actualizations, but it might also lead to discoveries that are not expected or even necessarily wanted in the current fascination with the totality and lightness of the embrace of the social web.

Probably, art platforms can be regarded as bastions of human dimensions in the space becoming increasingly and simultaneously formless and formalized. It is formless, because some of the core of the processes of subjectification that were previously private and lasting, as well as deeply technical, are exposed and fragmented through new techno-social settings, part of which is the social web, but also in other software-run socio-political procedures we are subjected to. We do not yet know what to do with such new degrees of exposure of some of the fundamental stages of human-technical actualization where the bareness itself makes an impact on the process. And the human-technical space is formalized, because many of the currents in both the making of and performing through the networks are about harnessing data through constant update to be made sense of with highly formalistic methods, based on analyses of large datasets. Such methods are substantially automated and able to detect quantitative changes and measureable relationships, recognize patterns and assign meaning on the basis of the analysis of units prone to such treatment or indeed to throw up new rule-sets for large-scale participation, 'grass-roots' marketing campaigns, profiling and segmentation.[1]

Here, a method of understanding and doing through engaged, laborious, sincere and informed attention, one that can work towards making art that, to paraphrase a poet, shamelessly grows out of rubbish, can become a glass bead game.

What will come along? Will museums 'version themselves to be pieces of software'[2] that as synthetic forms of life make art themselves, just like art platforms but more neatly and in a directed manner, where conflicts, conversations and even excitement will be carried out or be triggered by scripts and bots? Will we, as promised, progress through open and engaging creative collaboration to become free and informed individuals beyond the beauties of consumption? Making things happen on the web, will we make ourselves happen? Or will we become illiterate, dependant and satisfied in our self-contentment? Hopefully, and most likely, nothing of this, but something quite different, complex, exciting, and maybe ugly will take place.

Notes

NOTES TO THE INTRODUCTION

1. For instance, Micromusic.net, a platform for 'homemade' 8-bit music, produced a Microbuilder Community Construction Kit, which contains all software that Micromusic.net developed and runs on released as open source. The idea is to give people the technical backend for starting a new art platform, modifying software for the purposes of the aesthetic practice they wish to engage with. The Microbuilder Kit comes in a coloured cardboard box that also includes a book about Micromusic.net (an account of the project by its members), a small Micromusic.net style Swiss Army knife (both a nod to the Micromusic.net initiators' base in Switzerland and a reference to the partylike and fun atmosphere of the platform—'a knife as a bottle opener'), two Micromusic.net badges, and two music CDs (releases of the best tracks submitted to the platform and voted most popular). See *Microbuilder—Community Construction Kit*.
2. Bruno Latour, 'On Recalling ANT,' 19.
3. Gilles Deleuze and Félix Guattari, *A Thousand Plateaus: Capitalism and Schizophrenia*, vol. 2.
4. Albert-László Barabási, *Linked: How Everything Is Connected to Everything Else and What It Means*.
5. See Mark Newman, Albert-László Barabási, and Duncan J. Watts, eds., *The Structure and Dynamics of Networks*, 3.
6. Eugene Thacker, 'Networks, Swarms, Multitudes.'
7. Newman et al., 4–7.
8. Whereas the World Wide Web is found to be an hierarchical network, on the level of sites joined into larger modules, the router-level Internet network is devoid of such hierarchical characteristics. See Réka Albert, Hawoong Jeong, and Albert-László Barabási, 'Diameter of the World-wide Web,' 130–31. (Reprinted in Newman et al., ibid.).
9. Newman et al., 415.
10. Gilles Deleuze, *Negotiations, 1972–1990*, 29.
11. Matthew Fuller, *Media Ecologies: Materialist Energies in Art and TechnoCulture*.
12. Media Art Net (MedienKunstNetz, website), http://www.medienkunstnetz.de; Walker Art Centre Collections: Net Art (website), http://collections.walkerart.org; Netzspannung.org (website), http://netzspannung.org; V_2 Archive (website), http://archive.v2.nl (all accessed 21 Jan. 2011).
13. Dielo Trouda (Workers' Cause), 'Organizational Platform of the Libertarian Communists' (1926), Anarchist Platform (website), http://struggle.ws/platform/plat_preface.html (accessed 21 Jan. 2011).

14. See also, Aleksandre Skirda, *Facing the Enemy: A History of Anarchist Organization from Proudhon to May 1968.*

15. Gerrard Winstanley, 'The Law of Freedom in a Platform' (1652), Bilderberg. org (website) http://www.bilderberg.org/land/lawofree.htm (accessed 21 Jan. 2011).

16. Irina Aristarkhova, 'Stepanova's "Laboratory."'

17. See Gregory Scholette, 'Interventionism and the Historical Uncanny.'

18. Ibid.

19. For an account of a number of British art collectives of the 1970s and 1980s, see a doctoral dissertation by Stefan Szczelkun, *Exploding Cinema 1992–1999, Culture and Democracy*, (2002), Stefan Szczelkun (author's website), http://stefan-szczelkun.org.uk (accessed 21 Jan. 2011).

20. The RTMark group (a former incarnation of the Yes Men, an artist collective famously impersonating and performing the WTO and others) database allows people to submit ideas in order for others to fund them or implement them. RTMark (website), http://rtmark.com (accessed 21 Jan. 2011); the Yes Men (website), http://www.theyesmen.org (accessed 21 Jan. 2011).

21. See the projects the Black Factory (website), http://www.theblackfactory.com; and Container (website), http://www.container-project.net (both accessed 21 Jan. 2011).

22. From a series of no border camps to hackers' summer camps; see, for instance, the summer camps of the Berlin-based Chaos Computer Club (website), http://events.ccc.de/camp/2007 (accessed 21 Jan. 2011).

23. Tim O'Reilly, 'What Is Web 2.0? Design Patterns and Business Models for the Next Generation of Software,' O'Reilly Media (website), 30 Sept. 2005, http://www.oreillynet.com/pub/a/oreilly/tim/news/2005/09/30/what-is-web-20.html (accessed 21 Jan. 2011).

24. The term 'Web 2.0' was created as a business slogan, a logo, so it came as little surprise to hear that O'Reilly had applied for a patent on Web 2.0 as a trademark in 2003. The patent was pending the whole time O'Reilly was promoting it as a generic term.

25. O'Reilly Media is a United States-based media company founded by Tim O'Reilly. O'Reilly Media has characterized itself as 'the best computer book publisher' and it is famous for production of influential books, events, and concepts that capitalize on the knowledge of 'alpha geeks' and market them within business and programming circles.

26. Andrew Orlowski, 'Web 2.0: It's . . . like Your Brain on LSD!' the Register (website), 21 Oct. 2005, http://www.theregister.co.uk/2005/10/21/web_two_point_nought_poll (accessed 21 Jan. 2011).

27. Richard MacManus and Joshua Porter, 'Web 2.0 for Designers,' *Digital Web Magazine*, 2005, http://www.digital-web.com/articles/web_2_for_designers (accessed 21 Jan. 2011).

28. Paul Graham, 'Web 2.0,' Paul Graham (author's website), 2005, http://www.paulgraham.com/web20.html#f1n (accessed 21 Jan. 2011).

29. Jeffrey Zeldman, 'Web 3.0,' A List Apart (website), 2006, http://www.alistapart.com/articles/web3point0 (accessed 21 Jan. 2011).

30. O'Reilly, 'What Is Web 2.0?'

31. Paul Boutin, 'Web 2.0 Doesn't Live Up to its Name,' *Slate*, 29 Mar. 2006, http://www.slate.com/id/2138951; Nate Anderson, 'Tim Berners-Lee on Web 2.0: "Nobody Knows What it Means,"' *Ars Techica*, 2006, http://arstechnica.com/news.ars/post/20060901–7650.html (both accessed 21 Jan. 2011).

32. The term 'automated curating' appears to originate from Eva Grubinger's project *C@C—Computer-Aided Curating* (1993–1995). For an account of the project, see Eva Grubinger, 'C@C, Computer-Aided Curating (1993–1995)

Revisited.' Automated curation is usually referred to as a process detached from an individual curator and distributed between software and community, organized in the form of a self-developing system. The term itself, in my opinion, by trying to build a dichotomy between curation by an individual for an institution and other forms of curation, generally overestimates the degree of automation of such a process.

33. See Yochai Benkler, *The Wealth of Networks: How Social Production Transforms Markets and Freedom*, chap. 3.

34. Throughout this book, 'free software' will be used to refer to the free software movement in its original undifferentiated pathos, with its revolutionary rhetoric and a hope to transform society. 'Free software' as such is usually associated with the figure of Richard Stallman and the year 1983. 'Open source' will be used to refer to a more pragmatic, business-oriented trend in FLOSS development, started by Eric Raymond in 1998 with the Open Source Initiative. FLOSS as a generic term comprising both 'free software' and 'open-source software' was promulgated by Rishab Aiyer Ghosh. Ghosh explains that as an umbrella term, FLOSS originates from the titles of the project funded by the European Union's Fifth Framework Programme (IST), whose team was comprised of Ghosh, Ruediger Glott, Bernhard Krieger, and Gregorio Robles. Though Ghosh currently contributes to the pragmatic shift in free software development, 'FLOSS' will be used in this book as a generic 'neutral' term, in places where there is no need to emphasize either revolutionary hopes or business plans.

35. Sven-Olov Wallenstein, 'Institutional Desires.'

36. Ibid.

37. Although many humanities scholars may have never heard of organization theory, its project is an exemplary and juicy story in the understanding of the changing figure of the human that cannot be missed if we want to understand contemporary cultural forms of life. The following makes a good example of communicative misfortunes in academia. In his account of the history of organization theory, W. Richard Scott maintains that organizations constitute a particular level of juncture between normative, regulative, and cognitive perspectives that are part of 'institutions.' Such institutions give form to social meaning and enable social action while maintaining their sustainability. In Scott's terminology, art or culture would be a carrier of an institution of cognitive perspective, whereas a museum would be an organization that represents a particular combination of mechanisms of control (regulative), of valorization (normative), and of symbolic construction (cognitive). In this context, a Weberian social organization would stand for an institution, whereas organization would be something rather more concrete and formal. (See W. Richard Scott, *Institutions and Organizations*, 63). In this context, institutions would structure organizations—a theoretical language improper for cultural theorists, who would be shocked to learn that art is an institution whereas an art institution is, in fact, an organization.

38. Max Weber, *The Theory of Social and Economic Organization*.

39. See, for instance, Charles B. Handy, *Understanding Organizations*.

40. Such as Gustav Schmoller, Thorstein Veblen, John Commons, Westley Mitchell, J. A. Schumpeter, Emile Durkheim, and later, Talcott Parsons.

41. Talcott Parsons, *Structure and Process in Modern Societies*.

42. Such analysis of the organization was functionalist (purposeful), hierarchical (in terms of forms of power), and representational (in terms of the forms of the construction of meaning). It focused on interaction between entities as ontologically definite sculptural elements of organization entering into relationships between each other, a perspective that substantially deforms the

processual, informative character at the basis of an open-ended formation of agents and one that inherently tends to reduce the horizon of their potential interplay. For a critical account, see, for instance, John Hassard, Mihaela Kelemen, and Julie Wolfram Cox, *Disorganization Theory: Explorations in Alternative Organizational Analysis.*

43. The break traditionally drew some lament from those standing for a united and forceful well-synthesized paradigm of organization theory with a link to 'real' organizations, a state of affairs that would in turn contribute towards a longer life span and better material resources for the discipline. For a short and coherent introduction to the paradigms discussion in organization theory, see John Hassard, Kelemen, and Cox, chaps. 1 and 2, 'Paradigm Plurality and Its Prospects' and 'Organizational Knowledge: Production and Consumption.'

44. Gabriel Tarde, *The Laws of Imitation.*

45. Campbell Jones and Rolland Munro, eds., *Contemporary Organization Theory*, 30–31.

46. Gibson Burrell, 'Radical Organization Theory.' It is due to his efforts and those of his colleagues, Clegg and Hassard, that organizational studies became a more open enterprise. The way in which the logocentric representational focus of organization theory suppressed informal and rhizomatic forms of becoming was challenged. Burrell, and also David Cooper, brought postmodern philosophy into organization theory and worked on the construction of the basis for thinking the process of organization, emphasizing 'the production of organization rather than the organization of production.' See Stewart Clegg, *Power, Rule and Domination: A Critical and Empirical Understanding of Power in Sociological Theory and Organizational Life*; and Stewart Clegg and David Dunkerley, *Organization, Class and Control.*

47. John Hassard, Kelemen, and Cox, 132.

48. Ibid.

49. See, for instance, Antonio Strati, *Organization and Aesthetics*; Stephen Linstead and Heather Höpfl, *The Aesthetics of Organization.*

50. A. Rice, *Productivity and Social Organization.*

51. Though system theory can be traced back at least to Alexander Bogdanov and his *Tectology*, originally published between 1912 and 1917, and cybernetics as a model of thinking draws from experimentation rooted in the nineteenth century.

52. See, Ludwig von Bertalanffy, *General System Theory: Foundation, Development, Application*, 4; Norbert Wiener, *The Human Use of Human Beings*, 5–6.

53. Bertalanffy, 28.

54. For accounts demonstrating at times rather hidden linkages between technological developments, histories of wars, and domination, see Paul N. Edwards, *The Closed World: Computers and the Politics of Discourse in Cold War America*; and Manuel DeLanda, *War in the Age of Intelligent Machines.*

55. J. Barton Cunningham, *Action Research and Organizational Development*, 19–20.

56. Simon Yuill has done research on ideology of algorithms, analysing certain current trends in software modeling real world situations in a lecture given in Goldsmiths College in October 2008.

57. See, Humberto R. Maturana and Bernhard Poerksen, *From Being to Doing: The Origins of the Biology of Cognition.*

58. In his contribution to the philosophy of art, Rancière reflects on the political function of the aesthetic spectrum. This spectrum is composed of ways of 'doing and making,' their 'forms of visibility,' and ways of thinking about

their corresponding articulation. Here, forms of visibility (the distribution of the sensible) define the range of possibilities and modes of doing in a particular setting, a setting that may itself be an artwork, and it is precisely at this point that aesthetic practice becomes political engagement. If traditionally aesthetics is a function of perception, then the subject of perception is certainly the first thing to question. Is it human, animal, or technical? What is it that constitutes a percept, and how does it carry itself? See Jacques Rancière, *The Politics of Aesthetics*, 10.

59. Art and aesthetics had access to truth from their first conceptualization in the classical Greek thought of the seventh and sixth centuries BC to Plato and Aristotle. In his earlier writings, Badiou reminds us of art having a closer and more direct relationship with reality, if not access to or comparable level of existence with it, that philosophy can only envy. See, for instance Alain Badiou, *Peut-on penser la politique?* In Badiou's *Handbook of Inaesthetics*, it is the peculiarities of relationship to truth that define the understanding of art that philosophy can offer. Thus, for Badiou, didacticism (and here he places Plato and Marxism) understands art as the appearance of truth that is external to art, and therefore, art can only exhibit semblance to a truth, or rather a dangerous charm of a semblance, and has to have an instrumental-educational role. Romanticism endows art with the capacity to be the sole incarnation of truth. A classical vector (Aristotelian and psychoanalytical) regards art in terms of semblance, which is not intended. The semblance of truth which is then transference, is something that the truth scrapes out in the imaginary, where art ends up positioned. Art serves.

60. Badiou, *Handbook of Inaesthetics*.

61. Here, artistic truth exists through the recurrence and configurations of works of art (their multiplicity constitutes Badiou's event), where every individual work is an actualization of a fragment of truth. Ibid.

62. Friedrich Nietzsche, *The Birth of Tragedy and Other Writings*, 19, 120.

63. Isabelle Stengers, *Power and Invention: Situation Science*.

NOTES TO CHAPTER 1

1. Dmitry Kleiner and Brian Wyrick, 'Info-Enclosure 2.0.' In practical terms, criticism of participatory Web relies partly on the fact that 'grass-roots' initiatives launched by start-up companies, such as LiveJournal.com or YouTube.com, are later bought and managed by large corporations, subsuming all the collective effort that in fact has created the platform and in this way, monetizing the creative value that has been communally constructed. Commercial profit accrued by owners from platforms where users 'freely' create, collaborate, and communicate seems at least unjust if not highly problematic in terms of the financialization of individual and social becoming. The rapid expansion and 'devouring' of the Web involving the accumulation of large data sets and 'centralization' of power—for instance, by Facebook.com—complicates this issue further.

2. Tim O'Reilly claims: 'Much as the rise of proprietary software has led to the Free Software movement, we expect the rise of proprietary databases to result in a Free Data movement within the next decade.' Tim O'Reilly, 'What Is Web 2.0? Design Patterns and Business Models for the Next Generation of Software,' O'Reilly Media (website), 30 Sept. 2005, http://www.oreilly-net.com/pub/a/oreilly/tim/news/2005/09/30/what-is-web-20.html (accessed 21 Jan. 2011). Eugene Gorny, for instance, pursues an initiative to enable the Russian sector of the blogging platform LiveJournal.com to run on a

peer-to-peer (P2P) basis. Gorny came up with the idea to create a system of P2P backup that would enable the running of blogs without central servers. He came to the conclusion that this could be done quite easily with the help of existing programs, if P2P is transformed into F2F (friend-to-friend, a 'closed' analogy of P2P, with a limited and delayed ability to add new friends), but to my knowledge, the realization of such a 'function' has not yet been attempted. See Eugene Gorny, 'Muzyka_sfer,' (author's personal website, notes published on the project blog), 2007, http://muzyka-sfer.livejournal.com/ (accessed 21 Jan. 2011).

3. Among a number of theorists writing about the network society, Manuel Castells has probably produced the most pages. See the volumes in a series, first of which is Manuel Castells, *The Rise of the Network Society: Economy, Society and Culture*, vol. 1, *The Information Age*.

4. Antonio Negri, *Revolution Retrieved: Selected Writings on Marx, Keynes, Capitalist Crisis and New Social Subjects*, 205.

5. Ibid.

6. David Harvey, *A Brief History of Neoliberalism*.

7. Brian Holmes, 'The Flexible Personality: For A New Cultural Critique.'

8. Andrew Ross, *No-Collar: The Humane Workplace and Its Hidden Costs*.

9. Matthew Fuller, ed., *Software Studies: A Lexicon*, introduction.

10. Yochai Benkler, *The Wealth of Networks: How Social Production Transforms Markets and Freedom*, 278–79.

11. Ibid., 143, and elsewhere.

12. Richard Florida, *The Rise of the Creative Class*, 40–42.

13. Joseph Feller et al., eds., *Perspectives on Free and Open Source Software*; Rishab Aiyer Ghosh, ed., *CODE, Collaboration, Ownership and the Digital Economy*.

14. 'FLOSS-related services . . . reach a 32% share of all IT services by 2010, and the FLOSS-related share of the economy . . . 4% of European GDP by 2010. FLOSS directly supports the 29% share of software that is developed in-house in the EU (43% in the U.S.), and provides the natural model for software development for the secondary software sector. . . . Firms have invested an estimated Euro 1.2 billion in developing FLOSS software that is made freely available.' Rishab Aiyer Ghosh, *Study on the Economic Impact of Open Source Software on Innovation and the Competitiveness of the Information and Communication Technologies (ICT) Sector in the EU, Final Report*.

15. Ibid.

16. Creative Commons (website), http://creativecommons.org (accessed 21 Jan. 2011).

17. Continued: 'Where we would benefit from making space available for the political, the Creative Common's ideological stance has the effect of narrowing and obscuring political contestation, imagination and possibility. As a result, the Creative Commons network provides only a simulacrum of a commons. *It is a commons without commonality* [italics in the original]. Under the name of the commons, we actually have a privatised, individuated and dispersed collection of objects and resources that subsist in a technical-legal space of confusing and differential legal restrictions, ownership rights and permissions.' David M. Berry and Giles Moss, 'On the 'Creative Commons': A Critique of the Commons without Commonalty.'

18. See Lawrence Liang, *Guide to Open Content Licenses*; Lawrence Lessig, *Free Culture: How Big Media Uses Technology and the Law to Lock Down Culture and Control Creativity*. Feller et al., *Perspectives*.

19. GNU General Public License (website), http://www.gnu.org/copyleft/gpl.html (accessed 21 Jan. 2011).

20. Whereas the philosophy of art has dedicated extensive thought to this matter, it is probably worth referencing here a rather pragmatic approach by Pierre Bourdieu, for instance, in *The Rules of Art: Genesis and Structure of the Literary Field*.
21. Nicolas Malevé, 'Creative Commons in Context,' 64.
22. See an excellent analysis in Aymeric Mansoux, 'My Lawyer Is an Artist: The License as Art Manifesto.'
23. Simon Yuill, 'All Problems of Notation Will Be Solved by the Masses: Free Open Form Performance, Free/Libre Open Source Software, and Distributive Practice.'
24. Karl Marx, *Comment on James Mill*, Éléments D'économie Politique (written 1844), Marxist Internet Archive (website), http://www.marxists.org/archive/marx/works/1844/james-mill/index.htm (accessed 21 Jan. 2011).
25. Steve Wright, *Storming Heaven: Class Composition and Struggle in Italian Autonomist Marxism*, 38.
26. Ibid., 40–41.
27. Antonio Negri, *Revolution Retrieved. Selected Writings on Marx, Keynes, Capitalist Crisis and New Social Subjects*, 209.
28. Paolo Virno and Michael Hardt, *Radical Thought in Italy: A Potential Politics*, 133.
29. Tiziana Terranova, 'Free Labor: Producing Culture for the Digital Economy.'
30. Paolo Virno, *A Grammar of the Multitude*, 64.
31. Terranova, 'Free Labor.'
32. Ibid.
33. Tiziana Terranova, *Network Culture: Politics for the Information Age*, 79, 84.
34. Ibid., 83–84, 91.
35. Ibid., 94.
36. Ibid., 79.
37. Ibid., 153.
38. Ibid., 108.
39. Jameson suggests that the charge of Adorno's aesthetic theory is the tension between 'his formal project of desubjectifying the analysis of aesthetics phenomena' and 'his commitment . . . to prolong the traditional framework of philosophical aesthetics—to the description of aesthetic experience: some last remnant of absolutely subjective categories.' Fredric Jameson, *Late Marxism: Adorno and the Persistence of the Dialectic*, 123.
40. Gilles Deleuze, *Postscript on the Societies of Control*, 3–7.
41. Wendy Hui Kyong Chun, *Control and Freedom: Power and Paranoia in the Age of Fiber Networks*, 272, 290–91.
42. See 'Soft Control' in Terranova, *Network Culture*.
43. See Matthew Fuller, *Softness: Interrogability; General Intellect*.
44. Keith Negus and Michael Pickering, *Creativity, Communication, and Cultural*; Mihaly Csikszentmihalyi, *Creativity: Flow and the Psychology of Discovery and Invention*; Dean Keith Simonton, *Origins of Genius: Darwinian Perspectives on Creativity*; Robert Sternberg, ed., *Handbook of Creativity*.
45. Raymond Nickerson, 'Enhancing Creativity,' in Sternberg, *Handbook of Creativity*.
46. See, for instance, David Bohm, *On Creativity*.
47. See, for instance, an email from Brian Holmes, 'Subject: Year Zero Amsterdam Creative City,' Nettime.org (website mailing list), 6 Mar. 2008, http://www.nettime.org/Lists-Archives/nettime-l-0803/msg00009.html (accessed 21 Jan. 2011).

48. See, for instance, Merijn Oudenampsen, 'Back to the Future of the Creative City: An Archeological Approach to Amsterdam's Creative Development.'

49. Thomas Osborne, 'Against "Creativity": A Philistine Rant'; Alberto Toscano, 'In Praise of Negativism.'

50. See Matthew Fuller, 'Art Methodologies in Media Ecology.'

51. Henri Bergson, *Creative Evolution*, 250–51.

52. Ibid., 251.

53. Ibid., 269.

54. Ibid., 252, 264.

55. Isabelle Stengers and Ilya Prigogine, *Order Out of Chaos: Man's New Dialogue with Nature*, 93–96.

56. Alfred North Whitehead, *Modes of Thought*, 151.

57. Ibid., 151.

58. Ibid., 146, 164.

59. Alfred North Whitehead, *Process and Reality, An Essay in Cosmology*, 31–32.

60. Manuel DeLanda, *Intensive Science and Virtual Philosophy*, 174–75.

61. See, for instance, M. C. Yovits and S. Cameron, eds., *Self-Organizing Systems*; Heinz von Foerster and George Zopf, eds., *Principles of Self-Organization*.

62. Ross Ashby, 'Principles of the Self-organizing Dynamic System,' *Journal of General Psychology* 37, 1947.

63. Humberto R. Maturana and Francisco J. Varela, *Autopoiesis and Cognition: The Realization of the Living*.

64. Ibid., 79.

65. Humberto R. Maturana, Francisco J. Varela, *The Tree of Knowledge. The Biological Roots of Human Understanding*.

66. For instance, the Cerisy Symposium proceedings were published by Paul Dumouchel and Jean-Pierre Dupuy, eds., as *L'Auto-organisation, de la physique au politique*.

67. See, for instance, one of his earlier articles, in which he talks about the problems of applying the notion of autopoiesis to social systems. Niklas Luhmann, 'The Autopoiesis of Social Systems.'

68. See Scott Camarine, Jean-Louis Deneubourg, et al., eds., *Self-organization in Biological Systems*; Stuart A. Kauffman, *The Origins of Order: Self-organization and Selection in Evolution*.

69. Andrew Pickering, 'Cybernetics and the Mangle, Ashby, Beer and Pask.'

70. Brian Holmes, 'Future Map,' Continental Drift (website), http://brianholmes.wordpress.com/2007/09/09/future-map (accessed 21 Jan. 2011).

71. Pickering, 'Cybernetics,' 422.

72. Blake Stimson and Gregory Scholette, 'Periodising Collectivism.' See also Blake Stimson and Gregory Scholette, eds., *Collectivism after Modernism: The Art of Social Imagination after 1945*.

73. See, for instance, Johanna Billing, Maria Lind, and Lars Nilsson, eds., *Taking the Matter into Common Hands: On Contemporary Art and Collaborative Practices*; David Butler and Vivienne Reiss, eds., *Art of Negotiation*; Claire Bishop, ed., *Participation*; *Third Text*, vol. 18, no. 6, special issue (2004).

74. For examples, see Clay Shirky, *Here Comes Everybody: The Power of Organizing without Organization*.

75. Gilles Deleuze and Félix Guattari, *A Thousand Plateaus: Capitalism and Schizophrenia*. For a development of Deleuzo-Guattarian self-organization, see Manuel DeLanda, *A Thousand Years of Nonlinear History*.

76. See Félix Guattari, 'Machinic Heterogenesis, Machinic Orality and Virtual Ecology,' in *Chaosmosis: An Ethico-Aesthetic Paradigm*, 35, 40, and other essays in the same volume.

77. Ibid., 45.
78. Ibid., 56.
79. Ibid., 53.
80. Ibid., 50.
81. Ibid., 55.
82. Jacques Rancière, 'Problems and Transformations in Critical Art,' in Bishop, *Participation*.
83. Often referenced in the context of participatory art's critical account of Habermas and as an introduction of the idea of multiple public spaces is Oskar Negt and Alexander Kluge, *Public Sphere and Experience: Analysis of the Bourgeois and Proletarian Public Sphere*; Hannah Arendt, *The Human Condition*.
84. Nina Montmann, 'Art and Its Institutions.'
85. Nicolas Bourriaud, *Relational Aesthetics*.
86. Maria Lind, 'The Collaborative Turn,' in Billing, Lind, and Nilsson, *Taking the Matter into Common Hands*.
87. Anthony Davies, Stephan Dillemuth, and Jakob Jakobsen, 'There Is No Alternative: The Future is Self-Organized—Part1.'
88. Accounts of subjectification, and especially those concentrating on its relation to the technical, were inspired by Gilbert Simondon, who analysed the individuation of technical objects and the rise of associated milieu as concrete mixed assemblages, akin to living beings. See Gilbert Simondon, 'On the Mode of Existence of Technical Objects.' His work on individuation is available in French as *L'individuation psychique et collective*. Deleuze's, Guattari's, and Foucault's work on subjectification were profoundly influenced by Simondon; see Bernard Stiegler, 'About Simondon and the Current Question of Our Powerlessness in the Era of Nanotechnologies.' Individuation, according to Simondon, is not equal to subjectification because it occurs to all instances, not only subjects; but subsequent uses of the term made space for a more general use, followed in this book, where subjectification is not necessarily anthropomorphic and individuation can be regarded as its part.
89. Guattari, *Chaosmosis*, 91.
90. Virno, *A Grammar of the Multitude*, 84.

NOTES TO CHAPTER 2

1. Transduction here refers to the process of establishing or transforming entities and energies that are disparate or that exist at intersections of diverging realities. It is through transduction that they are able to enter a different process of becoming. Transduction is reliant on the sense in which technicity actualizes itself with and through humans, nonhumans, and collectives. Such meaning of the term is offered by Adrian Mackenzie in *Transductions: Bodies and Machines at Speed*. Mackenzie draws from Simondon and attends to Stiegler's thought.
2. *Economy and Society* released a special issue on Gabriel Tarde in 2007 (vol. 36, no. 4), a follow-up on a conference held in Goldsmiths in 2005. See also Bruno Latour, 'Gabriel Tarde and the End of the Social'; Éric Alliez, 'The Difference and Repetition of Gabriel Tarde'; David Toews, 'The New Tarde: Sociology after the End of the Social.' Gabriel Tarde's *The Laws of Imitation* were reprinted in 2009 by BiblioBazaar and in 2010 by General Books. See also Bruno Latour and Vincent Lepinay, *The Science of Passionate Interests: An Introduction to Gabriel Tarde's Economic Anthropology*.
3. Alliez, 'Difference and Repetition.'

4. Latour and Lepinay, *Science of Passionate Interests.*
5. Contrary to that, Lisa Blackman argues that Tarde's work remained an influence on Anglo-American social psychology and European mass psychology. See Lisa Blackman, 'Reinventing Psychological Matters: The Importance of the Suggestive Realm of Tarde's Ontology.'
6. Gabriel Tarde, *The Laws of Imitation,* 73.
7. Ibid., 72.
8. See Latour and Lepinay, *Science of Passionate Interests.*
9. Tarde, *Laws of Imitation,* 73.
10. Ibid., 145–46.
11. Ibid., 146.
12. Ibid., 50, 87–88, 150.
13. Blackman, 'Reinventing,' 581.
14. Gilles Deleuze, *Difference and Repetition,* 8.
15. See Deleuze, *Difference and Repetition,* 34n15.
16. Ibid., 2–3.
17. Ibid., 12.
18. Ibid., 51.
19. Ibid., 66.
20. Ibid., 69, 16–19.
21. Ibid., 141, 153.
22. Ibid., 365. See also a rather unusual interpretation, one that is brave in its explanatory drive, by James Williams, *Gilles Deleuze's "Difference and Repetition": A Critical Introduction and Guide,* 365.
23. Deleuze, *Difference and Repetition,* 368–69.
24. Ibid.
25. Gilles Deleuze, *Francis Bacon,* 63.
26. Ibid., 62–65.
27. Deleuze, *Difference and Repetition,* 365.
28. Ibid.
29. Jean-Francois Lyotard, *Soundproof Room: Malraux's Anti-aesthetics,* 102, 96.
30. Guattari, *Chaosmosis,* 106–7.
31. See Deleuze, *A Thousand Plateaus,* 175; Gregory Bateson, *Steps to an Ecology of Mind,* 107–28.
32. *Kreativ* is a loan word from the English 'creative.' This term appeared as a result of the arrival of capitalism in Russia. It is often used in connection with the labour of the *kreators* (creatives, the authors of the texts, plans, and concepts for various kinds of promotion and advertisement). It is interesting that the corresponding Russian words that probably retain their reference to divine creation and to 'high culture' are never used to designate this activity.
33. Udaff.com is an enterprise funded by enthusiasm, as are other art platforms. If we are to consider the commercial profits accrued, we can conduct a rough calculation on the basis of the site's statistics. The following calculation is based on display advertisement that populated Udaff.com during its peak years of existence and is not applicable to content advertisement, presently predominant on the Internet.

Udaff.com registered around 1.5 million hits per month in 2006. If that number is multiplied by 0.0033 (the average click rate is 0.33%), the total number of banner clicks per month is 5,000. On average, Udaff.com had three advertisement banners. If 1,000 banner clicks cost from US$5 to US$15 (an approximate figure obtained from the analysis of different advertisements accessible via the sites), by taking an average sum of US$10, the

following result could be obtained: 5,000 clicks gives US$50 dollars a month for one banner; the total sum accrued for three banners is therefore US$150 a month. Using these calculations as a rough guide, Udaff.com's statement that the advertising revenue from the website only just covers the hosting expenses is credible. The traffic is about one terabyte, and the price for the hosting of such a resource is comparable to the profits accrued from the website's advertisements.

34. Such as 1st place, Net writer of the year, ROTOR++ [Name of the prize] (2000); 1st place, Discovery of the year, ROTOR++ [Name of the prize] (2000); and some others.

35. A concept that would seem rather strange from today's point of view, but from 1998 to 2000, some Russian Internet pioneers were trying to preserve their authority in online spaces by building ratings, such as 'The Most Known People of Ru.Net,' or establishing the 'Russian Academy of Internet' and 'All-Russian Internet Academy' with those who were not invited to the original one, and so on.

36. In the time of its bloom, Udaff.com was comparable in popularity with mainstream information sources. In 2005, it had 35,000 unique visitors per day who would open 16.5 pages on average, whereas a news service RBC (RosBusinessConsulting (website), http://rbc.ru [accessed 21 Jan. 2011]) would log 90,000 users with less than five requests for pages.

37. Mikhail Bakhtin spoke of the specific materiality of genre, of genre as a means for the artist's 'reclamation' of reality. 'The word-artist has to learn to view the reality through the eyes of the genre.' Mikhail Bakhtin, *Éstetika slovesnogo tvorchestva*, 332. The essays included are published in English as Mikhail Bakhtin, *The Dialogic Imagination: Four Essays* (University of Texas Press, 1982); and Mikhail Bakhtin, *Toward a Philosophy of the Act* (University of Texas Press, 1993).

38. Klaus Theweleit, *Male Fantasies*, vol. 1, *Women, Floods, Bodies, History*; and *Male Fantasies*, vol. 2, *Male Bodies—Psychoanalyzing the White Terror*.

39. Several publications on the subject of the penetration of network jargon into everyday Russian language focus on the 'erratic' semantics of the new literary genres and fields enabled by the digital media. Gasan Guseinov, *Berloga vebloga* (blog), 'Vvedenie v érraticheskuyu semantiku' (An introduction into erratic semantics), 2005, http://www.speakrus.ru/gg/microprosa_erratica-1.htm? (accessed 21 Jan. 2011).

40. Velimir Khlebnikov, 'Nasha osnova' (Our foundation). Khlebnikov's works can be consulted via Velimir Khlebnikov, *Collected Works of Velimir Khlebnikov*, vol. 1, *Letters and Theoretical Writing*, ed. Charlotte Douglas, trans. Paul Schmidt, (Cambridge, MA: Harvard University Press, 1987).

41. Julia Kristeva, 'Word, Dialogue and Novel.'

42. The usage of *mat* within the 'official' literature is quite new. Edward Limonov, Victor Jerofeev, Vladimir Sorokin, and Victor Pelevin are the authors extensively using *mat* in their work—and none of them began publishing before the 1970s. For English translation, see Edward Limonov, *It's Me, Eddie: A Fictional Memoir* (New York, Grove Press, 1987); Victor Pelevin, *The Blue Lantern: Stories* (London, New Directions, 2000); Victor Pelevin, *The Life of Insects*, new edition (London, Faber and Faber, 1999); Vladimir Sorokin, *Ice* (New York, NYRB Classics, 2007).

 With the fall of the Soviet Union the nonnormative character of *mat* began to weaken. Still, one can presume that within public space the taboo on such a vocabulary as well as on the direct depiction of genitals will continue to stand in the near future.

43. Alexander Plucer-Sarno, *Bol'shoĭ slovar' mata* (Large *mat* dictionary), vol. 1, 77–78.
44. Igor Levshin, 'Étiko-éstéticheskoe prostranstvo Kurnosova-Sorokina' (Ethic-aesthetic dimension of Kurnosov-Sorokin), 1998, in *Biblioteka Moshkova* (website), http://www.lib.ru/SOROKIN/lewshin.txt (accessed 21 Jan. 2011).
45. Plucer-Sarno, *Bol'shoĭ slovar' mata*, 21–22.
46. Udaff.com (website), 'Polemika. Snark Khant: Kontrkul'tura umerla!' (Polemics. Snark Khant: Counterculture is dead!), 1 Jul. 2004, http://www.udaff.com/polemika/35165.html (accessed 21 Jan. 2011).
47. See Udaff.com (website), 'Polemika. Sirius: "Est'" li kontrkul'tura na Udave?" (Polemics. Sirius: 'Is there a counterculture on Udaff.com?'), 15 Oct. 2004, http://www.udaff.com/polemika/37869.html (accessed 21 Jan. 2011).
48. It is rather interesting to see if there are any grounds behind the declared anonymity and unique provision of free and uncensored place on the Net by Udaff.com. The following data was gathered with the help of the 'Whois' service of the domain-names registration system, Joker.com, the Traceroute program, 'view code' in the browser window, and the search engine Yandex. ru. The enquiry demonstrated that the resource's domain name was registered on 2 Apr. 2001; its mirrors, Udaff.org, Udaff.net, Zaloba.ru, and Padonki. ru, were registered later. The domain name 'Udaff.com' was registered for a person with the nickname 'maloletka' with a postal address in Lithuania. For all administrative, technical, and financial questions, users were instructed to contact the person 'maloletka.' Also, the name 'Alexey Besshchekov' was given and an address in the town of Troitsk. The site, registered in Besshchekov's name, publishes the Udaff.com statistics and gives proforg@maloletka. ru as the contact address of the resource's technical support. Udaff.com and its four mirrors are hosted by the Moscow server of the telecommunication company Transtelecom. Thus, the 'mirrors' are not genuine mirrors, for they loose their main function of replicating the site if it goes offline. A 'mirror' is a copy of a website, to which the users are redirected in case the traffic on the original site is heavy or it is down; if all the 'mirrors' are placed on the same server as the original site, then when the server goes down, the site and its copies go down and remain inaccessible.
 The fact that Udaff.com announces 'uncensored hosting' is also quite interesting because the anonymity of the resource is imperfect and its freedom excessively vulnerable. The creator and administrator of the site, Udav, whose real name remained a mystery for some considerable time, was deprived of his alias on 17 May 2005 when the journal Newsru.com declared him to be Dmitriĭ Sokolovskiĭ. See Newsru.com (website), 'Afftar "Russkogo Newsweek": "Padonki" iz Pitera sozdali novyĭ russkiĭ yazyk"' (Author of 'Russian Newsweek': 'Skumbags' from St. Petersburg created a new Russian language), 17 May 2005, http://www.newsru.com/russia/17may2005/afftor. html (accessed 21 Jan. 2011).
49. Dead link; I. Vlasov, 'Udav i ostal'nye' (Udav and the rest), *Ezhednevnye novosti* (Everyday news), 21 Aug. 2001.
50. Udaff.com (website), 'Est'' li kontrkul'tura' (Is there a counterculture).
51. Alexandre Koz and Dmitry Steshin, 'My gadim v pad'ezdakh, no iskrinne' (We shit in the staircases, but with sincerety), *Komsomol'skaya pravda*, 24 Nov. 2003, http://www.kp.ru/daily/23162.5/24867 (accessed 21 Jan. 2011).
52. Udaff.com (website), 'Kontrkul'tura umerla' (Counterculture is dead).
53. 'If culture is the totality of knowledge and skills that allow a man to become an integral part of society, then the counterculture has to be the totality of knowledge and skills allowing one to effectively resist society. The main question is: the culture of WHICH society should be considered

as the main one? . . . In my opinion the culture that dominates Udaff.com possesses all the characteristics of the predominant culture of Russian men between the ages of 20 and 40—i.e. some significant groups of our population. In this sense the Udaff.com culture is mainstream and basic . . . for nothing so popular and so 'visited' as this site can be really counter-cultural. . . . What you see here is not any fucking counterculture, it is the real culture of the male population in this country.' Udaff.com (website), 'Polemika. Sirius: 'Kontrkul'tura ili Udaff.com' (Counterculture or Udaff. com), 28 Sep. 2004, http://www.udaff.net/polemika/37285.html (accessed 21 Jan. 2011).

54. Udaff.com (website), 'Polemika. Temych: Éntsyklopediya po Udaff.com' (Polemics. Temych: Udaff.com encyclopedia), 1 Dec. 2004, http://www.udaff.com/polemika/39231.html (accessed 21 Jan. 2011).

55. Udaff.com (website), 'Rezul'taty golosovaniya: "Ftykatel," chto ty zhdesh' ot kreativa' (Voting results: Switcher, what do you expect from a kreativ), 8 Dec. 2003–15 Jul. 2004, http://voter.land.ru/view.php?pl=33978 (accessed 21 Jan. 2011).

56. See Udaff.com (website), 'Polemika. FimaPsikhopadt: Vopros k kollektivu' (Polemics. FimaPsychopath: A question to the collective), 26 Apr. 2004, http://www.udaff.com/polemika/33606.html (accessed 21 Jan. 2011).

57. Such a theory is interesting in terms of its relationship to the sociological literary theory of the school of Prof. Valerian Pereverzev, smashed by the Communist Party in the late 1920s. Valerian Pereverzev was a highly original thinker who developed an impressive analysis of literature through focusing on the complexity of its reciprocal connections with the social reality. He contributed to the form-content debate of the beginning of the century, and his account at some moments comes close to Mikhail Bakhtin's critique of formalism in *The Formal Method in Literary Scholarship: Critical Introduction to Sociological Poetics* (Baltimore: John Hopkins University Press, 1991). Pereverzev started writing before Bakhtin, and his first book, *Work of Dostoevsky*, originally published in 1912, presents an insightful analysis of Dostoevsky's dramas through the staging of its sociopolitical vectors without ever falling into direct determinism. In this book, for instance, he analyses female characters from positions gender studies developed decades later: for example, through their conceptualization of love informed by their (lack of) agency, constructing the prostitute/saint model of sacrifice. Pereverzev created an influential school of analysis that boomed in the 1920s, drawing on the works of Karl Marx and Georgi Plekhanov, a current interrupted by Stalinist repression and one still not widely known or popularized even within Russian academia. Imprisoned in 1938 and rehabilitated in 1956, Pereversev remains one of the most exciting among the tragic and forgotten theorists of the twentieth century.

The works of Valerian Pereverzev are available only in Russian. See Valerian Pereverzev, *Tvorchestvo Dostoevskogo* (Work of Dostoevsky) (Moscow: Sovremennye Problemy, 1912); and *U istokov russkogo realisticheskogo romana* (Tracing the origins of the Russian realist novel) (Moscow: Khudo-zhestvennaya literatura, 1965). An extensive list of literature accompanied, and to a degree documented, the 'campaign' against Prof. Pereverzev and his school from the late 1920s and early 1930s. See *Protiv men'shevisma v literaturovedenii: O teoriyakh prof. Pereverzeva i ego shkoly—Sbornik statei* (Against Menshevism in literary theory: On the theories of Prof. Pereverzev and his school—A collection of articles) (Moscow: Moskovskii rabochii, 1931); S. Malakhov, *Pereverzevshchina na praktike: Kritika teorii i praktiki* (Pereverzevism in practice: A critique of theory and practice) (Moscow: Gos.

Izd.Khud.Lit., 1931); S. Didamov. *Prof. Pereversev i ego partiĭnye 'druz'ya'* (Prof. Pereverzev and his party 'friends') (Moscow: Gos.Izd.Khud.Lit, 1931).

58. Isaiah Berlin, *Istoriya svobody: Rossiya*. This compilation includes the following articles by Isaiah Berlin: 'A Remarkable Decade,' 1955; 'Artistic Commitment: The Russian Legacy,' 1966; 'Herzen and Bakunin on Individual Liberty,' 1955; 'The Soviet Intelligentsia,' 1957; and others. Many of these are published in Isaiah Berlin, *The Proper Study of Mankind* (New York, Farrar, Straus and Giroux, 2000); and Isaiah Berlin, *Russian Thinkers* (London, Penguin, 1979).

59. As with other phenomena of the 'border' culture, the concept of intelligentsia was taken from Europe. The term itself comes from Latin and was reactivated during the Enlightenment and the French Revolution. In the seventeenth to eighteenth centuries the term denoted a 'capacity to think' or even of 'being educated' and was used mainly in literature. In the nineteenth century the meaning of the term was substantially broadened, acquiring new functions; from this time on, the word 'intelligentsia' was applied to the 'people of conscience,' not only of intellect. It was given new content within the Russian context and brought back to Europe, enriched with new meanings and marked as a 'Russian' term or phenomenon. See Berlin, *Istoriya*; and Mikhail Gasparov, *Zapisi i vypiski* (Notes and extracts).

60. Gasparov, *Zapisi*, 94.

61. Boris Uspensky, *Ét'yudy po russkoĭ istorii* (Etudes in Russian history), 403–4.

62. Ibid., 402.

63. Lev Gudkov, *Negativnaĭa identichnost: Stat'i 1997–2002 godov* (Negative identity: Articles 1997–2002), 717–25.

64. Peter Ludlow and Mark Wallace, *The Second Life Herald: The Virtual Tabloid that Witnessed the Dawn of the Metaverse*, 77.

65. This seems to be one of the major findings of Ludlow and Wallace. On Gazira's griefing, see also Patrick Lichty, 'I Know Gaz Babeli,' 75.

66. Ludlow and Wallace, *Second Life Herald*, 128–43.

67. Ibid.

68. Ibid., 138.

69. Ibid.

70. Gazira Babeli (artist website and documentation), http://gazirababeli.com (accessed 21 Jan. 2011).

71. Second Front (artist group website and documentation), http://slfront.blogspot.com; http://secondfront.org (accessed 21 Jan. 2011).

72. Domenico Quaranta, 'Second Front: A Leap into the Void,' in *Networked Performance* (website), 16 Apr. 2007, http://turbulence.org/blog/2007/04/16/domenico-quaranta-s-interview-with/ (accessed 21 Jan. 2011).

73. See the articles by Patrick Lichty and Alan Sondheim in Quaranta, 'Second Front'.

74. Luther Blissett (website), http://www.lutherblissett.net (accessed 21 Jan. 2011).

75. This is not to say that they are not interesting as a group and Gazira is their leader, although they do say the following in the interview with Domenico Quaranta: 'Second Front is using a growing set of code-based interventions in its performances, thanks to our techno-doyen, Mama Gaz Babeli.' Quaranta, 'Second Front.'

76. The performance group Streetwithaview, populating Google Maps captures with a carnival, group procession, artworks, and performances that can be seen as another example of an art platform making art in terms of reciprocal generation occurring between the systems producing Google Maps, the organizational aesthetics of Streewithaview, art and cultural history, societal

institutions and people. See Streetwithaview (website), http://streetwithaview.com (accessed 21 Jan. 2011).

NOTE TO CHAPTER 3

1. See introduction by Christophe Cherix to Hans Ulrich Obrist, ed., *A Brief History of Curating*. See also Karsten Schubert, *The Curator's Egg: The Evolution of the Museum Concept from the French Revolution to the Present Day*.
2. Bourdieu defines the cultural field as a subfield of restricted production, one that is not directed at large economic markets (production for producers). Opposed to the cultural field, he points to the subfield of large-scale production, aimed at acquiring the maximum profits possible (production for nonproducers). The capital of a subfield of restricted production is symbolic. Symbolic capital (that cannot be reduced to but sometimes can be transformed into economic capital) is achieved through different forms of recognition, legitimation, and consecration exercised in various ways. Pierre Bourdieu, *The Rules of Art: Genesis and Structure of the Literary Field*.
3. Position taking (works, acts, discussions—the strategies of struggle) usually reflects the relationship among the positions. For Bourdieu, the establishment of particular position takings from the 'space of possibles' is defined through dispositions arrived at by and constituting certain elements of particular habitus and the possession of symbolic capital. Changes in the structure of position takings (change in the field) can result from radical change in the space of positions constituted by relations of power and can be caused by new demands from producers or expectations from the public (the larger field of power). Pierre Bourdieu, *The Field of Cultural Production*, 181–82.
4. A new avant-garde group is usually constituted from authors who may be very different in their habitus, but who become united for a moment by their shared negativism towards the dominant position. This negativism is seen by Bourdieu as an instrument for acquiring symbolic capital. Such a process ends up with the dissolution of the group with those of the most privileged dispositions accumulating significant portions of symbolic profits.
5. To summarize, Bourdieu discusses a number of levels of the artistic field: of works (interpreted within the context of available positions and actual position takings); of producers (informed by their habitus, taking positions within the field, that define their social trajectory); of structure of the field (constituted by relations among the positions, among the position takings, between works and institutions of consecration, between the new and old avant-gardes), and the position of the field within the larger field of power. Bourdieu, *The Field of Cultural Production*.
6. Ibid., 121–22.
7. See Simondon, *On the Mode of Existence of Technical Objects*. Bernard Stiegler, *Technics and Time*, vols. 1 and 2.
8. For accounts of new kinds of curating, see Joasia Krysa's 'From Object to Process and System' and other articles in Christiane Paul, ed., *New Media in the White Cube and Beyond: Curatorial Models for Digital Art*.
9. See Adrian Mackenzie, *Cutting Code: Software and Sociality*, the field of software studies, with Matthew Fuller, ed., *Software Studies: A Lexicon*, and the series of the same name from MIT Press.
10. See Florian Cramer and Matthew Fuller, 'Interface,' in Fuller, *Software Studies*.

11. For instance, interchangeability analysed as 'import/export' by Lev Manovich in Fuller, *Software Studies* 1, 119–124.
12. This is an approach generally utilized in software studies.
13. See Mackenzie, *Cutting Code*.
14. See Matthew Fuller, 'A Means of Mutation: Notes on I/O/D 4: The Web Stalker.'
15. Runme.org was launched on the 15 January 2003. It was developed in three months, from the first email inviting discussion of the project until its official launch. Through the three months, not only were the database structure, interface design, and the questions of moderation discussed, but the idea itself of the software art repository was discovered 'out of thin air' and was realized through discussing, designing, programming, testing, and polishing. Runme.org was conceptualized by a group of ten people who took part in the discussion via a mailing list: Amy Alexander, Florian Cramer, Matthew Fuller, Olga Goriunova, Thomax Kaulmann, Alex McLean, Pit Schultz, Alexei Shulgin, and the Yes Men. Upon moving from discussion to designing Runme.org, a new mailing list was created in order not to spam people's mailboxes with a lot of possibly uninteresting, largely technical details. Everyone was invited to sign up for the new list on their own, but four have done so: Alexei Shulgin, myself, Amy Alexander, and Alex McLean (who coded the system). These four became the continuous Runme.org administrators, whereas the larger team and many more people took part in uploading and writing about the projects throughout subsequent years. There are about five hundred projects submitted and accepted, and about a hundred features written, all accessible on the platform.
16. Such as, for instance, Sourceforge.net (website), http://sourceforge.net; or Tucows Downloads (website), http://tucows.com; Sweetcode.org (website), http://sweetcode.org (all accessed 21 Jan. 2011).
17. There are twenty-four categories with forty-three subcategories and around 250 keywords.
18. Our keywords, conceptualized as an 'irrational taxonomy' (and any similar mechanism of attributing keywords to projects largely applied at online databases at the time when Runme.org was created) are largely similar to today's 'tags,' proximate in their use to those of online social bookmarking sites and tagging platforms, such as Del.icio.us at http://del.icio.us (accessed 21 Jan. 2011). Such tags create folksonomies, systems for the collaborative categorization of online content by applying tags (labels). The advocates of folksonomy claim that it is a low-cost and efficient categorization instrument. Folksonomies work because a user often finds a person that categorizes content in a (personal) way that is similar to her own, which thus makes a particular folksonomy very useful for a particular user. Displaying the most popular object, the use of keyword clouds, and search narrowed down through a step-by-step process, as implemented at Runme.org, are all features of today's collaborative tagging platforms.
19. Providing a title, names of authors, text and visual info, providing a URL or uploading a file, choosing a category/subcategory, suggesting a new subcategory, attributing keywords.
20. On average, one-third of the projects submitted are turned down. For the first year, the scheme was as follows: A project first waited for two yes votes (out of four) to gain approval. The same procedure was used for disapproval. A wiki page was sketched where all the projects were supposed to be discussed. In extreme situations, an email to the Runme.org mailing list was also an option. Approximately one year later the scheme changed: Each one administrated for two weeks in turn. Others helped if help was necessary

(i.e., technical platforms are unavailable, lack of technical skills to judge, or difficulty making a decision). Later, Amy Alexander took on most filtering work on Runme.org and continues to take care of the project most devotedly and consistently.

21. The jury members of the first Readme 2002 festival decided it was impossible to rank software art projects, explaining that 'the term «software art» is a decidedly broad category, and each of the awarded projects takes a very different approach to it. . . . In recognition of the fact that «software art» is not simply one genre but encompasses a variety of approaches, the jury has decided to dispense with the rankings and award each of the three selected projects equivalent prizes. Since readme 1.2 is one of the pioneering festivals of software art we felt it necessary to open up the field rather than to prematurely narrow it down.' Amy Alexander, Cue P. Doll, Florian Cramer, RTMark, and Alexei Shulgin, 'Read_me 1.2 Jury Statement,' 2002, Runme. org (website), http://readme.runme.org/1.2/adden.htm (accessed 21 Jan. 2011).

22. There is not a shared opinion on this today, however. The introduction to *New Media Art* by Mark Tribe and Reena Jana suggests net art and software art are both equal subgenres of new media art, whereas *Internet Art* by Rachel Greene includes software art in net art in a rather direct manner. See Mark Tribe and Reena Jana, *New Media Art*; and Rachel Green, *Internet Art*.

23. Alexei Shulgin and Nathalie Bookchin, 'Introduction to net.art (1994–1999),' Easylife.org (website), 1999, http://easylife.org/netart (accessed 21 Jan. 2011).

24. Deconstructions of HTML by Jodi, for instance, later lead to the modification of an old computer video game (*Wolfenstein 3D*) titled *SOD* (1999) and other games. Some other net art projects popular at that time could be seen as a step towards software art (i.e., *Multi-cultural Recycler* by Amy Alexander, 1996/1997). One of the influential pieces of software art, generative vector graphics application *Auto-Illustrator* by Adrian Ward, was already released in 2001. Towards the end of the 1990s and beginning of the 2000s, a few papers appeared that were later attributed to software art discourse. See Matthew Fuller and Simon Pope, 'Warning . . . This Computer Has Multiple Personality Disorder,' pHreak Webhub (website), 1995, http://www.phreak.co.uk/i_o_d/warning.html; Saul Albert, 'Artware,' *Mute*, no. 14 (1999), http://twenteenthcentury.com/saul/artware.htm; Adrian Ward, 'How I Drew One of My Pictures,' 1999, Generative.net (website), http://www.generative.net/papers/autoshop/index.html; Geoff Cox, Alex McLean, and Adrian Ward, 'The Aesthetics of Generative Art,' Generative.net (website), 2000, http://generative.net/papers/aesthetics/ (all accessed 21 Jan. 2011).

25. Ulrike Gabriel and Florian Cramer, 'Software Art' (2001), Netzliteratur.net (website), http://www.netzliteratur.net/cramer/software_art_-_transmediale.html (accessed 21 Jan. 2011); Florian Cramer, 'Concept, Notation, Software, Art,' Netzliteratur.net (website), 2002, http://www.netzliteratur.net/cramer/concepts_notations_software_art.html (accessed 21 Jan. 2011); See also Albert, 'Artware.'

26. Jacob Lillemose, *Art as Information Tool: Critical Engagements with Contemporary Software Culture*, PhD dissertation, University of Copenhagen, 2010.

27. See Florian Cramer, *Words Made Flesh* (Rotterdam: Piet Zwart Institute, 2005), Piet Zwart Institute (website), http://pzwart.wdka.hro.nl/mdr/research/fcramer/wordsmadeflesh/ (accessed 21 Jan. 2011).

28. Inke Arns, 'Read_me, Run_me, Execute_me: Software and Its Discontents, or: It's the Performativity of Code, Stupid!'; Geoff Cox, Alex McLean, and Adrian Ward, 'Coding Praxis: Reconsidering the Aesthetics of Code'; and Amy Alexander, Nick Collins, et al., 'Live Algorithm Programming and a Temporary Organisation for Its Promotion.'

29. From 1954 onwards, according to Paul Ceruzzi, *A History of Modern Computing*, 86–87; or from Short Code language (from the year 1950), according to Florian Cramer, 'Language' in Fuller, *Software Studies*.

30. Namely, by the Massachusetts Institute of Technology (MIT) in the end of the 1950s; see Steven Levy, *Hackers: Heroes of the Computer Revolution*. According to Levy, it was in 1961 that the first computer game 'space war' was created by 'Slug' and other students of MIT as a 'hacker aberration' (Levy, 65).

31. Levy, *Hackers*.

32. The Transmediale call for proposals used the following formula: 'The definition that we use for the as yet barely defined field of artistic software is that it incorporates projects in which self-written algorithmic computer software . . . is not merely a functional tool, but is itself an artistic creation and a form of aesthetic expression.' See email from Andreas Broeckmann, subject line 'Call for Entries,' 2000, http://amsterdam.nettime.org/Lists-Archives/nettime-bold-0009/msg00045.html (accessed 21 Jan. 2011). When releasing the call for works for the first Readme in 2001, the following description was cooked up: 'The following works can be referred to as artistic software: 1. Instructions (read_me) on adjusting standard (commonly used) software, as well as patches and any kind of impact on software, whose results are not planned by producers and application of which leads to creation of an artistic product; 2. Deconstruction of existing software products, including computer games. 3. Written from scratch program with purpose differing from usual rational software purposes, i.e., refusal of the idea of a program as a purely pragmatic tool.' See Olga Goriunova, Alexei Shulgin, and Sergei Teterin, 'Call for Works,' Runme.org (website), 2001, http://readme.runme.org/1.2/abouten.htm (accessed 21 Jan. 2011).

In May 2002 Florian Cramer as a part of Readme 2002 jury group proposed a generic description of software art that subsequently became widely used: 'Software art . . . [is] art of which the material is formal instruction code, and/or which addresses cultural concepts of software.' See Olga Goriunova and Alexei Shulgin, eds., *Read_me Festival 1.2. Software Art/Software Art Games*.

33. In one year, a number of events dedicated to one or another form of software art were held: art.bit in Tokyo, Generator (Liverpool Biennale) in Great Brittain, CODeDOC (Whitney Museum) in New York, and the Electrohype conference in Malmo (Sweden). In 2003/2004 other events were held: 'Software Art—Artistic Future or Curatorial Fiction?' panel discussion, Kuenstlerhaus Bethanien in cooperation with Transmediale.03, Berlin; Ars Electronica 'Code' edition, Linz, Austria; 'Skinning Our Tools' symposium, Banff New Media Center, Banff, Canada; 'Art-Oriented Programming' symposium, Paris, France; and several other related events and initiatives.

34. Runme.org grew from the thinking around Readme software art festivals held in Moscow in 2002, Helsinki in 2003, Aarhus in 2004, and Dortmund in 2005, curated by myself, Alexei Shulgin, and various partners; see Runme.org (website), http://readme.runme.org (accessed 21 Jan. 2011). It is through this link that its creation could be partly funded (with small fees for coding and writing features).

In subsequent years Runme.org was administered, filtered, and continuously restructured. The Readme software art festivals, for which Runme.

org has continuously served as the project submission platform, were funded by various institutional bodies. It is through such indirect financial channels that the Runme.org administrators and 'experts' writing featuring texts drew occasional modest financial support.

Features were published yearly in the festivals' catalogues along with articles submitted for the talk part of the event and uploaded on Runme.org as well. See Olga Goriunova and Alexei Shulgin, eds., *Read_me Festival 1.2. Software Art/Software Art Games*; Olga Goriunova and Alexei Shulgin, eds., *Read_me 2.3 Reader: About Software Art*; Olga Goriunova and Alexei Shulgin, eds., *Read_me. Software Art and Cultures*; Olga Goriunova, ed., *Readme 100: Temporary Software Art Factory*.

It is worth emphasizing that work on Runme.org was never directly paid, nor could the financial contribution from festivals cover the amount of labour put into this art platform. Such a scheme is not uncommon among art platforms in general.

35. For an account of net art pathos, see especially, Stallabras, *Internet Art*.
36. This concern was particularly expressed by Pit Schultz at the Kuenstlerhaus Bethanien panel in 2003; see Amy Alexander et al., 'Software Art, a Curatorial Fiction or a New Perspective?' Transcript of the panel discussion on 4 Feb. 2003 in Kuenstlerhaus Bethanien, Berlin, Germany, Softwareart.net (website), http://www.softwareart.net (accessed 21 Jan. 2011).
37. From Runme.org mailing list.
38. Olga Goriunova and Alexei Shulgin, 'Glitch,' in Fuller, *Software Studies*.
39. The following are some examples of proposed categories that were not included in the Runme.org taxonomy.

 11 Oct 2002, Alex McLean suggests:
 '- binary modification
 - obfuscated code
 - code obfuscating code
 - rss feeder (i.e., something that takes an rss, rdf or similar feed and does something with it)'
40. The culture of the demo scene produces a demo—a multimedia presentation computed in real time and used by programmers to compete on the level of the best graphical and music programming skills. The demo scene is an old and powerful culture that originates from the hackers' scene of the early 1980s, when short demos were added to the opening visuals of cracked video games. One of the portals for such activity is Scene.org (website), http://www.scene.org (accessed 21 Jan. 2011).
41. Lev Manovich in particular has criticized the equation of software art with algorithmically generated visuals and sound, writing on Ars Electronica 2003. See Lev Manovich, 'Don't Call it Art, Ars Electronica 2003,' Nettime.org (mailing list), http://www.nettime.org/Lists-Archives/nettime-l-0309/msg00102.html (accessed 21 Jan. 2011).
42. For a good analysis of writing on Jodi's work, see Adrian Mackenzie, *Cutting Code: Software and Sociality*; and Pit Schultz, 'JODI as Software Culture.'
43. 17 Oct 2002, Amy Alexander writes:
 'i still don't really understand the jodi categories too well; they concern me some. because, i think the idea of 'jodi plagiarism' can express a narrow, net-art-scene-centric view. a lot of people 'plagiarize' jodi without ever having seen their work, digitally, because they are picking up on certain inherent tendencies in software and systems that jodi also picked up on and conceptually, because for example, formalism and rhythm in time-based visual media has a long history before jodi, with abstract filmmakers (fischinger/ruttman/whitneys etc) and painters of course too. . . . so in short, i don't want to make

a mistake of implying that everything with similarities to jodi's work plagiarizes them—often people are just appropriating the same histories.'

17 Oct 2002, Florian Cramer writes:

'So what about renaming the category as follows: "Conscious or unconscious plagiarism of what jury members might, because of their own narrow aesthetic socializations, call 'jodi-style' digital art?" (This is a serious proposal.)'

44. The rise of the term 'folklore' dates back to the late nineteenth and early twentieth centuries when, for instance, within the German-originated Romanticist movements (sometimes known as National Romanticism) writers first used folklore materials in creating tales and poems, and folklore started to be collected, such as the Grimm Brothers' *Children's and Household Tales* (first published 1812), or fairytales by Vasiliĭ Zhukovskiĭ or Alexander Pushkin, collections by Vladimir Dal' or Petr Ershov, published in the early 1830s in Russia.

45. Vladimir Propp, *Fol'klor, literatura, istoriya*; Vladimir Propp, *Russkaya skazka*.

46. B. N. Putilov, *Fol'klor i narodnaya kul'tura. In Memoriam* (Folklore and people's culture: In memoriam).

47. Intangible cultural heritage is a concept most often linked to the UNESCO Convention for the Safeguarding of the Intangible Cultural Heritage 2003. It refers to 'the practices, representations, expressions, as well as the knowledge and skills, that communities, groups and, in some cases, individuals recognise as part of their cultural heritage.' Intangible cultural heritage is believed to be transmitted from generation to generation, being both traditional and living and providing «communities with a sense of identity and continuity.' See Unseco.org (website), http://www.unesco.org/culture/ich/index.php?pg=00002 (accessed 21 Jan. 2011).

48. Putilov, *Fol'klor*, 69.

49. Pit Schultz, 'Computer Age Is Coming into Age,' interview with Alexei Shulgin, 31–32.

50. *WinGluk Builder*. Runme.org (website), http://readme.runme.org/1.2/adden.htm (accessed 21 Jan. 2011).

51. See *Tempest for Eliza*, Home Page of Erik Thiele (website), http://www.erikyyy.de/tempest (accessed 21 Jan. 2011).

52. Some of the events conceptualizing this movement included Sleepover (2007), Eyebeam.org (website), http://eyebeam.org/events/the-great-internet-sleepover (accessed 21 Jan. 2011); and Letsmeetinreallife (2009), In Real Life (website), http://letsmeetinreallife.com (accessed 21 Jan. 2011).

53. Olga Goriunova, 'Idiocy and New Media,' talk delivered at the workshop 'Russia on Edge,' Cambridge University, December 2009.

54. See Marisa Olson, 'Words Without Pictures,' Words Without Pictures (website), 2009, http://wordswithoutpictures.org/main.html?id=276¬e=281 (accessed 21 Jan. 2011).

55. See Marcin Ramocki, 'Surfing Clubs: Organized Notes and Comments,' Ramocki.net (website), 2008, http://ramocki.net/surfing-clubs.html (accessed 21 Jan. 2011).

56. Olson, 'Words Without Pictures.'

57. Marocki, 'Surfing Clubs.'

58. Brian Droitcour, 'Members Only: Loshadka Surfs the Web.'

59. See *Bla-Bla Sites*, Desk.nl (website), 1995, http://www.desk.nl/~you/bla-bla (accessed 21 Jan. 2011); *XXX*, Easylife.org (website), 1995, http://www.easylife.org/xxx/anim.html (accessed 21 Jan. 2011). The project of the *First Cyberpunk Rock Band 386DX* was born from surfing and found (MIDI) files.

60. See NastyNets.com (website), http://nastynets.com; NetmaresNetdreams.net v. 2.2 (website), http://www.netmaresnetdreams.net; Supercentral.org (website), http://www.supercentral.org/wordpress; Loshadka.org (website) http://www.loshadka.org/wp; SpiritSurfers.net (website), http://www.spiritsurfers.net; and Double Happiness (website), http://doublehappiness.ilikenicethings.com (all accessed 21 Jan. 2011).

NOTES TO CHAPTER 4

1. Pit Schultz, 'Computer Age Is Coming into Age.'
2. The first part is the title of the article by DRX, published in *Microbuilder*. The second part is one of the slogans of Micromusic.net.
3. Paolo Virno, *A Grammar of the Multitude*, 21–29.
4. Giorgio Agamben, *The Coming Community*, 18–19.
5. Jean-Luc Nancy, *The Inoperative Community*, 60–62. See also Jean-Luc Nancy, *Being Singular Plural*.
6. Nancy, *Being Singular Plural*, 67.
7. Ibid., 60.
8. See Agamben, *The Coming Community*.
9. Nancy, *Being Singular Plural*, 4–6.
10. Ibid., 12–31, 38–40.
11. Ibid., 40–41, 80.
12. Christopher Kelty, *Two Bits: The Cultural Significance of Free Software*, 27–28.
13. Ibid., 29.
14. Ibid., 62.
15. Bruno Latour, 'From Realpolitik to Dingpolitik—or How to Make Things Public.'
16. Ibid., 15.
17. Noortje Marres, 'Issues Spark a Public into Being: A Key but Often Forgotten Point of the Lippmann-Dewey Debate.'
18. Ibid., 216.
19. Latour, *Making Things Public*.
20. Marres, op. cit.
21. Kelty, *Two Bits*, 50.
22. Marres, 'Issues,' 216.
23. See Kelty, *Two Bits*, 38, 40–42; and also Marres, 'Issues,' where a public is a phantom, an imaginary entity.
24. Kelty, *Two Bits*, 40.
25. Irina Aristarkhova, 'Stepanova's "Laboratories."'
26. John Roberts, 'Collaboration As a Problem in Art's Cultural Form.'
27. Ibid.
28. See Marion von Osten's figure of the unsuccessful artist that cannot be assimilated into the capitalist discourse of positivity. Commenting on creative capitalism, she finds alternative networks and institutions, and reminds us that 'artistic ways of living and working contain forces that cannot be fully controlled, because they not only engender but also always take part in dissolution of their own conditions. These myths (of artistic ways of life managers cannot handle) can also be used by social groups that would otherwise be silenced within existing power relations.' See Marion von Osten, 'Unpredictable Outcomes/Unpredictable Outcasts: A Reflection After Some Years of Debates on Creativity and Creative Industries,' Transform.eipcp.net

(website), European Institute for Progressive Cultural Policies, Nov. 2007, http://eipcp.net/transversal/0207/vonosten/en (accessed 21 Jan. 2011).

29. Bureau d'Études, 'Resymbolising Machines.'

30. See Brian Holmes, 'Guattari's Schizoanalytic Cartographies,' Continental Drift (website), 27 Feb. 2009, http://brianholmes.wordpress.com/2009/02/27/guattaris-schizoanalytic-cartographies (accessed 21 Jan. 2011).

31. Brian Holmes, 'Extradisciplinary Investigations: Towards a New Critique of Institutions,' Transform.eipcp.net (website), European Institute for Progressive Cultural Policies, Nov. 2007, http://eipcp.net/transversal/0106/holmes/en (accessed 21 Jan. 2011).

32. Stephen Zepke, 'Towards an Ecology of Institutional Critique,' Transform. eipcp.net (website), European Institute for Progressive Cultural Policies, Nov. 2007, http://eipcp.net/transversal/0106/zepke/en (accessed 21 Jan. 2011).

33. Félix Guattari, *Soft Subversions, Texts and Interviews 1977–1985*, 26.

34. Ibid., 74.

35. Ibid., 77.

36. Ibid., 266.

37. Somewhat similarly to other art platforms' economies, Micromusic.net was initiated without financial aid but received some support from the year 2000 and for the subsequent three years from MIGROS Kulturprozent; the same institution has also supported the development of *Microbuilder* (2004), which won a prize for best design from BAK (Bundesamt für Kultur).

38. In 1999 the Micromusic.net founding members consisted of five people; since then, some joined the crew and others are not active anymore, as Carl (Gino Esposto), the Micromusic.net 'boss,' explains: 'SuperB, joku, zorlac, Carl and arsa were the founding members. In the year 2000 Wanga joined the crew, while SuperB, joku and arsa do not participate in the project's life anymore.' Carl, email to author.

39. One can enter Micromusic.net as a guest for a fifteen-minute session, at the end of which one is thrown out; thus, Micromusic.net fosters registration. Every registered participant becomes a 'member' (although not every member gets to, or needs to, submit anything).

40. As mentioned, Micromusic.net organizes microconcerts, or rather, its members organize offline gigs under Micromusic.net's header. Any member of the community can post a suggestion to present her coming gig as a Micromusic. net concert. If the quality filter system (QFS) agrees, it is added to the list of microeventz. Members travel to microeventz around the world, staying in each others' homes, performing, and having a drink together: 'There are many music websites where people can chat and share their music, but events allow everyone to gather and meet the people they have been chatting with and one can experience the joy of live performance and hear more from the artists and have a dance together. . . . This is all dependent on trust and I love when it all works out well. . . . I think offline events give substance to the site.' *Microbuilder*, 111.

 Micromusic.net headquarters are mostly located in Europe, Japan, Australia, and the United States, but Micromusic.net members come from many areas of the world, including Russia, China, Chile, and the South African Republic.

41. An important section of Micromusic.net is 'microwarez' with 'music toolz recommended by the micromusic community,' a section where people share tools they use for music production, including emulators (software that 'emulates' the functions of certain computer system within a different computer system, which allows micromusicians to work in environments hardly available anymore), sound editors, voice synthesizers, converters, and many more,

including computers themselves. Many are freeware and open-source tools. Some of these programs are specifically designed for 8-bit music, and others are general music software not specifically aimed at micromusic.

42. A feature called microradio (C64-microstation) plays while one is chatting or up/downloading, and 'microeventz' provides information on future and past concerts with photographs and commentaries. In general, the structure and system of functioning of the community is carefully considered and discussed and constantly improves according to the requirements of its public; it is gradually becoming more complex as more sections are introduced over time.

43. At Micromusic.net the collective of editors listen closely for a number of times to the approximately one hundred compositions they receive every month, and only the best of them appear on the site. Micromusic.net's QFS is formed by two board members and two invited members of the community monthly. In the QFS, tracks receive marks according to which they pass or not, but sometimes a discussion occurs. Specifically for this purpose, a software program was written that allows the discussion of a composition online.

 The technical implementation of Micromusic.net's QFS is more laborious than those at any of the other two 'classical' art platforms discussed in previous chapters. Whereas Udaff.com's administrator manually filters out the content received into his mailbox and uploads it to the platform, and at Runme.org the discussion often takes place via email exchange and reply-to-all button, Micromusic.net's filtering software includes specifically developed features to make track-related discussions and decisions easier to manage, return to, and store.

44. *Microbuilder*, 48.

45. Ibid., 84.

46. Gwem, ibid.

47. 'Micro_style in effect, bringing us this beauty of text-only and animated gifs, soaked up with soul.' See ibid., 48.

48. See, for instance, 'micronewz 09/2001 dear amigas & amigos of deep_dope digital inputs and cyberSound_pleasurez !!! in days like these we try 2 work as hard as possible keepin' up the flow of good vibes by activatin' a hand full of tunes tracked down by our beloved quality_filter_system (qfs),' ibid.

49. Karen Collins, 'Fine Tuning the Terrible Twos: The Musical Aesthetic of Atari VCS,' Tagg.org (website), http://www.tagg.org/others/kcflat2.html (accessed 21 Jan. 2011); Paul Slocum, 'Atari 2600 Music and Sound Programming Guide,' Qotile.net (website), 2003, http://qotile.net/files/2600_music_guide. txt (accessed 21 Jan. 2011).

50. Kevin Driscoll and Joshua Diaz, 'Endless Loop: A Brief History of Chiptunes.'

51. Slocum, 'Atari 2600 Music.'

52. *Microbuilder*, 62.

53. But in any case, it is through the reference to game music that micromusic defines itself, so the works build a stylistic unity despite all the diversity. That is why Andrei Gorokhov, a German-based Russian music critic doubted that the first Micromusic.net CD release was indeed a collection of tracks produced by different authors: 'The album is designed as a collection of tracks, each of which would have a different author. Honestly, I cannot believe that. Not because all tracks sound similar, but because there is a clear and consistent aesthetic idea behind all the tracks. Their music is, roughly speaking, electro-pop, and more exactly electrocompulsive pop. There is a jumpiness, known rhythmical figures, a mass of momentarily recognizable techno-pop

cliché, but all that is dominated by nervous agitation and irregularities.' See Andrei Gorokhov, *Muzprosvet.ru* (author's translation).

54. *Microbuilder*, 46–47.
55. Ibid.; Arkanoid (1987) is a cult game for Commodore 64, Atari, and other platforms.
56. Tilman Baumgartel, *[Net.art 2.0] New Materials towards Net art*, 244.
57. Driscoll and Diaz, 'Endless Loop.'
58. Ibid.
59. Tilman Baumgartel introduces the interview with Carl (the 'leader' of Micromusic.net) by stating the following: 'Micromusic is a part of the tradition known as trackers. This widely overlooked youth culture of the 80s and 90s traded musical tracks created on computers on the Bulletin Board Systems of the time and very little of that culture made the move to the World Wide Web'. Such culture was a culture of computer nerds, 'swapping diskettes with music demos', reading 'very personal scroll texts of the programmers' and bringing one's 'own music into circulation'. With the development of World Wide Web, MP3 format, and the great increase in numbers of the Internet users, those who liked home computer music lost hold of each other. That is when Micromusic.net 'came along' with its update on essentially 'geek' cultures. See Baumgartel, *[Net.art 2.0]*, 242; *Microbuilder*, 45–46.
60. Baumgartel, *[Net.art 2.0]*, 245.
61. *Microbuilder*, 41.
62. Kelty, *Two Bits*, 35–38.
63. See Richard Stallman, *Free Software, Free Society: Selected Essays of Richard M. Stallman*; Levy, *Hackers: Heroes of The Computer Revolution*.
64. Guattari, *Soft Subversions*, 161.
65. Following a wave of utopian and naïve accounts that placed the hope of sociopolitical transformation with the potential of the forms of life propelled by the social Web, there is currently a rise in a number of books that deprive new media forms of culture in general of value or potential. Jodi Dean's *Blog Theory: Feedback and Capture in the Circuits of Drive* (Cambridge: Polity, 2010) is one such example. For Dean, if there is a resonance between the cognitive capitalist global devouring and new figures and practices, such as hackers or blogging, it is nothing short of a proof that such figures are in fact loyal capitalist agents. Instead of attempting to discern the grains of potential futures in the emerging technical sociopolitical processes, Dean happens to depict a world in which there never was, is, or will be anything that has relative autonomy or value because there is continuous stratification, domination, and linking between radically different strata of production to tune into a certain historical unison, inclusive of capitalist melody—but this does not equal immediate exhaustion and termination of all other harmonic-rhythmic patterns; there well may be a polyphony!
66. If the production of music machines (mechanical or semimechanical instruments in mid-nineteenth century, radio, amplifier, electronic instruments, etc.) is easy to describe historically, it would be very complex to build a hierarchy of mass-produced musical 'software' (sounds to be industrially produced and media to record and carry them within). Wallis and Malm describe the first mass-produced music albums and sheet music of the second half of the nineteenth century as possibly the first 'mass reproduced music.' Roger Wallis and Krister Malm, *Big Sounds from Small People: The Music Industry in Small Countries*, 2.
67. See Martin Clayton, Trevor Herbert, and Richard Middleton, eds., *The Cultural Study of Music: A Critical Introduction*; and Stuart Hall, Linda Janes, Hugh Mackay, Keith Negus, *Doing Cultural Studies: The Story of the Sony Walkman*.

68. For instance, Gorokhov describes the way King Tubby worked in his studio with his mixer, fading in and out on instrument tracks, making some disappear for a moment, punching echo effects, pulling the magnetic tape so the music will float. Gorokhov also dwells on the story of the acid-house style that was attributed to DJ Pierre, who manipulated the levels of Roland TB303 Bassline, a bass synthesizer, making it squeal and wheeze; an example of the technological system becoming the 'composer.' Gorokhov, *Muzprosvet.ru*, 100–1.
69. Wallis and Malm, *Big Sounds*, 7.
70. Norman Kelley, ed., *R&B Rhythm and Business: The Political Economy of Black Music*.
71. Derek Scott, ed., *Music, Culture, and Society: A Reader*, 206, 315.
72. Ibid., 24–46.
73. David Beer, ed., 'Music and the Internet.'
74. Julian Stallabras, *Internet Art: The Online Clash of Culture and Commerce*, 27–39; and *ZKP3.2.1.*
75. *Microbuilder*, 63–64.
76. Antoine Hennion, 'Music Industry and Music Lovers, Beyond Benjamin: The Return of the Amateur,' Soundscapes.info (website), 1996, http://www.icce.rug.nl/~soundscapes/DATABASES/MIE/Part2_chapter06.shtml (accessed 21 Jan. 2011); Martin Clayton, Trevor Herbert, and Richard Middleton, *The Cultural Study of Music*, 263.
77. Hennion, for instance, calls for an apprehension of the amateur's figure and role as one not opposed to the professional, or as one doing residual practice, but as one liberating music of its burdening rituals and functions, helping it to achieve its fullest autonomy—an amateur being the defining centre of the musical world. An amateur has an active character, recomposing and redefining music by interpretation and individual experiences; but he is also inherently connected to the evolution of technology and economy. An amateur is 'the child of the recent marriage of music to the market, whose union could only be consummated once techniques made it possible to turn music into goods and services.' Hennion's program inspires and opens up our understanding to a large degree. However, although he tries to avoid interpreting the figure of the amateur as opposed to that of the professional, he cannot escape doing so. Amateurs are interpreted as a mass of people practicing music and not composing it. The exclusion of music composition from the scope of Hennion's analysis leaves it loaded with all the essentialist meanings traditionally attached to it, thus emphasizing 'individual,' 'professional' creation and demarcating that from 'people.' Hennion, 'Music Industry.'
78. Kelley, *Two Bits*, 29.
79. Vilém Flusser, *Towards a Philosophy of Photography*, 21–33.
80. I am grateful to Bernard Stiegler for his discussion of amateur as professional in the framework of the workshop 'Global Economy of Contribution' held at Goldsmiths in February 2009.
81. 'Having a charting track on micromusic is a big ego boost I can tell you, and of course I wanted to make another hit, and even get to number 1!' 'i want to praise the composer directly. . . . In micromusic i will drop the composer a line: 'your tune roXOrz, 100% granular synthesis free!!' 'as a musician, i want an audience, i want feedback and applause. it's impossible to get feedback through file sharing networks, so it's better to put it on micromusic to spread it and become happy.' See *Microbuilder*, 78, 49.
82. Dorkbot.org (website), http://dorkbot.org (accessed 21 Jan. 2011).
83. Columbia University, where Douglas Irving Repetto works as a director of the Computer Music Centre, provides server space for Dorkbot websites and

mailing lists. See Douglas Repetto, 'Questions about self-organisation: Dork-bot,' Pixel Ache University (website), 2008, http://university.pixelache.ac/index.php?option=com_content&task=view&id=114&Itemid=43 (accessed 21 Jan. 2011).

84. See Dorkbot.org (website), http://dorkbot.org.
85. 'Most local Dorkbot chapters have their own vibe, and set of obsessions. New York's Dorkbot is very "Art with a Capital 'A'", and San Francisco's often explores social and political issues. Dorkbot Tokyo seems to be really interested in electronic music.' Michael Machosky, 'Getting Your Geek On,' *Pittsburgh Tribune-Review*, 25 Jan. 2007, http://www.pittsburghlive.com/x/pittsburghtrib/news/s_490107.html (accessed 21 Jan. 2011).

Dorkbot Eindhoven is 'an initiative of Art & Technology Festival STRP in collaboration with Studium Generale (TU/e) [University of Technology Eindhoven].' Dorkbot.org (website), http://dorkbot.org/dorkboteindhoven/v02/?page_id=2 (accessed 21 Jan. 2011).

86. See Rachel Beckman, 'Hearts of Dorkness,' *Washington Post*, 21 Dec. 2006, http://www.washingtonpost.com/wp-dyn/content/article/2006/12/20/AR2006122001723.html (accessed 21 Jan. 2011).
87. Douglas Irving Repetto, cited in Brian Braiker, 'When Art and Science Collide, a Dorkbot Meeting Begins,' *New York Times*, 17 Jan. 2006, http://www.nytimes.com/2006/01/17/science/17dork.html?_r=1 (accessed 21 Jan. 2011).
88. Beckman, 'Hearts of Dorkness.'
89. Braiker, 'When Art and Science Collide.'

NOTES TO THE AFTERWORD

1. Lev Manovich's Cultural Analytics is a rather brave and coolly ironic engagement with such developments. See: Lev Manovich and Jeremy Doug-lass, 'Visualizing Temporal Patterns in Visual Media' (2009), <http://soft-warestudies.com/cultural_analytics/visualizing_temporal_patterns.pdf>, (accessed 21 Jan 2011). For an analysis of information pull model and the way in which our digital footprint is harnessed, bought, and used to feed back the desired conceptual schemes through individualized 'keywords,' see Stephen Baker, *The Numerati* (Boston-N-Y: Houghton Mifflin Company, 2008).

2. Neil Cummings described his film *Museum Futures: Distributed* along these lines, while presenting it at a workshop 'Global Economy of Contribution' in Goldsmiths, February 2009. To find out more about the project, visit: <http://www.neilcummings.com/content/museum-futures-script-0>, (accessed 21 Jan 2011).

Bibliography

Agamben, Giorgio. *The Coming Community*. Minneapolis: University of Minnesota Press, 2007.

Albert, Réka, Hawoong Jeong, and Albert-László Barabási. 'Diameter of the World-wide Web.' *Nature 401*, Nov. 1999: 130–31. Reprinted in *The Structure and Dynamics of Networks*, ed. Mark Newman, Albert-László Barabási, and Duncan J. Watts.

Alexander, Amy, et al. 'Software Art, a Curatorial Fiction or a New Perspective?' Transcript of the panel discussion on 4 Feb. 2003 in Kuenstlerhaus Bethanien, Berlin, Germany. http://www.softwareart.net (accessed 21 Jan. 2011).

Alexander, Amy, Nick Collins, et al. 'Live Algorithm Programming and a Temporary Organisation for Its Promotion.' In *Read_me. Software Art and Cultures*, ed. Olga Goriunova and Alexei Shulgin.

Alliez, Éric. 'The Difference and Repetition of Gabriel Tarde.' *Distinktion*, no. 9 (2004).

Andersen, Christian Ulrik, and Soeren Bro Pold, eds. *Interface Criticism: Aesthetics Beyond Buttons*. Copenhagen: Aarhus University Press, 2011.

Arendt, Hannah. *The Human Condition*. Chicago: University of Chicago Press, 1958.

Aristarkhova, Irina. 'Stepanova's "Laboratory."' In *Place Studies in Art, Media, Science and Technology: Historical Investigations on the Sites and the Migration of Knowledge*, eds. Andreas Broeckmann and Gunalan Nadarajan. VDG, Weimar: 2008.

Arns, Inke. 'Read_me, Rune_me, Execute_me: Software and Its Discontents, or: It's the Performativity of Code, Stupid!' In *Read_me. Software Art and Cultures*, eds. Olga Goriunova and Alexei Shulgin.

Auto-Illustrator. Artwork by Signwave (Adrian Ward). 2001. http://swai.signwave.co.uk (accessed 21 Jan. 2011).

Badiou, Alain. *Handbook of Inaesthetics*. Stanford, NJ: Stanford University Press, 2005.

———. *Peut-on penser la politique?* Paris: Seuil, 1985.

Baker, Stephen. *The Numerati*. Boston: Houghton Mifflin, 2008.

Bakhtin, Mikhail. *Éstétika slovesnogo tvorchestva*. Moscow: Iskusstvo, 1979.

Barabási, Albert-László. *Linked: How Everything Is Connected to Everything Else and What It Means*. London: Plume, 2003.

Bateson, Gregory. *Steps to an Ecology of Mind*. Chicago: University of Chicago Press, 2000.

Baumgartel, Tilman. *[Net.art 2.0] New Materials towards Net art*. Nurnberg: Verlag fur moderne Kunst, 2001.

Beer, David, ed. 'Music and the Internet.' Special issue, *First Monday*, 2005. http://www.firstmonday.org/issues/special10_7 (accessed 21 Jan. 2011).

Benkler, Yochai. *The Wealth of Networks: How Social Production Transforms Markets and Freedom*. New Haven, CT: Yale University Press, 2006.

Bergson, Henri. *Creative Evolution*. New York: Dover, 1998.

Berlin, Isaiah. *Istoriya svobody: Rossiya*. Moscow: Novoe literaturnoe obozrenie, 2001.

Berry, David M., and Giles Moss. 'On the "Creative Commons": A Critique of the Commons without Commonalty.' *Free Software 5*, June 2005. http://www.free-softwaremagazine.com/files/nodes/1155/1155.pdf (accessed 21 Jan. 2011).

von Bertalanffy, Ludwig. *General System Theory: Foundation, Development, Application*. New York: George Braziller, 1969.

Billing, Johanna, Maria Lind, and Lars Nilsson, eds. *Taking the Matter into Common Hands: On Contemporary Art and Collaborative Practices*. London: Black Dog, 2007.

Bishop, Claire, ed. *Participation*. London: Whitechapel Gallery / MIT Press, 2006.

Bla-Bla Sites. Artwork by Alexei Shulgin. 1995. http://www.desk.nl/~you/bla-bla// (accessed 21 Jan. 2011).

Blackman, Lisa. 'Reinventing Psychological Matters: The Importance of the Suggestive Realm of Tarde's Ontology.' *Economy and Society* 36, no. 4 (2007).

Bohm, David. *On Creativity*. London: Routledge, 2005.

Bourdieu, Pierre. *The Field of Cultural Production*. Cambridge: Polity, 1993.

———. *The Rules of Art: Genesis and Structure of the Literary Field*. Cambridge: Polity, 2005.

Bourriaud, Nikolas. *Relational Aesthetics*. Bordeaux: Les Presses du Réel, 2002.

Boutin, Paul. 'Web 2.0 Doesn't Live Up to its Name.' *Slate*, 29 March 2006. http://www.slate.com/id/2138951 (accessed 21 Jan. 2011).

Broeckmann, Andreas. 'Call for Entries.' Email, 2000. http://amsterdam.nettime.org/Lists-Archives/nettime-bold-0009/msg00045.html (accessed 21 Jan. 2011).

Bureau d'Études. 'Resymbolising Machines.' In 'A Very Special British Issue,' *Third Text* 18, no. 6 (2004).

Burrell, Gibson. 'Radical Organization Theory.' In *The International Yearbook of Organization Studies 1979*, ed. David Dunkerley and Graeme Salaman. London: Routledge and Kegan Paul, 1979.

Butler, David, and Vivienne Reiss, eds. *Art of Negotiation*. London: Arts Council of England, 2007.

Camarine, Scott, Jean-Louis Deneubourg, et al., eds. *Self-organization in Biological Systems*. Princeton: Princeton University Press, 2003.

Castells, Manuel. *The Rise of the Network Society: Economy, Society and Culture*. Vol. 1. *The Information Age*. Oxford: Wiley-Blackwell, 2000.

Ceruzzi, Paul. *A History of Modern Computing*. Cambridge, MA: MIT Press, 1999.

Chun, Wendy Hui Kyong. *Control and Freedom: Power and Paranoia in the Age of Fiber Networks*. Cambridge, MA: MIT Press, 2006.

Clayton, Martin, Trevor Herbert, and Richard Middleton, eds. *The Cultural Study of Music: A Critical Introduction*. London: Routledge, 2003.

Clegg, Stewart. *Power, Rule and Domination: A Critical and Empirical Understanding of Power in Sociological Theory and Organizational Life*. London: Routledge and Kegan Paul, 1975.

Clegg, Stewart, and David Dunkerley. *Organization, Class and Control*. London: Routledge and Kegan Paul, 1980.

Container. Art project by Mongrel. http://www.container-project.net (accessed 21 Jan. 2011).

Cox, Geoff, Alex McLean, and Adrian Ward. 'Coding Praxis: Reconsidering the Aesthetics of Code.' In *Read_me. Software Art and Cultures*, eds. Olga Goriunova and Alexei Shulgin.

Csikszentmihalyi, Mihaly. *Creativity: Flow and the Psychology of Discovery and Invention.* New York: HarperCollins, 1996.

Cunningham, J. Barton. *Action Research and Organizational Development.* London: Praeger, 1993.

Davies, Anthony, Stephan Dillemuth, and Jakob Jakobsen. 'There Is No Alternative: The Future is Self-Organized—Part1.' In *Art and Its Institutions*, ed. Nina Möntmann.

DeLanda, Manuel. *Intensive Science and Virtual Philosophy.* London: Continuum, 2005.

———. *A Thousand Years of Nonlinear History.* New York: Zone, 1997.

———. *War in the Age of Intelligent Machines.* New York: Zone, 1992

Deleuze, Gilles. *Bergsonism.* Cambridge, MA: MIT Press, 1991.

———. *Difference and Repetition.* London: Continuum, 2008.

———. *Francis Bacon.* London: Continuum, 2008.

———. *Negotiations, 1972–1990.* New York: Columbia University Press, 1995.

———. *Nietzsche and Philosophy.* London: Continuum, 2006.

———. *Postscript on the Societies of Control.* Originally published in *October* 59 (Winter 1992): 3–7. http://libcom.org/library/postscript-on-the-societies-of-control-gilles-deleuze (accessed 21 Jan. 2011).

Deleuze, Gilles, and Félix Guattari. *A Thousand Plateaus: Capitalism and Schizophrenia.* Vol. 2. New York: Continuum, 2004.

Dumouchel, Paul, and Jean-Pierre Dupuy, eds. *L'Auto-organisation, de la physique au politique.* Paris: Seuil, 1983.

Economy and Society 36, no. 4 (2007). Special issue on Gabriel Tarde.

Edwards, Paul N. *The Closed World: Computers and the Politics of Discourse in Cold War America.* Cambridge, MA: MIT Press, 1996.

Feller, Joseph, et al., eds. *Perspectives on Free and Open Source Software.* Cambridge, MA: MIT Press, 2005.

First Cyberpunk Rock Band, 386DX. Artwork by Alexei Shulgin. http://www.easylife.org/386DX (accessed 21 Jan. 2011).

Florida, Richard. *The Rise of the Creative Class.* New York: Basic, 2004.

Flusser, Vilém. *Towards a Philosophy of Photography.* London: Reaktion, 2000.

von Foerster, Heinz, and George Zopf, eds. *Principles of Self-Organization.* Proceedings of the Second Conference on Self-Organization. New York: Pergamon, 1962.

Fuller, Matthew. 'Art Methodologies in Media Ecology.' In *Deleuze, Guattari and The Production of the New*, eds. Simon O'Sullivan and Stephen Zepke. London: Continuum, 2008.

———. *Media Ecologies: Materialist Energies in Art and TechnoCulture.* Cambridge, MA: MIT Press, 2005.

———. 'A Means of Mutation: Notes on I/O/D 4: The Web Stalker.' In *Behind the Blip: Essays on the Culture of Software.* New York: Autonomedia, 2003.

———. *Softness: Interrogability; General Intellect.* Huddersfield: University of Huddersfield, 2006.

———, ed. *Software Studies: A Lexicon.* Cambridge, MA: MIT Press, 2008.

Gasparov, Mikhail. *Zapisi i vypiski* (Notes and extracts). Moscow: Novoe Literaturnoe Obozrenie, 2001.

Gazira Babeli. Artwork, virtual persona. http://gazirababeli.com (accessed 21 Jan. 2011).

Ghosh, Rishab Aiyer, ed. *CODE, Collaboration, Ownership and the Digital Economy.* Cambridge, MA: MIT Press, 2004.

———. *Study on the Economic Impact of Open Source Software on Innovation and the Competitiveness of the Information and Communication Technologies (ICT) Sector in the EU, Final Report, Final Report.* European Commission,

2006. http://ec.europa.eu/enterprise/ict/policy/doc/2006–11–20-flossimpact.pdf (accessed 21 Jan. 2011).

Goriunova, Olga, ed. *Readme 100: Temporary Software Art Factory*. Dortmund: Hartware MedienKunstVerein, 2006.

Goriunova, Olga, and Alexei Shulgin, eds. *Read_me Festival 1.2: Software Art/Software Art Games*. Catalogue of Readme 2002. Moscow: Macros-center, 2002.

———, eds. *Read_me 2.3 Reader: About Software Art*. NIFCA publication 25. Helsinki, 2003.

———, eds. *Read_me: Software Art and Cultures*. Aarhus: University of Aarhus Press, 2004.

Gorokhov, Andrei. *Muzprosvet.ru*. Moscow: Isographus, 2001.

Green, Rachel. *Internet Art*. New York: Thames and Hudson, 2004.

Grubinger, Eva. 'C@C, Computer-Aided Curating (1993–1995) Revisited.' In *Curating Immateriality: The Work of the Curator in the Age of Network Systems*, ed. Joasia Krysa. New York: Autonomedia, 2006.

Guattari, Félix. *Chaosmosis, An Ethico-Aesthetic Paradigm*. Sydney: Power Publications, 1995.

———. 'Machinic Heterogenesis, Machinic Orality and Virtual Ecology.' In *Chaosmosis, An Ethico-aesthetic Paradigm*. Sydney: Power Publications, 1995.

———. *Soft Subversions, Texts and Interviews 1977–1985*. New York: Semiotext(e), 2009.

Gudkov, Lev. *Negativnaĭa identichnost': Stat'i 1997–2002 godov* (Negative identity: Articles 1997–2002). Moscow: Novoe Literaturnoe Obozrenie 'VCIOM-A', 2004).

Hall, Stuart, Linda Janes, Hugh Mackay, and Keith Negus. *Doing Cultural Studies: The Story of the Sony Walkman*. London: Sage, 1997.

Handy, Charles B. *Understanding Organizations*. London: Penguin, 1981.

Harvey, David. *A Brief History of Neoliberalism*. Oxford: Oxford University Press, 2005.

Hassard, John, Mihaela Kelemen, and Julie Wolfram Cox. *Disorganization Theory: Explorations in Alternative Organizational Analysis*. London: Routledge, 2008.

Hayles, Katherine. *How We Became Posthuman: Virtual Bodies in Cybernetics, Literature and Informatics*. Chicago: University of Chicago Press, 1999.

Holmes, Brian. 'The Flexible Personality: For a New Cultural Critique.' In *Economising Culture. On 'The (Digital) Culture Industry,'* eds. Joasia Krysa et al. New York: Autonomedia, 2004.

Jameson, Fredric. *Late Marxism: Adorno and the Persistence of the Dialectic*. New York: Verso, 2007.

Jones, Campbell, and Rolland Munro, eds. *Contemporary Organization Theory*. Oxford: Blackwell, 2005.

Kauffman, Stuart A. *The Origins of Order: Self-organization and Selection in Evolution*. Oxford: Oxford University Press, 1993.

Kelley, Norman, ed. *R&B Rhythm and Business: The Political Economy of Black Music*. New York: Akashic, 2005.

Kelty, Christopher. *Two Bits: The Cultural Significance of Free Software*. Durham, NC: Duke University Press, 2008.

Khlebnikov, Velimir. 'Nasha osnova' (Our foundation). In *Tvoreniĭa* (Oeuvres). Moscow, 1998. Originally published 1920.

Kleiner, Dmitry, and Brian Wyrick. 'Info-Enclosure 2.0.' *Mute* 2, no. 4 (Winter issue, 07 Jan 2006).

Kristeva, Julia. 'Word, Dialogue and Novel.' In *The Kristeva Reader*, ed. Toril Moi. New York: Columbia University Press, 1986.

Krysa, Joasia, ed. *Curating Immateriality: The Work of the Curator in the Age of Network Systems*. New York: Autonomedia, 2006.

————. 'From Object to Process and System.' In *New Media in the White Cube and Beyond: Curatorial Models for Digital Art*, ed. Christiane Paul. Berkeley: University of California Press, 2008.

Krysa, Joasia, Geoff Cox, and Anya Lewin, eds. *Economising Culture: On 'The (Digital) Culture Industry.'* New York: Autonomedia, 2004.

Latour, Bruno. 'From Realpolitik to Dingpolitik or How to Make Things Public.' In *Making Things Public: Atmospheres of Democracy*, eds. Bruno Latour and Peter Weibel. ZKM; Cambridge, MA: MIT Press, 2005.

————.'Gabriel Tarde and the End of the Social.' In *The Social in Question: New Bearings in History and the Social Sciences*, ed. Patrick Joyce. London: Routledge, 2002.

————. 'On Recalling ANT.' In *Actor Network Theory and After*, eds. John Law and John Hassard. Oxford: Blackwell, 2006.

Latour, Bruno, and Vincent Lepinay. *The Science of Passionate Interests: An Introduction to Gabriel Tarde's Economic Anthropology*. Chicago, IL: Prickly Paradigm, 2010.

Lessig, Lawrence. *Free Culture: How Big Media Uses Technology and the Law to Lock Down Culture and Control Creativity*. London: Penguin, 2004.

Levy, Steven. *Hackers: Heroes of the Computer Revolution*. London: Penguin, 2001.

Liang, Lawrence. *Guide to Open Content Licenses*. Rotterdam: Piet Zwart Institute, 2004.

Lichty, Patrick. 'I Know Gaz Babeli.' In *Gazira Babeli*, ed. Domenico Quaranta. Paris: Fabio Paris, 2008.

Lillemose, Jacob. *Art as Information Tool: Critical Engagements with Contemporary Software Culture*. PhD dissertation, University of Copenhagen, 2010.

Lind, Maria. 'The Collaborative Turn.' In *Taking the Matter into Common Hands*, eds. Johanna Billing, Maria Lind, Lars Nilsson.

Linstead, Stephen, and Heather Höpfl. *The Aesthetics of Organization*. London: Sage, 2000.

Ludlow, Peter, and Mark Wallace. *The Second Life Herald: The Virtual Tabloid that Witnessed the Dawn of the Metaverse*. Cambridge, MA: MIT Press, 2007.

Luhmann, Niklas. 'The Autopoiesis of Social Systems.' In *Sociocybernetic Paradoxes: Observation, Control and Evolution of Self-Steering Systems*, eds. Felix Geyer and Johannes van der Zouwen. London: Sage, 1986.

Luther Blissett. Shared identity, art project. http://www.lutherblissett.net/ (accessed 21 Jan. 2011).

Lyotard, Jean-Francois. *Soundproof Room: Malraux's Anti-aesthetics*. Stanford: Stanford University Press, 2001.

Mackenzie, Adrian. *Transductions: Bodies and Machines at Speed*. New York: Continuum, 2002.

Mackenzie, Adrian. *Cutting Code: Software and Sociality*. New York: Peter Lang, 2006.

Malevé, Nicolas. 'Creative Commons in Context.' In *The Mag.net Reader: Experiences in Electronic Publishing*, ed. Miren Eraso et al. Italy: Arteleku-Deputación Foral de Gipuzkoa, 2006.

Mansoux, Aymeric. 'My Lawyer Is an Artist: The License as Art Manifesto.' In *Media-N, Journal of the New Media Caucus*, forthcoming.

Marres, Noortje. 'Issues Spark a Public into Being: A Key but Often Forgotten Point of the Lippmann-Dewey Debate.' In *Making Things Public*, eds. Bruno Latour and Peter Weibel.

Maturana, Humberto R., and Bernhard Poerksen. *From Being to Doing: The Origins of the Biology of Cognition*. Heidelberg: Karl Aeur Systeme Verlag, 2004.

Maturana, Humberto R., and Francisco J. Varela. *Autopoiesis and Cognition: The Realization of the Living.* Dordrecht: D. Reidal, 1972.

———. *The Tree of Knowledge: The Biological Roots of Human Understanding.* Boston: Shambala, 1987.

Microbuilder—Community Construction Kit. Switzerland: Waller's JDR Digital World, 2004.

Möntmann, Nina. 'Art and Its Institutions.' In *Art and its Institutions Current Conflicts, Critique and Collaborations,* ed. Nina Möntmann.

Multi-cultural Recycler. Artwork by Amy Alexander. 1996/97. http://recycler.plagiarist.org/ (accessed 21 Jan. 2011).

Museum Futures: Distributed. Artwork by Neil Cummings. 2008. http://www.neilcummings.com/content/museum-futures-script-0 (accessed 21 Jan. 2011).

Nancy, Jean-Luc. *Being Singular Plural.* Stanford: Stanford University Press, 2009.

———. *The Inoperative Community.* Minneapolis: University of Minnesota Press, 2008.

Negri, Antonio. *Revolution Retrieved: Selected Writings on Marx, Keynes, Capitalist Crisis and New Social Subjects.* London: Red Notes, 1988.

Negt, Oskar, and Alexander Kluge. *Public Sphere and Experience: Analysis of the Bourgeois and Proletarian Public Sphere.* Minneapolis: University of Minnesota Press, 1993.

Negus, Keith, and Michael Pickering. *Creativity, Communication, and Cultural Value.* London: Sage, 2004.

Newman, Mark, Albert-László Barabási, and Duncan J.Watts, eds. *The Structure and Dynamics of Networks.* Princeton: Princeton University Press, 2006.

Nietzsche, Friedrich. *The Birth of Tragedy and Other Writings.* Trans. Ronald Speirs. Cambridge: Cambridge University Press, 1999.

Obrist, Hans Ulrich, ed. *A Brief History of Curating.* Bordeaux: Ringier Kunstverlag AG / Les Presses Du Réel 2008.

Osborne, Thomas. 'Against "Creativity": A Philistine Rant.' *Economy and Society* 32, no. 4 (2003).

Oudenampsen, Merijn. 'Back to the Future of the Creative City: An Archeological Approach to Amsterdam's Creative Development.' In *MyCreativity Reader: A Critique of Creative Industries,* eds. Geert Lovink and Ned Rossiter. Amsterdam: Institute of Network Cultures, 2007.

Parsons, Talcott. *Structure and Process in Modern Societies.* New York: Free Press, 1960.

Pickering, Andrew. 'Cybernetics and the Mangle, Ashby, Beer and Pask.' *Social Studies of Science* 32, no. 3 (June 2002).

Plucer-Sarno, Alexander. *Bol'shoǐ slovar' mata,* T. 1. (Large Mat Dictionary, vol. 1). St. Petersburg: Limbus-press, 2001).

Propp, Vladimir. *Fol'klor, literatura, istoriya.* Moscow: Labirint, 2002. Available in English as *Theory and History of Folklore* (Manchester: Manchester University Press, 1984).

———. *Russkaya skazka.* Moscow: Labirint, 2005. Available in English as *Morphology of the Folktale* (Austin: University of Texas Press, 1968).

Putilov, B. N. *Fol'klor i narodnaya kul'tura: In memoriam* (Folklore and people's culture: In memoriam). St. Petersburg: Peterburgskoe vostokovedenie, 2003.

Rancière, Jacques. *The Politics of Aesthetics.* New York: Continuum, 2007.

———. 'Problems and Transformations in Critical Art.' In *Participation,* ed. Claire Bishop.

Rice, A. *Productivity and Social Organization.* London: Tavistock, 1958.

Roberts, John. 'Collaboration As a Problem in Art's Cultural Form.' In 'A Very Special British Issue,' *Third Text* 18, no. 6 (2004).

Ross, Andrew. *No-Collar: The Humane Workplace and Its Hidden Costs.* Philadelphia: Temple University Press, 2004.

Scholette, Gregory. 'Interventionism and the Historical Uncanny.' In *The Interventionists: Users' Manual for the Creative Disruption of Everyday Life.* eds. Nato Thompson and Gregory Scholette. Cambridge, MA: MIT, 2004.

Schubert, Karsten. *The Curator's Egg: The Evolution of the Museum Concept from the French Revolution to the Present Day.* London: Ridinghouse, 2009.

Schultz, Pit. 'Computer Age Is Coming into Age.' Interview with Alexei Shulgin. In *Read_me 2,3 Reader,* eds. Olga Goriunova and Alexei Shulgin.

———. 'JODI as Software Culture.' In *Install.exe/JODI,* ed. Tilman Baumgaertel. Basel: Christoph Merian Basel: Verlag, 2002.

Scott, Derek, ed. *Music, Culture, and Society: A Reader.* Oxford: Oxford University Press, 2000.

Scott, W. Richard. *Institutions and Organizations.* London: Sage, 1995.

Shirky, Clay. *Here Comes Everybody: The Power of Organizing without Organization.* London: Allen Lane, 2008.

Simondon, Gilbert. *L'individuation psychique et collective.* Paris: Aubier, 1989 and 2007.

———. 'On the Mode of Existence of Technical Objects.' Trans. Ninian Mellamphy, preface by John Hart. University of Western Ontario, 1958, 1980.

Simonton, Dean Keith. *Origins of Genius: Darwinian Perspectives on Creativity.* New York: Oxford University Press, 1999.

Skirda, Aleksandre. *Facing the Enemy: A History of Anarchist Organization from Proudhon to May 1968.* Edinburgh: AK, 2005.

SOD. Artwork by Jodi. 1999.

Stallabras, Julian. *Internet Art: The Online Clash of Culture and Commerce.* London: Tate, 2003.

Stallman, Richard. *Free Software, Free Society: Selected Essays of Richard M. Stallman.* Boston: Free Software Foundation, 2002.

Stengers, Isabelle, and Ilya Prigogine. *Order Out of Chaos: Man's New Dialogue with Nature.* London: Flamingo, 1985.

Stengers, Isabelle. *Power and Invention: Situation Science.* Minneapolis: University of Minnesota Press, 1997.

Sternberg, Robert, ed. *Handbook of Creativity.* Cambridge: Cambridge University Press, 1999.

Stiegler, Bernard. 'About Simondon and the Current Question of Our Powerlessness in the Era of Nanotechnologies.' Manuscript, Northwestern seminars.

———. *Technics and Time: The Fault of Epimetheus, No. 1.* Stanford: Stanford University Press, 1998.

———. *Technics and Time, 2: Disorientation.* Stanford: Stanford University Press, 2003.

Stimson, Blake, and Gregory Scholette, eds. *Collectivism after Modernism: The Art of Social Imagination After 1945.* Minneapolis: University of Minnesota Press, 2007.

Stimson, Blake, and Gregory Scholette. 'Periodising Collectivism.' *Third Text* 18, no. 6 (2004).

Strati, Antonio. *Organization and Aesthetics.* London: Sage, 1999.

Tarde, Gabriel. *The Laws of Imitation.* Reprint. Gloucester: Peter Smith, 1962.

Tempest for Eliza. Software, art project by Erik Thiele. http://www.erikyyy.de/tempest/ (accessed 21 Jan. 2011).

Terranova, Tiziana. *Network Culture: Politics for the Information Age.* London: Pluto, 2004.

Theweleit, Klaus. *Male Fantasies*. Vol. 1. *Women, Floods, Bodies, History*. Minneapolis: University of Minnesota Press, 1987.
———. *Male Bodies—Psychoanalyzing the White Terror*. Vol. 2. Minneapolis: University of Minnesota Press, 1989.
Third Text 18, no. 6. Special issue, 2004.
Toews, David. 'The New Tarde: Sociology after the End of the Social.' *Theory Culture & Society* 20, no. 5 (2003).
Toscano, Alberto. 'In Praise of Negativism.' In *Deleuze, Guattari and The Production of the New*, eds. Simon O'Sullivan and Stephen Zepke. London: Continuum, 2008.
Tribe, Mark, and Reena Jana. *New Media Art*. New York: Taschen, 2006.
Uspensky, Boris. *Ét'yudy po russkoĭ istorii* (Etudes in Russian history). St. Petersburg: Azbuka, 2001.
Virno, Paolo. *A Grammar of the Multitude*. New York: Semiotext(e), 2004.
Virno, Paolo, and Michael Hardt. *Radical Thought in Italy: A Potential Politics*. Minneapolis: University of Minnesota Press, 1996.
Vishmidt, Marina, et al., eds. *Media Mutandis: A NODE.London Reader*. Node. London, 2006.
Wallenstein, Sven-Olov. 'Institutional Desires.' In *Art and Its Institutions. Current Conflicts, Critique and Collaborations*, ed. Nina Möntmann.
Wallis, Roger, and Krister Malm. *Big Sounds from Small People: The Music Industry in Small Countries*. London: Constable, 1984.
Weber, Max. *The Theory of Social and Economic Organization*. Free Press, 1947.
Whitehead, Alfred North. *Modes of Thought*. New York: Free Press, 1968.
———. *Process and Reality, An Essay in Cosmology*. New York: Free Press, 1985.
Wiener, Norbert. *The Human Use of Human Beings*. New York: Da Capo Press, 1950.
Williams, James. *Gilles Deleuze's "Difference and Repetition": A Critical Introduction and Guide*. Edinburgh: Edinburgh University Press, 2003.
Wright, Steve. *Storming Heaven: Class Composition and Struggle in Italian Autonomist Marxism*. London: Pluto, 2002.
XXX. Artwork by Alexei Shulgin. 1995. http://www.easylife.org/xxx/anim.html (accessed 21 Jan. 2011).
Yovits, M. C., and S. Cameron, eds. *Self-Organizing Systems*. Proceedings of the first conference on self-organization. London: Pergamon, 1960.
Yuill, Simon. 'All Problems of Notation Will Be Solved by the Masses: Free Open Form Performance, Free/Libre Open Source Software, and Distributive Practice.' In *FLOSS+ART*, eds. Aymeric Mansoux and Marloes de Valk. London: MetaMute, 2008.
ZKP3.2.1. Filtered by Nettime. Dry books # 1. Lubljana Digital Media Lab, 1996.

Index

RSITIES AT MEDWAY LIBRARY